THE ARTIST'S GUIDE TO USING COLOR

A complete step-by-step guide in watercolor, acrylic and oil

by Wendon Blake

Paintings by
Ferdinand Petrie
and other artists
where credited

Cincinnati, Ohio

The Artist's Guide to Using Color. Copyright © 1992 by Don Holden. Paintings copyright © 1992 by Ferdinand Petrie and other artists where credited. Printed and bound in Hong Kong. All rights reserved. No part of this book may be reproduced in any form or by any electronic or mechanical means including information storage and retrieval systems without permission in writing from the publisher, except by a reviewer, who may quote brief passages in a review. An earlier version of this book was originally published by Watson-Guptill Publications in 1981 as *The Color Book*. Published by North Light Books, an imprint of F&W Publications, Inc., 1507 Dana Avenue, Cincinnati, Ohio 45207; 1-800-289-0963. First edition.

96 95 94 93 92 5 4 3 2 1

Library of Congress Cataloging-in-Publication Data

Blake, Wendon.
 [Color book]
 The artist's guide to using color : a complete step-by-step guide in watercolor, acrylic and oil / by Wendon Blake : paintings by Ferdinand Petrie and other artists where credited.
 p. cm.
 Originally published as: The Color book.
 Includes bibliographical references and index.
 ISBN 0-89134-378-4 (hard cover)
 1. Color in art. 2. Color guides. 3. Painting—Technique. I. Petrie, Ferdinand. II. Title.
ND1488.B55 1992
751.4—dc20 91-29859
 CIP

Edited by Rachel Wolf
Designed by Paul Neff

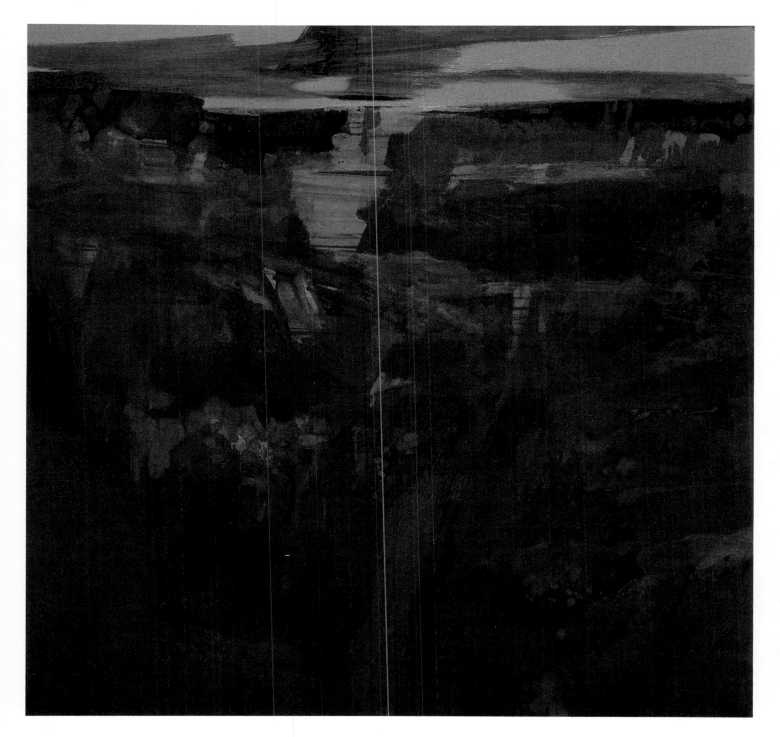

CANYON

by Edward Betts, acrylic on board, 48" × 48"

*The hot color of the massive rock formations is accentuated by the brilliant blue
of the sky. This sky color reappears in the small, inconspicuous notes of cool
color that the artist deftly places in the foreground. This contrast of
complementary colors — blue against orange — is a classic color strategy. The
complements, placed side by side, brighten one another. And the touches of cool
color in the foreground serve to relieve the overwhelming warmth of the canyon.*

Photo courtesy Midtown-Payson Galleries, New York

Table of Contents

INTRODUCTION
vii

PART ONE: GETTING STARTED
1

Getting organized for oil painting 2
Oil colors and mediums ... 3
Getting organized for watercolor painting 4
Colors for watercolor painting 5
Getting organized for acrylic painting 6
Acrylic colors and mediums ... 7

PART TWO: COLOR BASICS
9

Color terms .. 10
Color wheel ... 11
Testing oil colors .. 12
Making oil color charts .. 13
Testing watercolors .. 14
Making watercolor charts .. 15
Testing acrylic colors ... 16
Making acrylic color charts .. 17
Understanding values .. 18
Controlling value and intensity 20
Analyzing key and contrast .. 22
Mixing colors .. 25

PART THREE: PUTTING COLOR TO WORK
27

Composing with color .. 28
Creating space with color ... 30
Rendering light and weather ... 32
Conveying time of day ... 34
Achieving color harmony ... 35

PART FOUR: PAINTING WITH A LIMITED PALETTE
37

Demo One: Oil painting with a tonal palette 38

Table of Contents

Demo Two: Acrylic painting with a tonal palette 42

Demo Three: Oil painting with a primary palette 45

Demo Four: Watercolor painting with a
primary palette ... 48

Demo Five: Acrylic painting with a primary palette 51

PART FIVE: COLOR STRATEGIES — GALLERY I
55

PART SIX: PAINTING WITH A FULL PALETTE
71

Demo One: Oil painting in subdued color 72

Demo Two: Watercolor painting in subdued color 76

Demo Three: Oil painting in rich color 79

Demo Four: Watercolor painting in rich color 82

Demo Five: Acrylic painting in rich color 85

PART SEVEN: COLOR STRATEGIES — GALLERY II
89

PART EIGHT: ADVANCED PAINTING METHODS
105

Demo One: Monochrome underpainting in oil 106

Demo Two: Monochrome underpainting
in watercolor ... 108

Demo Three: Color underpainting in acrylic 111

Demo Four: Color underpainting in watercolor 113

Demo Five: Wet-in-wet painting in oil 116

Demo Six: Stroke technique in acrylic 118

Demo Seven: Knife painting in oil 120

PART NINE: COLOR STRATEGIES — GALLERY III
123

BIBLIOGRAPHY
135

INDEX
136

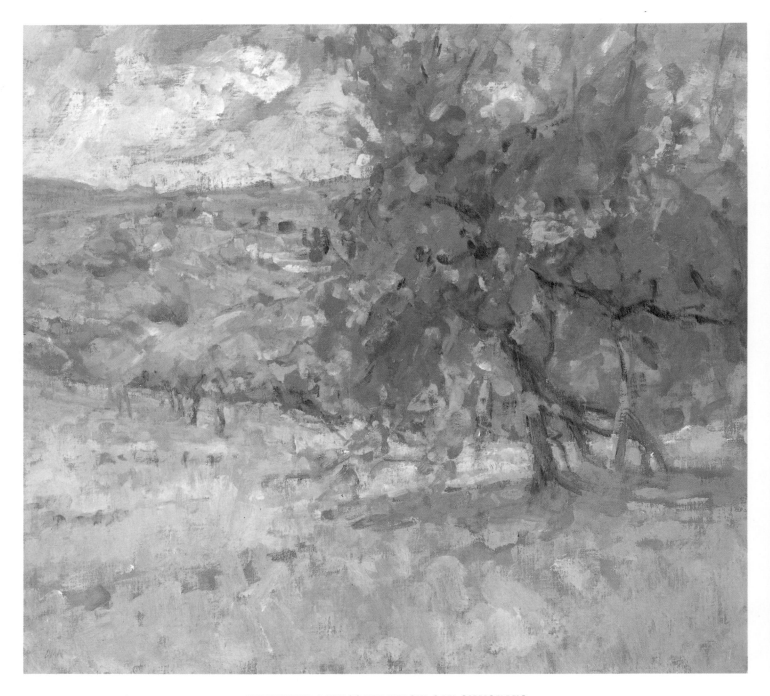

SEPTEMBER LANDSCAPE BELOW SAN GIMIGNANO

by Diana Armfield, oil on board, 15 ¾" × 17"

This is a wonderful example of a method that was perfected by the Impressionists to achieve color harmony. The artist interweaves strokes of the same colors throughout the picture. Touches of the sky colors appear in the trees and in the distant landscape. The colors of the distant landscape appear in the foreground, within the foliage of the tree, and in the shadow beneath the tree. And the foliage colors reappear in the distance. Every area of the painting echoes the colors of other areas. The strokes interweave like the strands of a tapestry.

Photo courtesy Browse & Darby, London

COLOR IS LOGICAL

People often say that a "color sense" is some sort of gift, some magic power that you're born with. Supposedly, only a few lucky artists are born with this power, while all the others just have to struggle with color all their lives. But this is a myth—a terribly discouraging myth that leads beginning painters to believe that color is a lot harder than it has to be. The fact is that a good "color sense" isn't merely a matter of instinct, but something you can develop, just like your drawing skill. Working with color is a logical process. There are logical ways to plan a harmonious color scheme, to organize your colors to enhance the composition of your paintings, and to use color to create a convincing sense of space, light, and atmosphere. And you can master many different techniques of applying color—techniques that will enrich your paintings in oil, watercolor, or acrylic.

THEORY VERSUS PRACTICE

This is a practical book, not a theoretical one. It focuses entirely on the concrete color problems of the artist who's standing at the easel—or maybe sitting under a tree—trying to paint a picture that *works*. Scientific color theories are generally useless to the artist who wants practical help in rendering the colors of a tree or a sky. So you'll find no color theory in this book, and only a single diagram: the classic color wheel, which (as you'll see) is actually a very practical guide to color mixing and color harmony. Instead of theories, you're given a practical guidance on how color behaves in nature and how to make color behave in your paintings.

LEARNING COLOR FUNDAMENTALS

After a brief review of the materials and equipment needed to handle the techniques presented here—with particular attention to recommended colors and mediums—you'll move right into the basics that you need "on the job." You'll learn practical definitions of color terms; how to use the color wheel as a tool in planning your paintings; how to test and get to know the behavior of the colors on your palette; how to mix colors; and how to make the most effective use of value, intensity, key, and contrast in your paintings.

PUTTING COLOR TO WORK

Having absorbed these fundamental color principles, you'll then learn how to compose with color, create space with color, render the colors of light and weather, convey the unique color effects of various times of day, and achieve color harmony.

STEP-BY-STEP DEMONSTRATIONS

To show you how to work with color in the studio or on location, three groups of step-by-step demonstrations are offered, analyzing works by noted painter, Ferdinand Petrie. The best way to learn about color is to start with just a few colors—and discover how much you can do with them. So the first five demonstrations show you what you can accomplish with limited palettes in oil, watercolor, or acrylic. The next five demonstration paintings are done with a full palette of oil, watercolor, and acrylic colors. And the final group of seven demonstrations will introduce you to such advanced color techniques as underpainting and overpainting, wet-in-wet painting, the stroke technique of the Impressionists, and knife painting for maximum color brilliance.

COLOR STRATEGIES

The three groups of demonstrations alternate with three sections on "color strategies." In these sections, fifty paintings by leading contemporary artists are reproduced and the planning behind each picture is explained. How do professional artists make color work for *them*? How do they orchestrate color? How do they apply color to the painting surface? How do they use color *creatively*?

HOW TO USE THIS BOOK

As you'll see, the step-by-step demonstrations show you every significant painting operation—with detailed captions describing the colors, mixtures, and ways of handling the brush or knife. After watching these demonstrations "over the artist's shoulder," you're encouraged to try the process yourself. But don't just copy the painting in the book! Find a similar subject and attempt a similar painting, using the methods you've seen in the demonstration. When time and weather permit, go outdoors and paint directly from nature, which is always the best way to learn how to observe, analyze, and render color.

Wendon Blake

Wendon Blake
New York, 1991

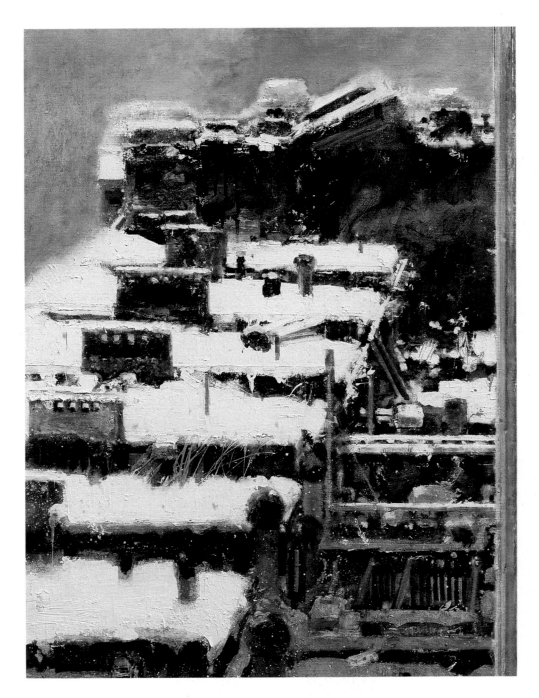

VIEW FROM THE STUDIO, WINTER III

by Morton Kaish, acrylic on canvas, (detail), 48″ × 48″

Because this winter cityscape is dominated by cool colors — blues and blue-violets — the few warm colors really sing out. The red wall and the rosy blushes at the horizon are very subdued mixtures, but they have great power because they're surrounded by cool mixtures. And the icy colors look even icier by contrast. Notice how the artist places small touches of warm color within the cool strokes of the foreground, where these reddish notes are inconspicuous, but "pull the painting together" by echoing the larger areas of warm color. The strategy reminds you of Canyon *(opposite the copyright page) — a painting where a few cool notes make the hot colors even hotter.*

Photo courtesy Staempfli Gallery, New York

PART ONE
GETTING STARTED

BUYING BRUSHES

There are three rules for buying brushes. First, buy the best you can afford—even if you can afford only a few. Second, buy big brushes, not little ones; big brushes encourage you to work with bold strokes. Third, buy brushes in pairs, roughly the same size. This is how these pairs of brushes would work: if you're painting a sky, for example, you'll probably want one brush for the blue areas and the gray shadows on the clouds, and another brush to paint the pure white areas of the clouds.

BRUSHES FOR OIL PAINTING

Begin with a couple of really big bristle brushes, around 1" (25 mm) wide for painting your largest color areas. You might want to try different shapes: one can be a flat, while the other might be a filbert, and one might be just a bit smaller than the other. The numbering systems of manufacturers vary, but you'll probably come reasonably close if you buy a number 11 and a number 12. You'll also need two or three bristle brushes about half this size: numbers 7 and 8 in the catalogs of most brush manufacturers. Again, try a flat, a filbert, and perhaps a bright. Then, for painting smoother passages, details and lines, you'll find three softhair brushes useful: one that's about ½" (13 mm) wide; one that's about half this wide; and a pointed, round brush that's about ⅛" or 3/16" (3 to 5 mm) thick at the widest point.

KNIVES

For scraping a wet canvas when you want to correct or to repaint something, a palette knife is essential. Many oil painters also prefer to mix colors with a knife (rather than a brush). If you like to *paint* with a knife, however, don't use a palette knife. Instead, buy a painting knife with a short, flexible, diamond-shaped blade.

PAINTING SURFACES

When you're starting to paint in oil, you can buy inexpensive canvas boards at any art supply store. Canvas boards are made of canvas that has been coated with white paint and glued to sturdy cardboard. They come in standard sizes that will fit into your paintbox. Later, you can buy stretched canvas: sheets of canvas precoated with white paint, nailed to a rectangular frame made of wooden "stretcher bars." If you like to paint on a smooth surface, buy sheets of hardboard and coat them with acrylic gesso, a thick, white paint that you buy in cans or jars.

EASEL

An easel is helpful but not essential. Basically, an easel is just a wooden framework with two "grippers" that hold the canvas upright while you paint. The "grippers" slide up and down to fit larger or smaller paintings—and to match your height. If you'd rather not invest in an easel, you can always hammer a few nails partway into the wall and rest your painting on them. If the heads of the nails overlap the painting, they'll hold it securely.

PAINTBOX

To store your painting equipment and to carry your gear outdoors, a wooden (or aluminum) paintbox is a great convenience. The box has compartments for brushes, knives, tubes, small bottles of oil and solvent, and other accessories. It usually holds a palette—plus some canvas boards—inside the lid.

PALETTE

A wooden paintbox often comes with a wooden palette. Before you squeeze out your paint on it, rub the palette with several coats of linseed oil to make the surface smooth, shiny, and nonabsorbent. When the oil is dry, the palette won't soak up your tube colors, and the surface will be easy to clean at the end of the painting day. A paper palette is even more convenient. This looks like a sketchpad, but the pages are nonabsorbent paper and it comes in standard sizes that fit into paintboxes. At the beginning of the painting day, you squeeze out your colors on the top sheet. When you've finished painting, you just tear off and discard the sheet.

ODDS AND ENDS

To hold your solvent and your painting medium—which might be plain linseed oil or one of the mixtures you'll read about shortly—buy a pair of metal palette cups (or "dippers") to clip onto your palette. You'll also need a few sticks of natural charcoal—not charcoal pencils or compressed charcoal—to sketch the composition on your canvas before you start to paint. Then you'll need to keep a clean rag or paper towel handy to dust off the charcoal and make the lines paler before you start to paint. Smooth, absorbent, lint-free rags are also good for wiping mistakes off your painting surface. Paper towels or old newspapers (which are a lot cheaper) are essential for wiping your brush after you've rinsed it in solvent.

WORK LAYOUT

Before you start to paint, lay out your equipment in a consistent way so that everything is always in its place when you reach for it. If you're right-handed, place the palette on a table to your right, along with a jar of solvent, your rags and newspapers, your paper towels, and a clean jar in which you store your brushes (hair end up). Also, establish a fixed location for each color on your palette. One good arrangement is to place your *cool* colors (black, blue, green) along one edge, and the *warm* colors (yellow, orange, red, brown) along another edge. Put a big dab of white in a corner where it won't be fouled by other colors.

COLOR SELECTION

When you walk into an art supply store, you'll probably be dazzled by the number of different colors you can buy. But there are far more tube colors in existence than any artist can use. In reality, all the oil paintings in this book are done with roughly a dozen colors, about the average number used by most professionals. So the colors listed below can be enough for a lifetime of painting. You'll notice that most colors are in pairs—two blues, two reds, two yellows, two browns—and that one member of each pair is bright, while the other is more subdued. This combination should give you the greatest possible range of color mixtures. Now here's a suggested palette.

BLUES

Ultramarine blue is a dark, subdued hue with a faint hint of violet. Phthalocyanine blue is much more brilliant and has surprising tinting strength. This means that just a little goes a long way when you mix it with another color, so you must always add phthalocyanine blue very gradually to your mixtures. Although these two blues will do almost every job, you may want to keep a tube of cerulean blue handy for painting skies, distant hills, and other atmospheric tones. This beautiful, delicate blue can be considered an optional color.

REDS

Cadmium red light is a fiery red with a hint of orange. (All cadmium colors have tremendous tinting strength, so remember to add them to mixtures just a bit at a time.) Alizarin crimson is a darker red and has a slightly violet cast.

YELLOWS

Cadmium yellow light is a dazzling, sunny yellow with tremendous tinting strength, like all the cadmiums. Yellow ochre is a soft, tannish tone. If your art supply store carries two shades of yellow ochre, buy the lighter one.

BROWNS

Burnt umber is a dark, somber brown. Burnt sienna is a coppery brown that has a suggestion of orange.

GREEN AND ORANGE

Although nature is full of greens—and so is your art supply store—you can mix an extraordinary variety of greens with the colors on your palette. But it *is* convenient to have just one green available in a tube. The most useful green is a bright, clear hue called viridian. The reds and yellows on your palette will make a variety of oranges, but you still may enjoy having the brilliant, sunny cadmium orange on your palette. Both viridian and cadmium orange are optional colors.

BLACK AND WHITE

The standard black used by almost every oil painter is ivory black. The white you buy can be either zinc white or titanium white. Always buy the biggest tube of white you can find because you'll be using lots of it.

LINSEED OIL

Although the color in the paint tubes already contains some linseed oil, the manufacturer has added only enough oil to produce a paste thick enough to squeeze out in little mounds around the edge of your palette. To make the paint more fluid, you can add more linseed oil to the color on your palette. So pour some oil into one of the metal cups (or "dippers"). You can then dip your brush into the oil, pick up some paint on the tip of the brush, and blend oil and paint together on your palette to produce the consistency you want.

SOLVENT

You'll also need a big bottle of turpentine or one of the petroleum solvents—called mineral spirits, white spirit, or rectified petroleum—to fill the second metal cup that's clipped to the edge of your palette. You can then add a few drops of solvent to the mixture of paint and linseed oil on your palette. The more solvent you add, the thinner the paint will become. (Some oil painters prefer to premix their linseed oil and solvent, 50-50, in a bottle before they start. They then keep this thin "painting medium" in one palette cup, and pure solvent—for thinning it further—in the other.) For cleaning your brushes as you paint, you can pour some solvent into a small jar. Then, when you want to rinse out the color on your brush before picking up fresh color, you simply swirl the brush around in the solvent and wipe the bristles on a newspaper.

PAINTING MEDIUMS

The simplest painting medium is the traditional 50-50 blend of linseed oil and solvent. Many painters are satisfied to thin their paint with that medium for the rest of their lives. However, after you've tried the traditional medium, you might like to try some commercial mediums, available in art supply stores. The most popular ones are usually a blend of resin, solvent, and perhaps some linseed oil. They're called damar, copal, mastic, or alkyd mediums. The resin that's added is really a kind of varnish that adds luminosity to the paint and makes it dry more quickly.

VARNISHES

A finished oil painting is normally protected by a layer of varnish. There are two types: retouching varnish and picture varnish. As soon as the painting surface feels dry to your fingertips, you can brush or spray on a coat of *retouching varnish* to make the surface appear glossy. After drying for about six months, most oil paintings are ready for a coat of *picture varnish*. So buy both retouching *and* picture varnish.

STUDIO SETUP

Whether you work in a studio or just in a corner of a bedroom or kitchen, it's important to be methodical about setting up. Let's review the basic equipment and its arrangement.

BRUSHES FOR WATERCOLOR

You'll need just a few brushes for watercolor painting, but you should buy the very best brushes you can afford. You can perform every significant painting operation with just four soft-hair brushes, whether they're expensive sable, less costly oxhair or soft nylon, or perhaps some blend of natural and synthetic hairs. All you really need are a big number 12 round and a smaller number 7 round, plus a big 1″ (25 mm) flat and a second flat about half that size.

PAPER

The best all-purpose watercolor paper is moldmade 140-pound stock in the *cold-pressed* surface (called a ''not'' surface in Britain), which you ought to buy in the largest available sheets and cut into halves or quarters. The most common sheet size is 22″×30″ (55×76 cm). This paper has a distinct texture, but it's not as irregular as the surface called *rough*. Later, you might like to try both rough and smooth papers or illustration board.

DRAWING BOARD

The simplest way to support your paper while you work is to tack or tape the sheet to a piece of hardboard, cut just a little bigger than a full sheet or half sheet of watercolor paper. You can rest this board on a tabletop, perhaps propped up by a book at the back edge so the board slants toward you. You can also rest the board in your lap or even on the ground. Art supply stores carry more expensive *wooden* drawing boards to which you tape your paper. At some point, you may want to invest in a professional draw-

ing table, with a top that tilts to whatever angle you find convenient. But you can easily get by with an inexpensive piece of hardboard, a handful of thumbtacks (drawing pins) or pushpins, and a roll of drafting tape 1″ (25 mm) wide to hold down the edges of your paper.

PALETTE OR PAINTBOX

Some professionals simply squeeze out and mix their colors on a white enamel tray—which you can probably find in a shop that sells kitchen supplies. The palette made *specifically* for watercolor is white metal or plastic with compartments into which you squeeze tube colors, plus a mixing surface for producing quantities of liquid color. For working on location, it's convenient to have a metal watercolor box with compartments for your gear. But a toolbox or a fishing tackle box—with lots of compartments—will do just as well. If you decide to work outdoors with *pans* of color (more about these in a moment), buy an empty metal watercolor box that's equipped to hold pans, and then buy the selection of colors listed in this book. Don't buy a box that contains preselected pans of color.

ODDS AND ENDS

You'll also need some single-edge razor blades or a knife with a retractable blade (for safety) to cut paper. Paper towels and cleansing tissues are useful, not only for cleaning up, but for lifting wet color from a painting in progress. A sponge is excellent for wetting paper, lifting wet color, and cleaning up spills. You obviously need a pencil for sketching your composition on the watercolor paper before you start to paint: buy an HB drawing pencil in an art supply store or just use an ordinary office pencil. To erase the pencil lines when the watercolor is dry, buy a kneaded rubber (or ''putty rubber'') eraser, so soft that you can shape it like clay and erase a pencil line without abrading the delicate surface of the sheet. You'll also need

three wide-mouthed glass jars, big enough to hold a quart or a liter of water (you'll find out why in a moment). If you're working outdoors, a folding stool is a convenience—and insect repellent is a *must*!

WORK LAYOUT

Lay out your supplies and equipment in a consistent way, so that everything is always in its place when you reach for it. Directly in front of you is your drawing board with your paper tacked or taped to it. If you're right-handed, place your palette and those three wide-mouthed jars to the right of the drawing board. In one jar store your brushes, hair end up; don't let them roll around on the table and get squashed. Fill the other two jars with clear water. Use one jar of water as a ''well'' from which you draw water to mix your colors; use the other for washing your brushes. (Be sure to change the water when it gets really dirty.) Keep the sponge in a corner of your palette, with the paper towels nearby, ready for emergencies. Line up your tubes of color someplace where you can get at them quickly (possibly along the other side of your drawing board) when you need to refill you palette. Reverse these arrangements if you're left-handed.

PALETTE LAYOUT

In the excitement of painting, it's essential to dart your brush at the right color instinctively. So establish a fixed location for each color on your palette. There's no one standard arrangement. One good way is to line up your colors in a row with the *cool* colors at one end and the *warm* colors at the other. The cool colors would be black, two or three blues, and green, followed by the warm yellows, orange, reds, and browns. The main thing is to be consistent in your arrangement, so you can find your colors when you want them.

TUBES AND PANS

Watercolors are normally sold in collapsible metal tubes about as long as your thumb, and in metal or plastic pans about the size of the first joint of your thumb. The tube color is a moist paste that you squeeze out onto the surface of your palette. The color in the pan is dry, but dissolves as soon as you touch it with a wet brush. The pans, which lock neatly into a small metal box made to fit them, are convenient for rapid painting on location. But the pans are useful mainly for small pictures—no more than twice the size of this page—because the dry paint in pans is best for mixing small quantities of color. The tubes are more versatile and more popular. The moist color in the tubes will quickly make small washes for small pictures and big washes for big pictures. If you must choose between tubes and pans, buy the tubes.

COLOR SELECTION

All the watercolors in this book are painted with just a dozen tube colors. Once you learn to mix the various colors on your palette, you'll be astonished at the range of colors you can produce. Seven of these twelve colors are *primaries*—blues, reds, and yellows. Primaries are colors you can't create by mixing other colors. There are just two *secondaries*, orange and green. Secondaries are colors you *can* create by mixing two primaries. For example, you can mix a rich variety of greens by combining various blues and yellows, plus many different oranges by combining reds and yellows. You could really do without the secondaries, but it does save time to have them. Finally, there are two browns, plus black.

BLUES

Ultramarine blue is a dark, warm blue that produces a rich variety of greens when blended with the yellows, and a wide range of grays, browns, and brown-grays when mixed with the two browns on your palette. Phthalocyanine blue is clear, cool, and brilliant. Cerulean blue is a light, bright blue that's popular for skies and atmospheric effects. It's an optional hue that you might like to have available.

REDS

Alizarin crimson is a bright red with a hint of purple. It produces lovely oranges when mixed with the yellows, subtle violets when mixed with the blues, and rich darks when mixed with green. Cadmium red light is a dazzling red, producing rich oranges when mixed with the yellows, coppery tones when mixed with the browns, and surprising darks (not violets) when mixed with the blues.

YELLOWS

Cadmium yellow light is bright and sunny, producing luminous oranges when mixed with the reds, and rich greens when mixed with the blues. Yellow ochre is a much more subdued yellow that produces subtle greens when mixed with the blues, and muted oranges when mixed with the reds. You'll find that both cadmium yellow and cadmium red tend to dominate mixtures, so add them just a bit at a time. Some watercolorists find cadmium yellow *too* strong—and just a bit too opaque—so they substitute new gamboge, which is bright, very transparent, and less apt to dominate a mixture.

ORANGE

Cadmium orange is a color that you really could create by mixing cadmium yellow light (or new gamboge) and cadmium red light. But it's a beautiful, sunny orange, and convenient to have ready-made.

GREEN

Viridian is another optional, but convenient color. Just don't become dependent on this one green. Learn how many other greens you can mix by combining blues, blacks, and yellows. And see how many other greens you can make by modifying viridian with other colors.

BROWNS

Burnt umber is a dark, subdued brown that produces lovely brown-grays and blue-grays when blended with the blues, subtle foliage colors when mixed with green, and warm autumn colors when mixed with reds, yellows, and oranges. Burnt sienna is a bright orange-brown that produces a very different range of blue-grays and brown-grays when mixed with the blues, plus rich, coppery tones when blended with reds and yellows.

BLACK

This is a controversial color among watercolorists. Many painters don't use black because they can mix more interesting darks—containing a fascinating hint of color—by blending such colors as blue and brown, red and green, orange and blue. And blue-brown mixtures also make more interesting grays. However, ivory black is worth having on your palette if you use it for mixing. For example, mixed with the yellows, ivory black produces beautiful, subdued greens for landscapes; and mixed with blues and greens, ivory black produces deep, cool tones for coastal subjects. If you find ivory black too strong, you might like to try Payne's gray, which is softer, lighter, and a bit bluer, making it popular for painting skies, clouds, and atmosphere.

NO WHITE

Your sheet of watercolor paper provides the only white you need. You lighten a watercolor mixture with water, not with white paint.

BRUSHES FOR ACRYLIC PAINTING

Because you can wash out a brush quickly when you switch from one color to another, you'll need very few brushes for acrylic painting. Two large, flat brushes will do for covering big areas: a 1" (25 mm) bristle or nylon brush, and a softhair brush the same size, preferably a soft synthetic or a blend of natural and synthetic hairs. Then you'll need another bristle or nylon brush and another softhair brush, each half that size. For more detailed work, add a couple of round softhair brushes—a number 10, which is about ¼" (6 mm) in diameter, and a number 6, which is about half as thick. If you find that you like working in very fluid color, thinned to the consistency of watercolor, it might be helpful to add a big number 12 round, softhair brush, either nylon or a blend. Since acrylic painting will subject brushes to a lot of wear and tear, few artists use their expensive sables.

PAINTING SURFACES

If you like to work on a smooth surface, you can use illustration board, which is white drawing paper with a stiff cardboard backing. You can also use watercolor paper; the most versatile one is moldmade 140-pound stock in the *cold-pressed* surface. Acrylic handles beautifully on canvas, but make sure that the canvas is coated with white acrylic paint, not white oil paint. Your art supply store will also sell inexpensive canvas boards—thin canvas glued to cardboard—that are usually coated with white acrylic, and are excellent for acrylic painting. You can create your own painting surface by coating hardboard with acrylic gesso—a thick, white acrylic paint that comes in cans or jars. For a smooth surface, brush on several thin coats of acrylic gesso diluted with water to the consistency of milk or thin cream. For a rougher surface, brush on the gesso straight from the can so that the white coating retains the marks of the brush. Use a big nylon house painting brush.

DRAWING BOARD

To support your illustration board or watercolor paper while you work, the simplest solution is a piece of hardboard. Just tack or tape your painting surface to the hardboard. You can tack down a canvas board in the same way. If you like to work on a vertical surface—which many artists prefer when they're painting on canvas, canvas board, or hardboard coated with gesso—a wooden easel is the solution. If your budget permits, you may like a wooden drawing table, which you can tilt to a horizontal, diagonal, or vertical position by turning a knob.

PALETTE

One of the most popular palettes for acrylics is the least expensive—a white enamel tray. Another good choice is a white metal or plastic palette (the kind used for watercolor) with compartments into which you can squeeze your tube colors. Some acrylic painters like a paper palette (a pad of waterproof pages that you can tear off and discard after painting).

ODDS AND ENDS

For working outdoors, it's helpful to have a wood or metal paintbox with compartments for tubes, brushes, bottles of medium, knives, and other accessories. You can buy a tear-off paper palette and canvas boards that fit neatly into the box. Many acrylic painters carry their gear in a toolbox or a fishing tackle box, both of which have lots of compartments. Buy a sharp knife with a retractable blade (or some single-edge razor blades) to cut paper, illustration board, or tape. You'll also find paper towels and a sponge useful for cleaning up.

You'll need a pencil for sketching in your composition before you start to paint. To erase the pencil lines, get a kneaded rubber eraser that's so soft you can shape it like clay and erase a pencil line without hurting the surface. To hold down that paper or board, get a roll of 1" (25 mm) drafting tape and a handful of thumbtacks (drawing pins) or pushpins. Finally, to carry water when you work outdoors, you can take a discarded plastic detergent bottle (if it's big enough to hold a couple of quarts or liters) or buy a water bottle or a canteen in a store that sells camping supplies. For the studio, you'll need three wide-mouthed glass jars, each big enough to hold a quart or a liter.

WORK LAYOUT

As in oil and watercolor painting, before you start to paint, lay out your supplies and equipment in a consistent way, so everything is in its place when you reach for it. Obviously your drawing board or easel is directly in front of you. Place your palette, those three jars, and a cup of medium within comfortable reach. In one jar, store your brushes, hair end up. Then fill the other two jars with clear water: one for washing your brushes and the other for diluting your colors. Also establish a fixed location for each color on your palette. As suggested earlier, one good way is to place your *cool* colors (black, blue, and green) at one end and the *warm* colors (yellow, orange, red, and brown) at the other. Put a big blob of white in a distant corner where it won't pick up traces of the other colors.

COLOR SELECTION

The acrylic paintings in this book—like the oils and watercolors—are all done with about a dozen colors, and fewer than a dozen in many cases. If you've read the preceding pages about colors for oil and watercolor painting, you know by now that this book recommends a modest group of colors that will give you all the mixtures you need—in *any* medium. The next few paragraphs repeat the basic list with a few variations, since there *are* some colors that are particularly useful for acrylic painting.

BLUES

Once again, ultramarine blue and phthalocyanine blue are the two basic blues, while cerulean blue is an attractive optional color.

REDS

Cadmium red appears on all three palettes—oil, watercolor, and acrylic—and naphthol crimson is the acrylic equivalent of alizarin crimson. By the way, when you mix these two reds, you get the most vivid color mixture that your palette can produce.

YELLOWS

Cadmium yellow light and yellow ochre are the basic yellows again. Yellow ochre is often called yellow oxide in acrylic.

GREEN

An optional, but useful green is phthalocyanine green, which is a clear, brilliant hue that has enormous tinting strength, like phthalocyanine blue. Add *both* phthalo colors in very small amounts.

ORANGE

Although orange is also optional, cadmium orange can be convenient to have around.

BROWNS

By now familiar, the two basic browns are burnt umber and burnt sienna.

BLACK AND WHITE

The demonstration paintings in this book are done with ivory black, but you might also like to try Mars black, which has greater tinting strength. Titanium white is the standard acrylic white.

GLOSS AND MATTE MEDIUMS

Although you can simply thin acrylic tube color with water, most manufacturers produce liquid painting mediums for this purpose. Gloss medium will thin your paint to a delightful, creamy consistency; if you add enough medium, the paint turns transparent and allows the underlying colors to shine through. As its name suggests, gloss medium dries to a shiny finish. Matte medium has exactly the same consistency and will also turn your color transparent if you add enough medium, but it dries to a satin finish with no shine. Try both mediums and see which you prefer. It's a matter of taste.

GEL MEDIUM

Still another medium comes in a tube and is called gel because it has a consistency like thick, homemade mayonnaise. The gel looks cloudy as it comes from the tube, but dries clear. Blended with tube color, gel produces a thick, juicy consistency that's lovely for heavily textured brush and knife painting.

MODELING PASTE

Even thicker than gel is modeling paste, which comes in a can or jar and has a consistency more like clay because it contains marble dust. You can literally build a painting ¼″ to ½″ (6 to 13 mm) thick if you blend your tube colors with modeling paste. But build gradually in several thin layers, allowing each one to dry before you apply the next, or the paste will crack.

RETARDER

One of the advantages of acrylic is its rapid drying time, since it dries to the touch as soon as the water evaporates. However, if you find that it dries *too* fast, you can extend the drying time by blending retarder with your tube color.

COMBINING MEDIUMS

You can also mix your tube colors with various combinations of these mediums to arrive at precisely the consistency you prefer. For example, a 50-50 blend of gloss and matte mediums will give you a semigloss surface. A combination of gel with one of the liquid mediums will give you a juicy, semiliquid consistency. A simple mixture of the tube color and modeling paste can sometimes be a bit gritty; this very thick paint will flow more smoothly if you add some liquid medium or gel. To create a roughly textured painting surface, you can combine acrylic gesso with modeling paste and brush the mixture over a sheet of hardboard with a stiff house painting brush.

ACRYLIC MEDIUM AND COLLAGE

It's worth remembering that matte and gloss acrylic mediums are actually very powerful adhesives. For this reason, acrylic lends itself—more than oil or watercolor—to combinations of acrylic paint and collage. It's easy to brush acrylic medium or acrylic tube color onto a scrap of paper or cloth, which will then adhere firmly to the painting surface. And you can paint right over the collage element with liquid color. Although collage is beyond the scope of this book, it's a delightful mixed media technique. Keep it in mind.

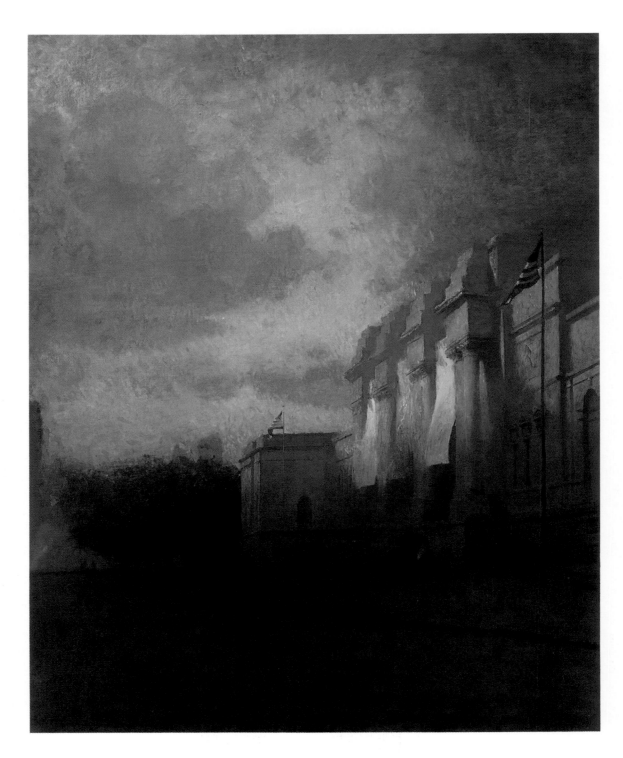

METROPOLITAN DAWN

by Gregg Kreutz, oil on canvas, 28″ × 24″

The artist places his greatest contrasts of color and value at the center of interest. The viewer's eye travels instinctively to the façade of the building, where the shadowy foreground area meets the flash of golden light on the wall. The dark clouds part at the horizon and just above the focal point of the picture, where the morning light breaks through to spotlight the building. The color scheme is rich but subdued; hints of warm color appear among the clouds and at the horizon. But the truly brilliant colors — the brightest and the lightest — are saved for the wall, where they're dramatized by the surrounding darkness.

PART TWO
COLOR BASICS

TALKING ABOUT COLOR

When artists discuss color, they use a number of words that may or may not be familiar to you. Because many of these words will appear in this book, this page will serve as a kind of informal glossary of color terms.

HUE

When you talk about color, the first thing you probably do is name the color. You say that it's red or blue or green. That name is the *hue*.

VALUE

As you begin to describe that color in more detail, you probably say that it's dark or light or something in between. Artists use the word *value* to describe the comparative lightness or darkness of a color. In judging value, it's helpful to pretend that you're temporarily colorblind, so that you see all colors as varying tones of black, gray, and white. Thus, yellow becomes a very pale gray—a light or high value. In the same way, a deep blue is likely to be a dark gray or perhaps black—a low or dark value. And orange is probably a medium gray—a middle value.

INTENSITY

In describing a color, artists also talk about its comparative intensity or brightness. The opposite of an intense or bright color is a subdued or muted color. Intensity is hard to visualize, so here's an idea that may help: pretend that a gob of tube color is a colored light bulb. When you pump just a little electricity into the bulb, the color is subdued. When you turn up the power, the color is more intense. When you turn the power up and down, you don't change the hue or value—just the brightness or *intensity*.

TEMPERATURE

For psychological reasons that no one seems to understand, some colors look warm and others look cool. Blue and green are usually classified as cool colors, while red, orange, and yellow are considered warm colors. Many colors can go either way. A bluish green seems cooler than a yellowish green, while a reddish purple seems warmer than a bluish purple. And there are even more subtle differences: a red that has a hint of purple generally seems cooler than a red that has a hint of orange; a blue with a hint of purple seems warmer than a blue that contains a hint of green. All these subtle differences come under the heading of *color temperature*.

PUTTING IT ALL TOGETHER

When you describe a color, you generally mention all four of these factors: hue, value, intensity, and temperature. If you want to be very technical, you might describe a particular yellowish green as "a high-value, high-intensity, warm green." Or you might say it more simply: "a light, bright, warm green."

PRIMARY, SECONDARY, AND TERTIARY COLORS

The primaries are blue, red, and yellow—the three colors you can't produce by mixing other colors. To create a secondary, you mix two primaries: blue and red to make violet; blue and yellow to make green; red and yellow to make orange. The six tertiary colors are blue-green, yellow-green, blue-violet, red-violet, red-orange, and yellow-orange. As you can guess the tertiaries are created by mixing a primary and a secondary: red and orange produce red-orange, yellow and orange produce yellow-orange, etc. You can also create tertiaries by mixing uneven amounts of two primaries: a lot of red and a little yellow will make red-orange; a lot of blue and a little yellow will make blue-green, and so forth.

COMPLEMENTARY COLORS

The colors that are opposite one another on the color wheel are called *complementary colors* or just *complements*. As you move your eye around the color wheel, you'll see that blue and orange are complements, blue-violet and yellow-orange are complements, violet and yellow are complements, and so forth. Memorize these pairs of complementary colors, since this information is useful in color mixing and in planning the color scheme of a painting. One of the best ways to subdue a color on the palette—to reduce its intensity—is to add a touch of its complement. On the other hand, one of the best ways to brighten a color in your painting is to place it *next* to its complement. Placing complements side by side is also one of the best ways to direct the viewer's attention to the center of interest in a painting, since this always produces a particularly vivid contrast.

ANALOGOUS COLORS

When colors appear next to one another—or fairly close—on the color wheel, they're called *analogous* colors. They're considered analogous because they have something in common. For example, blue, blue-green, green, and yellow-green are analogous because they *all* contain blue. Planning a picture in analogous colors is a simple, effective way to achieve color harmony.

NEUTRAL COLORS

Brown and gray are considered neutral colors. A tremendous variety of grays and browns—which can be quite colorful in a subtle way—can be mixed by combining the three primaries or any pair of complements in varying proportions. For example, various combinations of reds and greens make a diverse range of browns and grays, depending upon the proportion of red and green in the mixture.

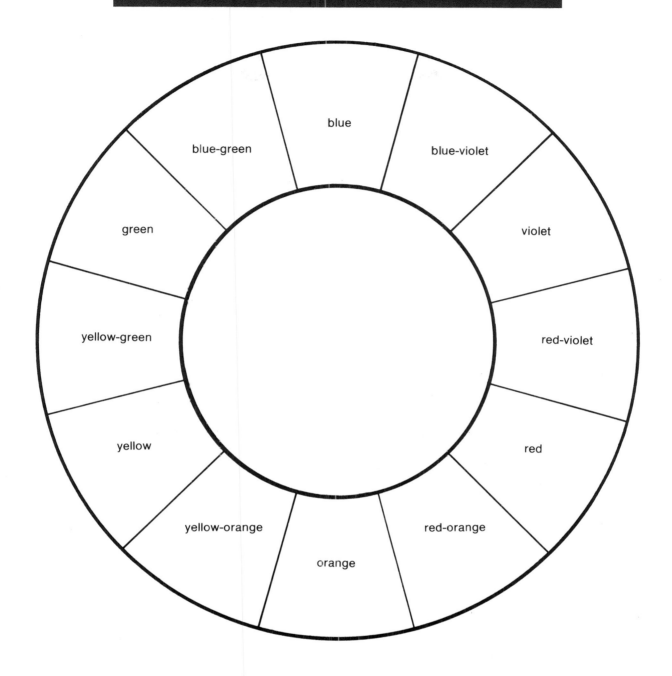

SOLVING COLOR PROBLEMS

It's helpful to memorize the classic diagram that artists call a *color wheel*. This simple diagram contains the solutions to a surprising number of color problems you may run into when you're working on a painting. For example, if you want a color to look *brighter*, place a bit of that color's complement nearby to strengthen it. (You'll find the complement directly across the wheel from that color.) On the other hand, if you want to *subdue* that original color, add a touch of its complement. If color harmony is your problem, one of the simplest ways to design a harmonious color scheme is to choose three or four colors that appear side-by-side on the color wheel, and build your painting around these *analogous* colors. Then, to add a bold note of contrast, you can enliven your color scheme by introducing one or two of the complementary colors that appear on the *opposite* side of the wheel from the original colors that you've chosen for your painting.

GETTING TO KNOW OIL COLORS

To work with oil colors successfully, you must learn how every color on your palette behaves when it's mixed with every other color. No two colors behave exactly alike, and they can be unpredictable. For example, you've certainly been taught that you can make purple by combining red and blue. That *is* true when you mix phthalocyanine blue with alizarin crimson, but prepare yourself for a shock when you mix phthalocyanine blue with cadmium red. The result is a strange brown that has its own special kind of beauty, but it's certainly not purple! Rather than make surprising discoveries like this one in the middle of a painting, it's best to store up this information by conducting a series of tests and recording the results on color charts. These charts are fun to make and useful to tack on your studio wall.

MAKING OIL COLOR CHARTS

Buy a pad of inexpensive, canvas-textured paper, or collect some old scraps of canvas and cut them to a size that's roughly that of the page you're now reading. With a sharp pencil, or perhaps a felt or fiber-tipped marker, plus a ruler, draw a series of boxes on the paper or canvas, forming a kind of checkerboard. The boxes should be 2″ to 3″ (50 to 75 mm) square. Each box should give you just enough space for a single color mixture. (It helps to write the names of the colors in the boxes.) The simplest way to plan these color charts is to make a separate sheet for each color on your palette. If you draw a dozen boxes on each chart, you'll have enough boxes to mix ultramarine blue, for example, with white and with all the other colors on your palette. If you run out of room on one chart, continue your mixtures on a second chart.

ADDING WHITE

Because you'll eventually be mixing white with every other color on your palette, it's essential to find out how each tube color behaves when it's blended with white. Place a few broad strokes of color in its box on the chart. Then pick up a clean brush, dip it into pure white, and scrub the white into *half* of the tube color in the box. Now you've got a color sample that's divided into two halves: one half is the pure tube color and the other half is tube color blended with white. When you study the completed charts, you'll discover some fascinating facts. For example, while a touch of white brightens the blues and makes yellows even sunnier, it reduces the intensity of reds and oranges.

MIXING PAIRS OF COLORS

Here's how to mix every color on your palette with every other color. In each box of this "pairing" chart, paint a thick stroke of two colors, slanting the strokes inward so they converge. At the point where they converge, scrub the colors together to find out what kind of mixture they make. It may be necessary to add a touch of white to the mixture to bring out the full color. For example, a mixture of ultramarine blue and viridian will look dark and dull, but a gorgeous blue-green emerges when you add just a little white. On the other hand, cadmium red light and cadmium yellow light will produce a stunning orange without the aid of white. Once again, prepare yourself for some surprises. Although experienced oil painters normally avoid adding black to subdue another color, ivory black produces wonderful mixtures when it's used as a cool color, like blue or green. Thus, the combination of yellow ochre and ivory black will produce a lovely, subtle olive green or greenish brown that's useful in landscape painting. And cadmium orange joins with ivory black to produce lovely coppery tones.

OPTICAL MIXING

When you blend two wet colors on your palette or directly on the painting surface, this is a *physical* mixture. But there's another way to mix colors that has been neglected by contemporary painters, although it was widely used by the old masters. In this method, the old masters often placed a layer of color on the canvas, allowed that layer to dry, then brushed on a second layer of transparent color (called a *glaze*) or semitransparent color (called a *scumble*) that allowed the underlying color to shine through. The two colors mixed in the eye of the viewer to form a third color—an *optical* mixture. Glazing and scumbling produce color effects that are impossible to get through purely physical mixtures. Several of the demonstrations in this book involve such optical mixtures. To see how optical mixtures work, you'll probably have to start a new chart. Paint a few strokes of a tube color in its own box on the color chart. (Lighten some of the darker colors such as black, blue, green, and brown with white.) Leave some canvas bare at one end of the box. Let the strokes dry. Before you brush the second color over the dry paint, add some painting medium to make the tube color fluid and transparent. Then brush this glaze over the bare canvas and carry the color *halfway* over the dried color. Now you can see how the underlying color looks by itself, how the transparent color looks by itself on the bare canvas, and how the two colors combine optically to create a third color. It's revealing to compare a physical mixture with an optical mixture of the same two colors: the optical mixture is sometimes more subtle and mysterious, sometimes more brilliant.

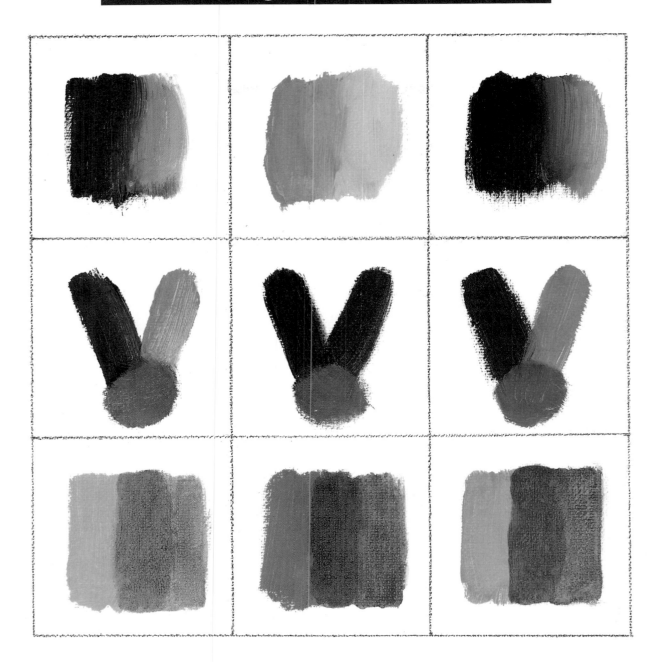

EXPLORING OIL COLOR MIXTURES

Here are some samples of the mixtures to test on your oil color charts. (Bear in mind that this isn't a typical chart, but a selection of typical boxes from various charts.) In the top row, there are three primary colors, each taken straight from the tube *and* blended with white. Ultramarine blue (left) as it comes from the tube is fairly dark and subdued, but turns to a soft blue with a hint of warmth when you add white. Cadmium yellow (center) is bright and sunny from the tube, and

even sunnier with white added. Alizarin crimson (right) is rather murky as it comes from the tube, but turns bright pink with a touch of white. In the second row, from left to right, a stroke of ultramarine blue and a stroke of cadmium yellow meet to form a subdued green; ultramarine blue and alizarin crimson produce a soft violet; and alizarin crimson and cadmium yellow make a hot orange. These six mixtures are all *physical mixtures*; that is, two wet colors are brushed together to produce a third. The third row shows *optical mixtures* in which one color is allowed to dry, and a second color is

diluted with painting medium to a transparent consistency and brushed halfway over the first color. From left to right, ultramarine blue is brushed over cadmium yellow, alizarin crimson over ultramarine blue (lightened with white), and alizarin crimson over cadmium yellow. In a printed book, the differences between physical and optical mixtures are less obvious than they'll be when you paint your own color charts—so be sure to try optical mixtures for yourself.

GETTING TO KNOW WATERCOLORS

Watercolor dries so rapidly that you've got to make your color mixing decisions quickly and carry the color from palette to paper without a moment's hesitation. Thus, you must know the color so intimately that you instinctively reach for the right one, visualizing in advance how it's going to behave. Once again, the best way to learn what your colors can do is to conduct a series of mixing tests and record the results on simple color charts that you can study and memorize at your leisure.

MAKING WATERCOLOR COLOR CHARTS

To prepare your charts, buy an inexpensive pad of cold-pressed paper about the size of the page you're now reading. If you can save money by buying the paper in large sheets, cut up the sheets to make your charts. With a pencil, draw a series of boxes on the paper with the aid of a ruler, to form a kind of checkerboard. Make the boxes 2″ to 3″ (50 to 75 mm) square, giving you enough room to paint a single color sample inside each box and to write the names of the colors. Make a separate sheet for each color on your palette, so you'll have enough boxes to mix that color with each of the others.

ADDING WATER

First you'll see how each tube color behaves when you add water. Water makes the tube colors fluid enough to brush across the paper, and also lightens the colors in the same way that white lightens oil paint. Now just make a few parallel strokes of each color, adding very little water to the first strokes at the left and adding a lot more water to the final strokes at the right. The darker area of the sample will show you how the color looks as it comes straight from the tube, while the paler area will show you how the

color looks when it's diluted. Let the samples dry and study them carefully. You'll see that each color has its own special character. For example, phthalocyanine blue is so powerful that you'll need a great deal of water to dilute it—and even when you do add a lot of water, you'll still get a rich, vivid blue. On the other hand, the more subdued ultramarine blue has less *tinting strength*; you'll need much less water to produce a pale wash of ultramarine. You'll also discover that watercolor lightens as it dries, so remember to make your mixtures a bit "too dark."

MIXING TWO COLORS

Next, you'll mix each color on your palette with every other color. The best way is to make a few broad strokes in the left-hand side of your box. Then, while those first few strokes are wet and shiny, add some strokes of the second color in the right-hand side of the box, carefully bringing the second color over to meet the first and letting them flow together. At the point where they flow together, you'll get a third color, showing you how the two colors mix. If you do this carefully, the dried sample will contain three ragged bands of color: the original two colors at the right and left, and the mixture in the middle. Don't worry if the two colors flow together so swiftly that they disappear and all you've got left is the mixture. After all, it's the mixture that you're really trying to record. (Don't forget to write the names of the colors somewhere in the box.) Now analyze the dried chart to see what you can learn. Some colors, like cadmium red light and cadmium yellow light, flow together smoothly to form a soft, glowing mixture. Others, such as ultramarine blue and burnt sienna, may form a more granular, irregular mixture. Complements like viridian and alizarin crimson make lovely grays and browns. And some colors— like phthalocyanine blue again—are so powerful that they obliterate the other colors they're mixed with. So the

next time you add phthalocyanine blue, for instance, to alizarin crimson to make purple, add more crimson and just a *speck* of blue.

OPTICAL MIXING

When you brush two hues together on your palette, you're creating a *physical* mixture. The two colors are physically combined to create a third color. But because watercolor is essentially transparent and quick-drying, experienced watercolorists often mix their colors in a different way: they brush one color over the paper, let it dry, and then brush a second color over the first. The two colors mix in the viewer's eye like two overlapping sheets of colored glass to create a third color—an *optical* mixture. Try a series of optical mixtures. Dilute each of your tube colors with a fair amount of water and brush a few strokes of color into the left-hand side of the box, leaving some bare paper at the right. When the first color is dry—*absolutely* dry— dilute a second color with water and brush it over the dry color. Make the first few strokes of the second color on the bare paper at the right, and then carry some strokes halfway over the patch of dried color. When both layers of color are completely dry, you'll have three bands of color: the original, unmixed colors at either end, and a third band of color in the middle—the optical mixture. Compare physical and optical mixtures of the same two colors. The mixtures will be equally beautiful, but they'll often be different. The physical mixture tends to look bolder, stronger, but the optical mixture has a special kind of clarity, purity, and inner light.

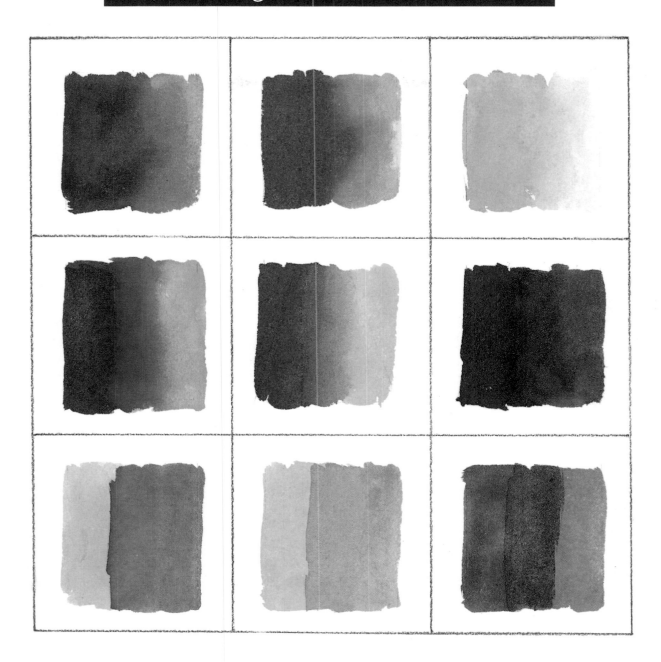

EXPLORING WATERCOLOR MIXTURES

Like the oil color chart, this watercolor chart is actually a composite, showing typical boxes from the various color charts you should make. In the top row, from left to right, you can see how alizarin crimson, ultramarine blue, and cadmium yellow react when they're diluted with water. With a small amount of water, alizarin crimson is a bright, cool red that becomes a cool pink with more water. The dark, subdued ultramarine blue turns soft and atmospheric as you add more water. Cadmium yellow, which is bright and sunny, is so powerful that you need a great deal of water to produce a pale, delicate yellow. In the three samples in the second row, a wet stripe of one color is painted at the left, a wet stripe of another color is painted at the right, and the two wet stripes are then brushed together to create a third color. From left to right, you see that alizarin crimson and cadmium yellow meet to produce a bright orange; ultramarine blue and cadmium yellow produce a subdued green; and ultramarine blue and alizarin crimson produce a subdued violet. These three samples are all *physical* mixtures: that is, two colors are blended to produce a third. On the other hand, the colors in the third row are *optical* mixtures. To make an optical mixture, one color is painted across two-thirds of the box and allowed to dry. Then a second color is painted from right to left, partly overlapping the first color to create a third color. The overlapping colors are considered an optical mixture because the colors mix in your *eye*. Compare the optical mixtures with the physical mixtures, bearing in mind that the *same* tube colors are used in the second and third rows.

GETTING TO KNOW ACRYLIC COLORS

As you squeeze acrylic color from the tube, it's a thick paste similar to oil paint. If you add just a bit of water, liquid acrylic medium, or gel medium, the paint becomes creamy. This consistency lends itself to a technique somewhat like oil painting—thick strokes of solid, opaque color—although acrylic dries far more rapidly than oil paint and has its own special handling qualities, as you'll see in the painting demonstrations. Acrylic paint is highly versatile. If you add a lot more liquid painting medium or gel medium, the color turns transparent, like oil paint that's been diluted with a lot of medium, or like a thick version of watercolor. And if you just add a lot of water to acrylic color, the result is a highly fluid consistency that looks and handles like transparent watercolor. It's important to get to know the different ways of handling acrylic color so you can take full advantage of the techniques that are possible with this remarkable medium.

MAKING ACRYLIC COLOR CHARTS

To understand how acrylic colors work, make another series of color charts. Because acrylic will stick to any surface that's not oily or greasy, work on illustration board, canvas-textured paper that's made for oil and acrylic painting, canvas boards, or small scraps of canvas. To begin, use a sharp pencil and a ruler to make a checkerboard pattern of boxes, each about 2″ to 3″ (50 to 75 mm) square. For each color on your palette, make a separate chart with about a dozen boxes so you'll have room to mix that color with all of the others. In the boxes, write the names of the colors used to make the mixtures.

ADDING WHITE

Many of your mixtures will require white, so it's essential to find out how each of your acrylic tube colors behaves when white is added. Therefore, the first stage in making your chart is to brush a few broad strokes of tube color—diluted with just a touch of water to make the color creamy—into its own box on the chart. While the first strokes are still wet, pick up a brushload of pure white and blend it into half of the wet color in the box. Let the sample dry. When you've done this with each tube color, you'll see that some colors, like cadmium red light and cadmium orange, are brightest when they come from the tube and quickly lose their intensity as soon as you add even a small amount of white. Other colors, like the blues and greens, tend to look murky as they come straight from the tube, but suddenly come to life and reveal their richness when you add a touch of white. Also watch the subtle changes that take place in color temperature: alizarin crimson, for example, becomes distinctly cooler when you add white.

MIXING TWO COLORS

Next, you're going to mix every tube color with every other tube color. Once again, add just a touch of water to each color to produce a creamy paint consistency. In each box on your color chart, make a pair of broad, juicy strokes, one stroke for each color. Angle the strokes so that they converge. Where they meet and overlap, blend the two colors together in a circular patch. Now you can see the original two colors, plus the mixture that they make. If you have the patience, you may want to conduct this series of tests with two different paint consistencies: thick, creamy color that's diluted with a small amount of water; and thin, transparent color that's diluted with lots of water. When the samples are dry, analyze and compare the mixtures. You'll see that cadmium yellow and ultramarine blue produce a much softer green than cadmium yellow and phthalocyanine blue. And when you mix yellow ochre and ultramarine blue, you'll get a green that's softer still. When you're working with thick, opaque colors, a mixture may look dull until you add a speck of white—so don't hesitate to add some white to bring out the full color.

OPTICAL MIXING

As mentioned earlier, when you add a lot of liquid acrylic medium, gel medium, or just plain water, acrylic tube color turns transparent. This gives you an opportunity to try *glazing* in acrylic paint. First add just a bit of white to each tube color and brush a few broad strokes of each into separate boxes, allowing some extra white space at the right. When these strokes are dry, dilute another color to a transparent consistency—called a *glaze*—with liquid or gel medium, or with water, and brush this mixture into the box so that it covers some of the white space and some of the dried color. When this glaze is dry, you'll have three parallel bands of color. At either side, you'll find the two original colors. Where they meet and overlap, you'll find an *optical mixture* of the two. Now make these optical mixtures with all the tube colors on your palette. When you compare the optical mixtures with the physical mixtures, it's surprising how different they look. Sometimes the physical mixture is brighter, sometimes the optical mixture seems clearer and more luminous, and sometimes the optical mixture is quite a different color.

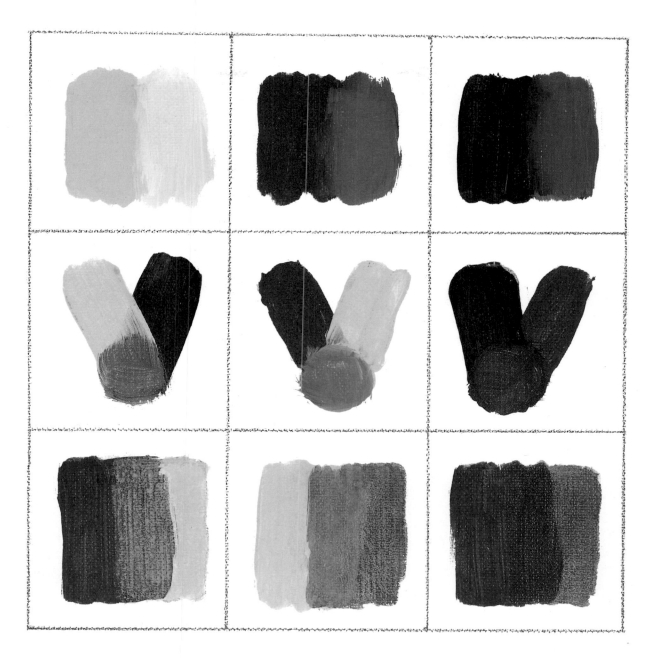

EXPLORING ACRYLIC COLOR MIXTURES

Here are some typical boxes selected from various color charts. Since titanium white will appear in most opaque mixtures, start out by mixing each tube color with white, as is done in the top row. Looking from left to right, you see cadmium yellow light, cadmium red light, and ultramarine blue—straight from the tube and then blended with white. The second row shows how to mix every color on your palette with every other color. From left to right, a stripe of cadmium yellow light meets a stripe of ultramarine blue, cadmium red light meets cadmium yellow light, and ultramarine blue meets cadmium red light. The second row shows *physical* mixtures, where two colors are brushed together to make a third. The bottom row shows *optical* mixtures, when you thin a color to a transparent *glaze* with painting medium or water, then brush it partially over a dried patch of another color. From left to right, transparent cadmium yellow light is brushed over ultramarine blue, transparent cadmium red light is brushed over cadmium yellow light, and transparent cadmium red light is brushed over ultramarine blue. Also try adding water or painting medium—instead of white—to the mixtures in the first and second rows.

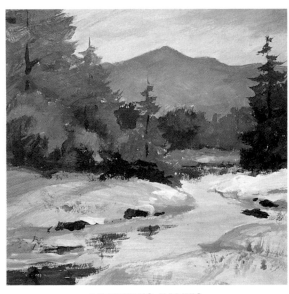

ANALYZING VALUES

Train yourself to look at a subject like this landscape and see colors as values—as they'd appear in a black-and-white photograph. Of course, there's no way that you can possibly identify the infinite number in any subject, so try to simplify the subject into just a few values.

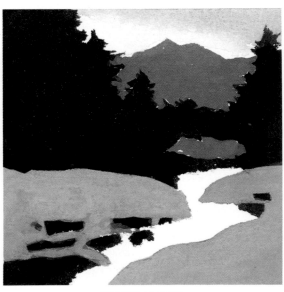

VALUE STUDY

The artist visualizes the values of the main shapes. The trees, rocks, and dark reflections are the *darkest value*. The distant mountain and the patch of snow within the trees are a *dark middletone*. The foreground snow is a *lighter middletone*. The stream is the *lightest value*.

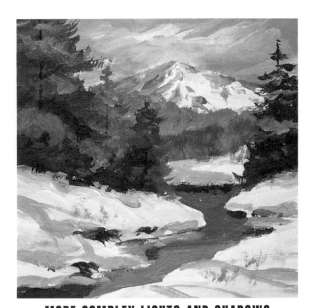

MORE COMPLEX LIGHTS AND SHADOWS

When the light changes, we see a more complex pattern of lights and shadows. But the artist can still visualize the colors as four basic values: a dark, a light, and two middletones. This kind of value analysis helps you to mix your colors accurately and *also* helps you to plan a bolder, simpler, more powerful design.

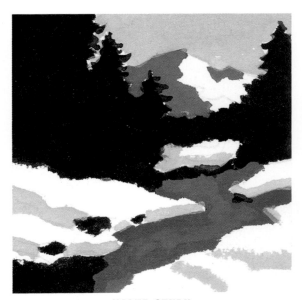

VALUE STUDY

Once again, the trees, rocks, and dark reflections are the *dark*. But now the *dark middletone* is the shadow side of the mountain and the stream. The *lighter middletone* is the value of the sky and the shadow areas on the snow. The *light* is the value of the sunlit patches of snow and the sunlit side of the mountain.

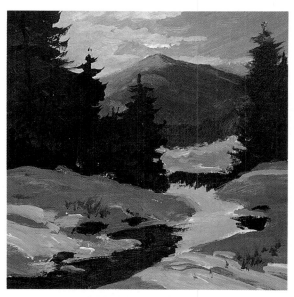

DARKER LANDSCAPE

As the light fades, the values tend to become darker—or *lower*. You're going to mix darker colors and the little value study shown here will be your guide. That's why so many professional artists make these little value studies before they start to paint. The studies don't have to be as neat as the ones you see here. With experience, you can just do a rough pencil sketch.

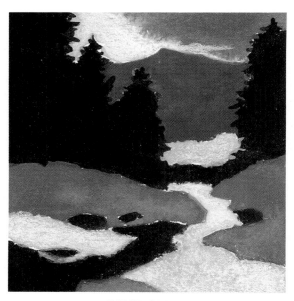

VALUE STUDY

The *dark* is still the mass of the trees, the rocks, and the dark reflection in the stream. The mountain is a *dark middletone*, while the snow and the dark patch in the sky are a slightly *lighter middletone*. The stream, the sunlit patches of snow, and the light in the sky are the *light* value. So there are the usual four values. But the two middletones are so close that you could merge them and make this a three-value scheme.

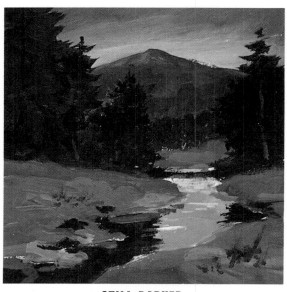

STILL DARKER

Nightfall approaches and the values become still lower—and simpler. The sun is behind the mountain and the last glow appears in the lower sky and in the stream. It's almost impossible to paint this kind of subject on location, but a quick, accurate value sketch will help a lot when you go back to the studio. Many painters make only a value sketch on location, scribble notes about the colors in the margins of the sketch, and base the whole painting on this essential scrap of paper.

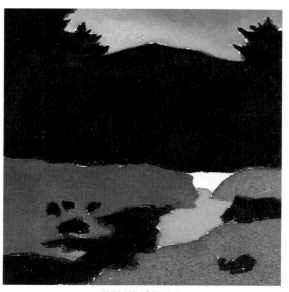

VALUE STUDY

Now the mountain and trees merge into a single *dark* value, which reappears in the rocks and the reflections in the stream. The snowbanks and upper sky are a *dark middletone*. The lower sky and one patch of water are a *lighter middletone*. And a single patch of *light* appears in the distant water. This is virtually a three-value scheme, except for that one patch of light.

Controlling Value and Intensity

COMPLEMENTARY BACKGROUND

You can control the intensity of your colors by carefully selecting the colors you place next to one another. The tones of this brilliant autumn tree are mixtures of cadmium yellow light, cadmium red light, and burnt sienna. But the red-golds look particularly bright because the autumn foliage is surrounded by the complementary colors of the trees in the background, which are deep green, punctuated by touches of blue. Since green is the complement of red, and blue is the complement of orange, these two cool colors work together to intensify the warm autumn foliage by contrast.

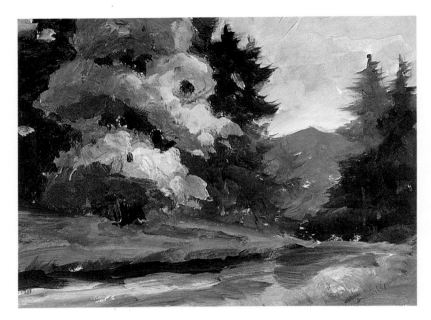

ANALOGOUS BACKGROUND

But what if you *don't* want that autumn tree to look quite so bright? The solution is to surround the tree with analogous colors—colors that are *near* each other on the color wheel—instead of the complementary colors at the *opposite* side of the wheel. Here the artist has surrounded the red-gold tree with reds and browns that harmonize with the tree instead of contrasting with it. The brilliant tree begins to melt away into the background. However, that touch of blue sky (the complement of orange) helps to emphasize the general warmth of the entire landscape.

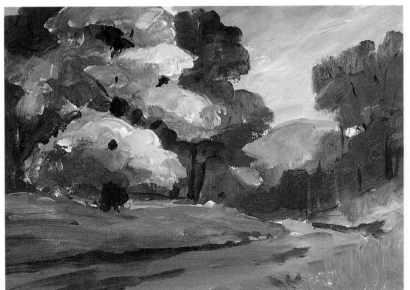

NEUTRAL BACKGROUND

What if you want to dramatize the brilliant color of the tree, but you *don't* want to surround it with other bright colors? You can surround the bright colors with neutrals—quiet grays, browns, or brown-grays. In this oil sketch, the bright autumn foliage is surrounded by subdued mixtures of ultramarine blue, burnt umber, and white. This is an overcast day, so the sky and foreground are also painted in quiet, neutral colors. The "rules" are simple: to make a color look brighter, surround it with complements or neutrals; to make a color look more subdued, surround it with analogous colors.

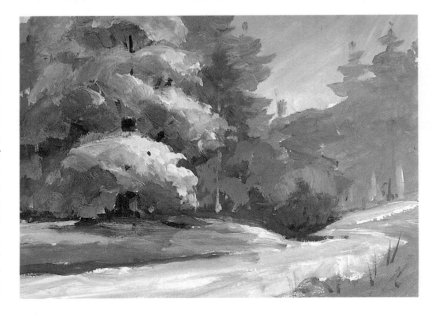

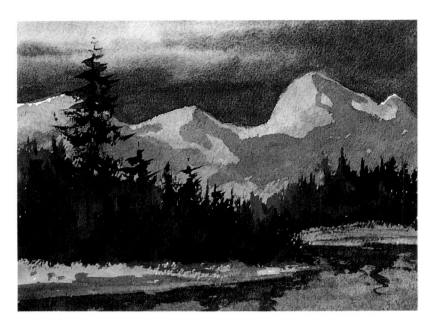

DARK BACKGROUND

Just as the *intensity* of a color can be controlled by carefully planning your color relationships, so the *value* of a color can be altered by carefully selecting its surroundings. Against a dark, stormy sky, the lighted planes of these mountains look pale and dramatic. The dark value of the sky and the light value of the mountains actually strengthen one another. That is, the sky looks darker and the mountains look lighter.

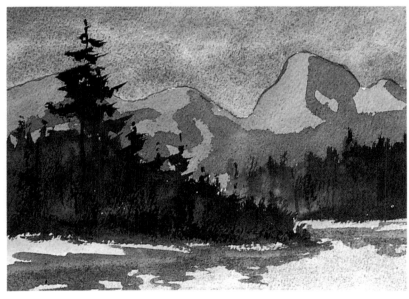

MIDDLETONE BACKGROUND

If you lighten the sky to a middletone, both the sky and the mountain colors are roughly the same value. Thus, the contrast between the two areas has been reduced. The reduced contrast makes the picture more benign and the landscape more friendly, as compared with the ominous, dramatic landscape above. Neither value plan is better than the other—they're just different.

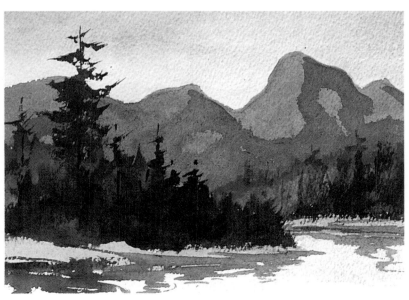

LIGHT BACKGROUND

The artist now places the mountains against a much paler value. Immediately, the shapes of the mountains become dark silhouettes against the pale sky, and the mood of the picture changes once again. The "rules" are obvious. To make a color look lighter, place it against a darker background. To make it look darker, place it against a lighter background. And if you want to call less attention to a color, place it against a background of roughly the same value.

HIGH KEY

As you study your subject, it's often helpful to decide on the *key* of your picture. In a high-key picture like this one, all the values—including the darks—are fairly light. The darkest values of the picture are middletones, and probably *light* middletones. High-key pictures are often studies of hazy subjects like this one, or snow scenes, or just subjects that are filled with light and not much shadow, like some desert landscapes.

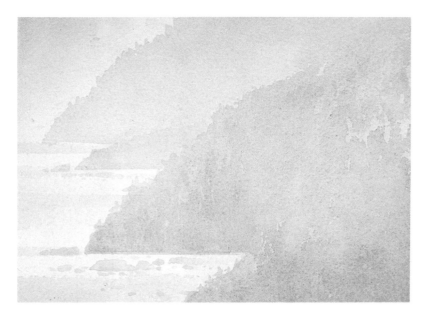

MIDDLE KEY

When the weather clears and the shapes become more distinct, the same subject may turn into a middle-key landscape. The dominant shapes are middletones, but there are *light* middletones in the distant headlands and *dark* middletones in the foreground. There are some strong lights on the sea, of course, but the overall tonality is neither very light nor very dark. Middle-key subjects are probably the most common.

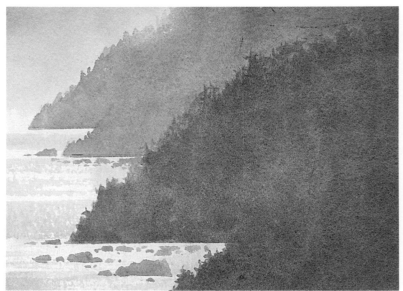

LOW KEY

As night falls and the whole landscape darkens, the moonlit headlands become a low-key subject. The foreground shapes are very dark and the more distant headlands aren't much lighter. The sky is darker too, although there are some strong patches of moonlight in the sky and water. A good way to learn about high, middle, and low *key* is to go outdoors and paint some small, sketchy pictures with mixtures of black and white tube color. This is also good training in identifying values.

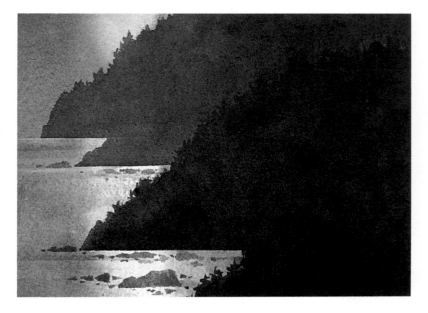

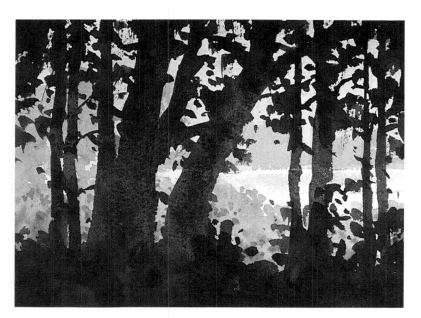

HIGH CONTRAST

It's also helpful to decide whether you're painting a high, middle, or low *contrast* subject. This is a high-contrast picture because the foreground trees are very dark, while the sunlit landscape that you see beyond the trees is quite pale—although both are full of color. A high-contrast subject usually has no particular key because the values can be all over the map: lights, middletones, and darks.

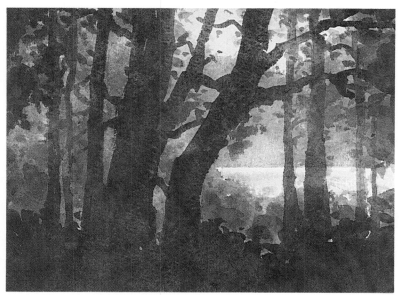

MEDIUM CONTRAST

The same subject becomes a medium-contrast picture when the trees become a bit lighter and the distant landscape is a bit darker. To put it another way, the values are *closer*. This medium-contrast landscape is in the middle key. But don't assume that medium contrast and middle key always go together. If there were snow on the ground and on the branches, this might become a high-*key*, medium-*contrast* picture.

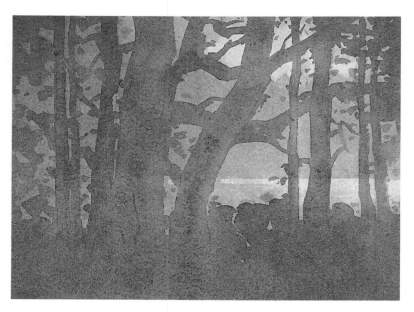

LOW CONTRAST

On an overcast day, this landscape becomes a low-contrast subject. The light is dim. The foreground tree trunks are a middletone. And the distant trees are a somewhat lighter middletone. There are no strong darks or lights and therefore not much contrast. But notice that this low-contrast picture isn't a low-key picture; it's closer to the middle key. There are no rules about contrast. Nature keeps surprising you.

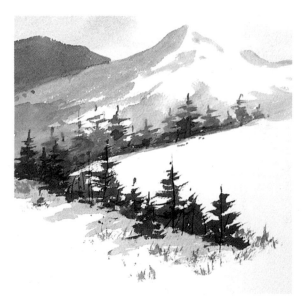

HIGH KEY, HIGH CONTRAST

Typical of so many snow scenes in bright sunlight, this is a high-key, high-contrast subject. The sky and the sunlit snow occupy most of the picture—and these are very light in value. The trees and the darker shapes on the two peaks are middletones that contrast sharply with the lighter values. But the light values dominate.

LOW KEY, MEDIUM CONTRAST

This somber landscape is generally in a low key, since the darker values dominate the picture. But there are some notes of contrast where the light breaks through the lower sky and shines on the water. Notice how the lighted strips of water lead your eye into the picture, carrying you from the foreground to the focal point of the composition at the horizon.

LOW KEY, HIGH CONTRAST

Most of the picture is dark. The grass, the woods, the patch of sky, and the shadow side of the rock are all darks and dark middletones. Only the lighted side of the rock catches a strong burst of light from some distant light source—perhaps a break in the woods, allowing the sun to come through. The artist emphasizes this contrast by placing the lighted side of the rock against the dark trees in the distance.

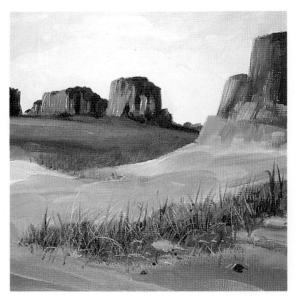

NO SPECIAL KEY—BUT HIGH CONTRAST

Not all subjects have a clearly defined key. Nor do they have to! The values in this sunny desert landscape run the full range from pale to middletone to dark. But the artist has planned the picture so that the highest contrast appears at the focal point of the design. The dark shadows of the rock formations meet the pale value of the sky at the exact point where he wants your eye to go.

PLAN YOUR MIXTURES

Certainly the most important "rule" of color mixing is to plan each mixture before you dip your brush into the wet colors on your palette. Don't poke your brush into various colors and scrub them together at random, adding a bit of this and a bit of that until you get what you want—more or less. Instead, at the very beginning, you must decide which colors will produce the mixture you want. Try to limit the mixture to just two or three tube colors plus white—or water if you're working with watercolor—to preserve the brilliance and clarity of the mixture.

DON'T OVERMIX

No one seems to know why, but if you stir them around too long on the palette, colors *lose* their brilliance and clarity. So don't mix your colors too thoroughly. As soon as the mixture looks right, stop.

WORK WITH CLEAN TOOLS

To keep each mixture as pure as possible, be sure your brushes and knives are clean before you start mixing. If you're working with oil paint, rinse the brush in solvent and wipe it on a scrap of newspaper before you pick up fresh color, or better still, try mixing with a palette knife, wiping the blade clean before you pick up each new color. If you're working with watercolor or acrylic, rinse the brush in clean water, making sure to replace the water in the jar as soon as it becomes dirty.

GETTING TO KNOW YOUR MEDIUM

As you experiment with different media, you'll discover that subtle changes take place as the color dries. When you work in oil, you'll discover that it looks shiny and luminous when it's wet, but often "sinks in" and looks duller after a month or two, when the picture is thoroughly dry. Some painters restore the freshness of a dried oil painting by brushing or spraying it with retouching varnish. A better way is to use a resinous medium—damar, mastic, copal, or alkyd—when you paint. A resinous medium preserves luminosity because it's like adding varnish to the tube color. If you're working in watercolor, you'll find that watercolor becomes paler as it dries. To make your colors accurate, you'll have to make all your mixtures *darker* than you want them to be in the final picture. And if you're using acrylic, you'll discover that, unlike watercolor, acrylic has a tendency to become slightly more subdued when it dries. So you may want to exaggerate the *brightness* of your acrylic colors as you mix them.

LIGHTENING COLORS

The usual way to lighten oil color is to add white, while the usual way to lighten watercolor is simply to add water. If you're working with acrylic, you can do both: you can add white to lighten an opaque mixture and water to lighten a transparent one. However, it's not always that simple. White may not only lighten the color; it may actually change it. For example, a hot color like cadmium red light rapidly loses its intensity as it gets paler, so it may be a good idea to restore its vitality by adding a touch of a vivid color (such as alizarin crimson) in addition to white or water. If the crimson turns your mixture just a bit too cool, you may also want to add a speck of cadmium yellow. In other words, as you lighten color, watch carefully and see if it needs a boost from some other hue.

DARKENING COLORS

The worst way to darken any color is by adding black, because it tends to destroy the vitality of the original hue. Instead, try to find some other color that will do the job. For example, try darkening a hot red or orange—such as cadmium red light, alizarin crimson, or cadmium orange—with a touch of burnt umber or burnt sienna. Or darken a brilliant hue like cadmium yellow light by adding a more subdued yellow like yellow ochre. Although darkening one rich color with another may produce slight changes in hue or intensity, it's preferable to adding black.

BRIGHTENING COLORS

Experimentation is the only way to find out how to brighten each color on your palette, since every color behaves in its own unique way. For example, a touch of white (or water) will make cadmium yellow light look brighter, while that same touch of white will make cadmium orange look more subdued. As it comes from the tube, cadmium red light looks so brilliant that it's hard to imagine any way to make it look brighter, but a touch of alizarin crimson will do it. Ultramarine blue looks dull and blackish as it comes from the tube, yet a touch of white (or water) will bring out the richness of the blue. It will become even brighter if you add a tiny hint of green.

SUBDUING COLORS

Again, the first rule is to avoid black, which *will* subdue your color by reducing it to mud. Instead, look for a related color, one that's less intense than the color you want to subdue. The color tests described in the oil, watercolor, and acrylic parts of this book will show you how each color behaves when it's mixed with every other color on your palette. The tests should also help you decide which color to choose when you want to lessen another color's intensity. For example, a touch of yellow ochre is often a good way to reduce the intensity of the hot reds, oranges, and yellows. And a speck of burnt umber will reduce the intensity of blue without a major color change.

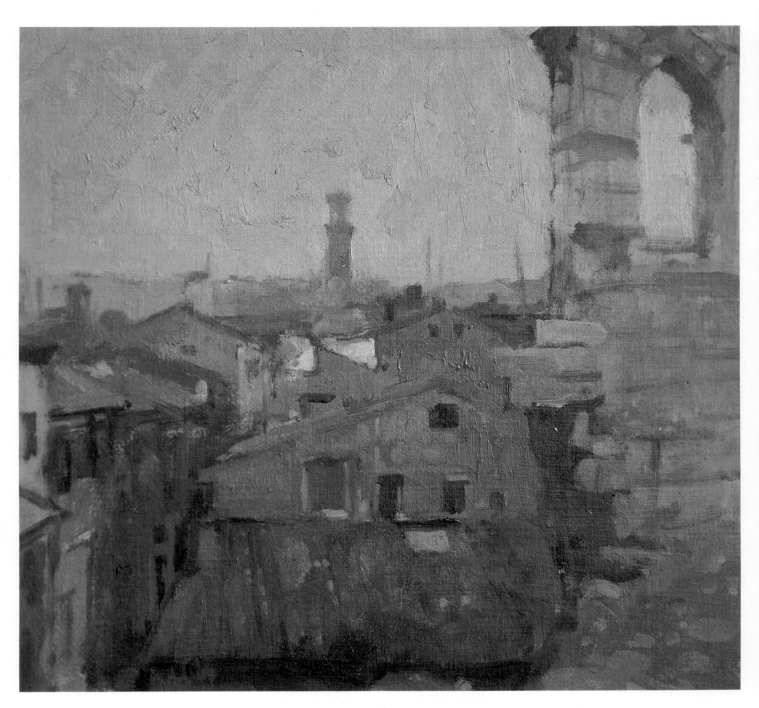

VERONA

by Bernard Dunstan, oil on board, 10″ × 11″

*This is a notable example of tonal painting—a picture that's executed with a
limited range of subdued colors. This quiet cityscape is painted almost entirely
in golden tones with touches of gray. But look closely and you'll discover an
amazingly diverse patchwork of luminous mixtures. There seems to be an infinite
number of golden yellows and golden browns, no two of them alike. The grays
are blue-grays, brown-grays, gold-grays, and other grays that defy description.
This seemingly monochromatic picture is filled with atmospheric color.*

Photo courtesy Thos. Agnew & Sons Ltd., London

PART THREE
PUTTING
COLOR
TO WORK

WARM AND COOL

A successful color scheme not only achieves color harmony, but leads the viewer's eye to the focal point of the picture. Thus, the warm tone of the dead tree—a mixture of burnt sienna and cadmium yellow light—captures the viewer's eye because the tree is surrounded by cool shadows on the snow and the cool tone of the ice.

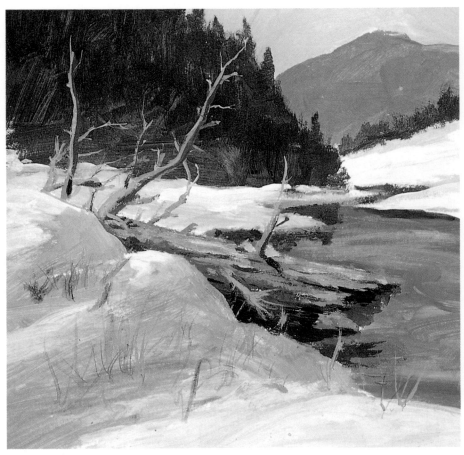

BRIGHT AND SUBDUED

Another way to direct the viewer's eye to your picture's center of interest is to plan a contrast of bright and subdued colors. Here, the sunlit tone of the tree is surrounded by the subdued colors of the sky, the mountain, and the icy water.

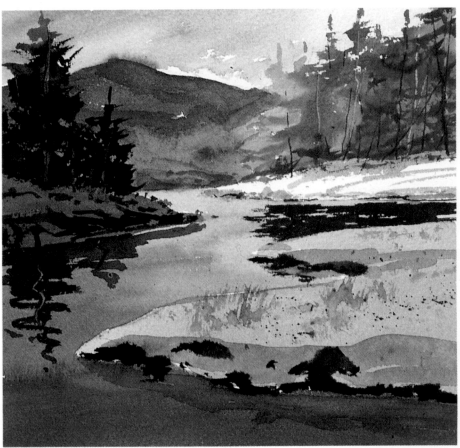

LIGHT AGAINST DARK

When you're working with subdued colors, a contrast of values is particularly effective. Here, the pale, wind-blown palms in the distance are framed by the dark shape of the palm and the grass in the foreground.

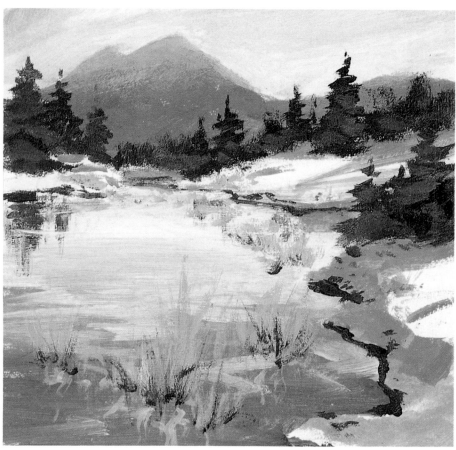

LEADING THE EYE

To carry the viewer's eye from the bottom of the picture to the mountains, the warm tones of the weeds create a curving path from the foreground to the center of interest. Next to this warm tone, a cool complementary tone follows the same path. The two complementary colors enhance each other as the eye moves into the picture.

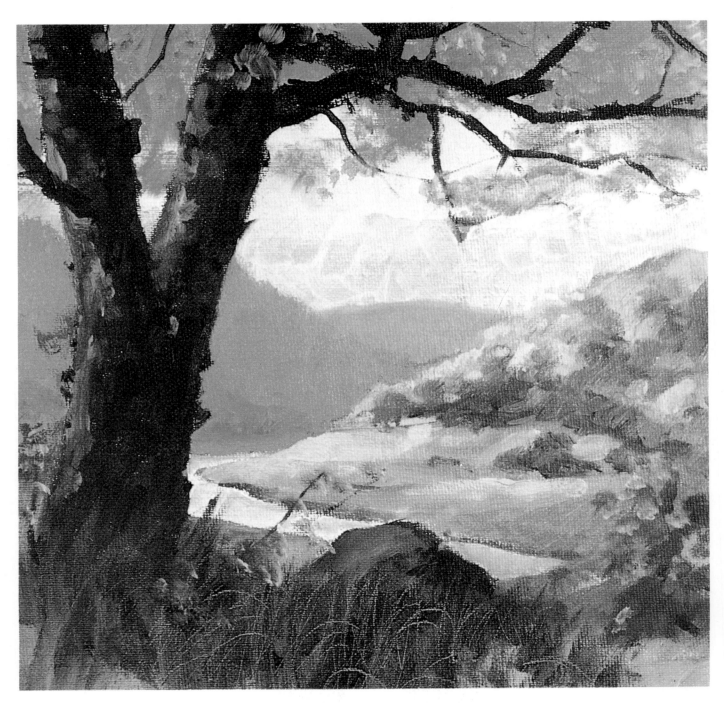

SUNNY DAY

To create a convincing sense of space in a painting—particularly in a landscape or a seascape—it's important to understand the "laws" of *aerial perspective*. According to these "laws," the colors closest to the viewer tend to appear darker, warmer, and brighter than the colors in the distance; and as objects recede into the distance, their colors tend to grow cooler, paler, and less intense. In fact, that's what's happening in this landscape. The darkest colors are in the shadowy foreground, and the brightest colors are on the sunlit slope just beyond. As your eye moves to the slope in the middleground, just beyond the dark tree on the left, you see that the hill is paler and cooler. And the very distant mountain in the middle of the picture, just beneath the sky, is paler and cooler still. Warm colors dominate the mixtures in the foreground: burnt sienna, yellow ochre, and ivory black in the trees and rocks; cadmium yellow light, burnt sienna, and ultramarine blue on the sunny slopes. Beyond the slopes, cooler colors begin to take command: phthalocyanine blue, viridian, burnt umber, and white for the hill in the middleground; ultramarine blue with a touch of alizarin crimson and a lot of white in the paler mountain at the horizon.

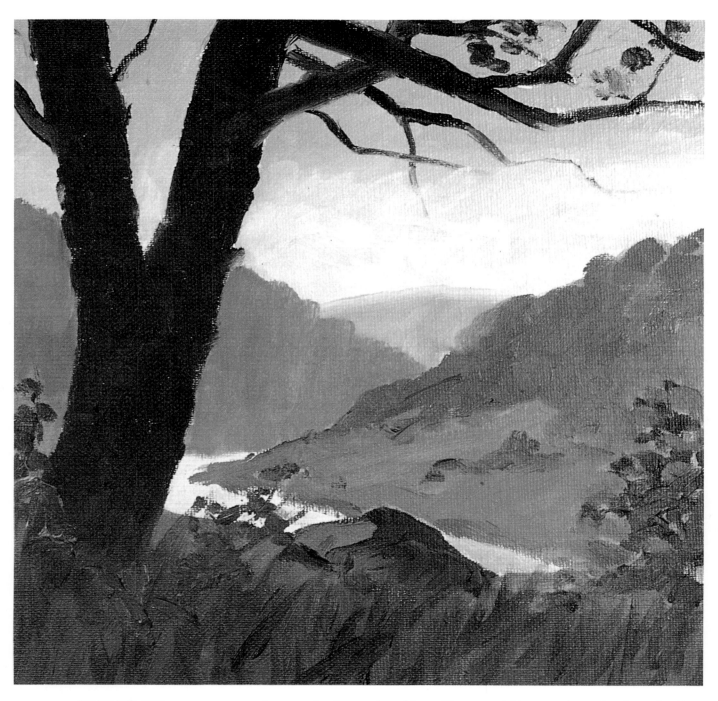

OVERCAST DAY

Although the colors become a lot more subdued on an overcast day, the basic "laws" of aerial perspective still apply in any kind of weather. Typically, all the colors are cooler and more muted when the sun disappears behind a layer of clouds. But the tree, grass, and rock in the immediate foreground are still the darkest, warmest elements in this landscape; they're mixtures of burnt umber, yellow ochre, and ultramarine blue. The nearby slope is no longer sunny, but it's still brighter than the slopes in the distance; it's a mixture of phthalocyanine blue, yellow ochre, burnt sienna and white. The hill in the middleground, just beyond the tree, becomes cooler, paler, and more subdued—painted with a mixture of ultramarine blue, burnt umber, yellow ochre, and white. And the remote mountain at the horizon is the palest mixture in the landscape: a little ultramarine blue and burnt umber, plus lots of white. Comparing these two studies of the same landscape, it's exciting to see how a change in weather can create two totally different pictures. As many great artists have done, you can set up your easel in the same place every day, discovering dramatic new possibilities in the subject as the weather and the seasons change before your eyes.

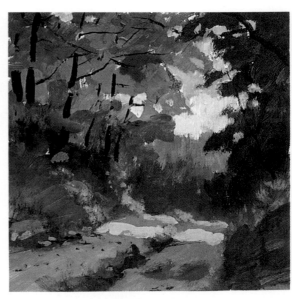

DIRECT SUNLIGHT

The direction of the light and the character of the weather have a powerful influence on color. On a clear, sunlit day, the light creates distinct planes of light and shadow with clear, luminous color. Struck by direct sunlight, the top planes of the rock and the foam glow with light, while the shadows are transparent—filled with reflected color.

BROKEN LIGHT

Here the sunlight breaks through the gaps in the trees. The only bright light appears in the few patches of sky and the "spotlit" area of the road. Most of the landscape is in shadow. But the shadows are filled with subtle color. It's important to remember that shadow is not the *absence* of light, but just a part of the picture that receives *less* light. Always look for the colors in the shadows.

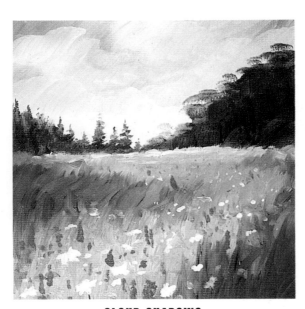

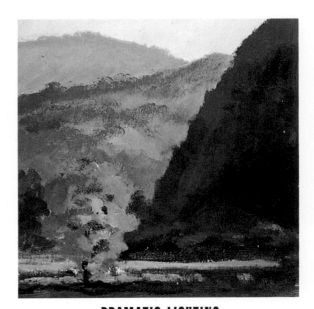

CLOUD SHADOWS

Here's another sunny day with a bright, blue sky, but only *part* of the meadow is in direct sunlight. Clouds cast shadows and some of these shadows fall on the meadow, breaking the foreground into light and dark patches. Watch for the effects of cloud shadows. They can make your landscapes and seascapes much more dramatic. And you can *invent* cloud shadows if you think your pictorial design needs them.

DRAMATIC LIGHTING

You can invent light as well as shadow. To dramatize this tree—which becomes the center of interest in the landscape—the artist imagines a break in the clouds, through which the sunlight passes and falls on the tree like a spotlight. The break in the clouds is outside the picture, so you can't see it. But you know it's there.

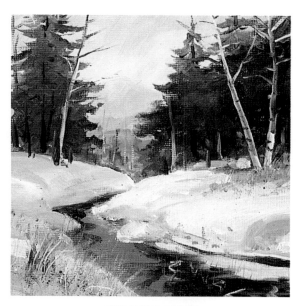

DIFFUSED LIGHT

The day is slightly overcast and there's snow on the ground. The cloudy sky diffuses the light, which is then reflected from the surface of the snow and further diffused. The light has no distinct direction, and there are no distinct shadows. The whole effect is a soft, delicate glow. Both the stream and the snow (which is also water) reflect the sky color.

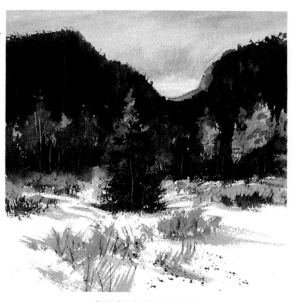

STRONG SHADOWS

But winter isn't always a time of diffused light and quiet color. Just enough light breaks through the dark sky to brighten the snow and the dead weeds—and to cast very distinct shadows. The sunlight also spotlights the tops of the trees. There's no such thing as winter color—or spring or summer or fall color, for that matter. You must analyze the light and weather at a particular moment and paint what you *see*.

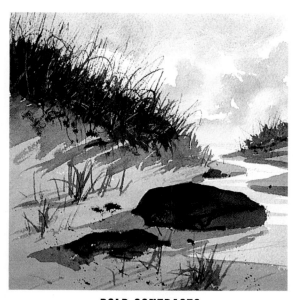

BOLD CONTRASTS

Here's another interesting comparison. These dunes and beach grass are illuminated by strong light, even though the day is cloudy. Just enough light breaks through the clouds to brighten the sand, silhouette the grass, and send crisp shadows across the dunes. Now compare this painting with the next study of dunes on a *sunny* day.

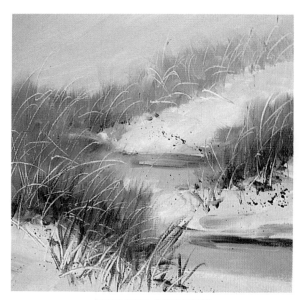

DIFFUSED SUNLIGHT

You can't just make a rule that sunny days always produce strong, colorful lights and shadows. For some reason, there's a slight haze on this sunny day, so the sunshine fills the beach with luminous color; but there are no distinct lights and shadows. Of course, light and weather keep changing; an hour later, the haze may vanish and you may find yourself painting bold lights and shadows after all. So keep watching.

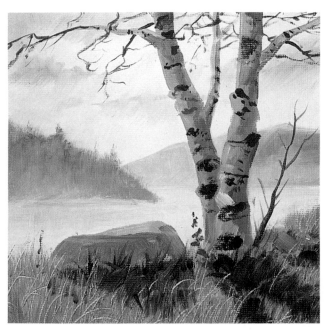

EARLY MORNING

In the early morning, when the sun is low in the sky and the light hasn't reached its full brilliance, the landscape is often filled with delicate colors. You're apt to see soft yellows, yellow-greens, pinks, and violets. Here, the distant sun illuminates the lake and the far shore, while the tree and rock appear as dark silhouettes.

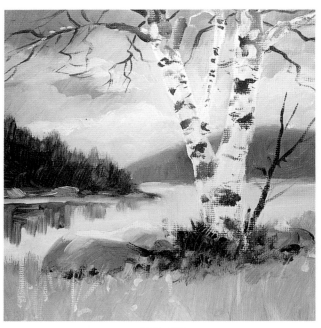

MIDDAY

By the middle of the day, the sun has risen high in the sky, bathing the entire landscape in light and bringing out the full colors. The grass and foliage appear as rich yellows and greens. The early morning haze has disappeared, revealing the blues and whites of the sky and water. The sun brightens the top of the rock and illuminates the bark of the tree.

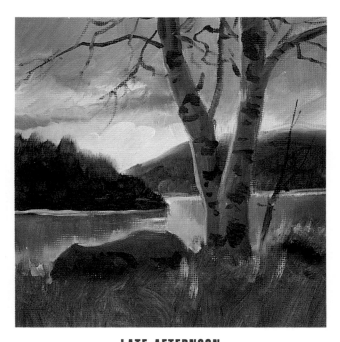

LATE AFTERNOON

In late afternoon, the sun starts to sink behind the hills, throwing them into dark silhouettes. The tree and rock are also lighted from behind and silhouetted. There's a strong contrast between the lights and shadows, as well as between the dark, upper sky and the brilliant sky at the horizon—and these colors are repeated in the water.

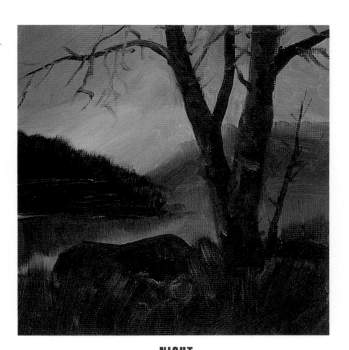

NIGHT

On a clear night, once your eyes become used to the darkness, you'll find that the moonlit sky can be filled with magical blues, greens, and violets. Similar colors can reappear in the landscape that receives the light of that sky. The moonlit sky is much lighter than the forms of the landscape, which are transformed into handsome silhouettes.

Achieving Color Harmony

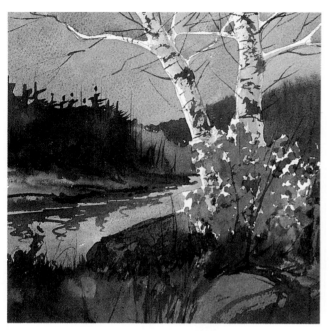

COOL PICTURE, WARM NOTES

This landscape emphasizes cool mixtures on the blue-violet side of the color wheel. For contrast, the artist looks across the wheel for the complement of blue, and he adds an orange shrub. To accentuate this cool harmony, he paints a delicate blue wash over the entire picture, leaving only the birches and orange shrub untouched.

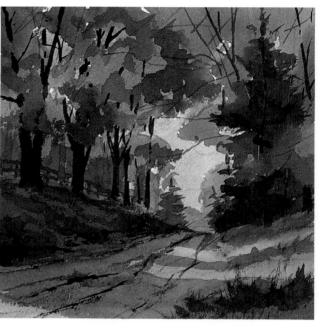

WARM PICTURE, COOL NOTES

To paint a picture that's predominantly warm, the artist finds a cluster of analogous hues on the orange side of the color wheel. For a cool note of contrast—which is always welcome—he looks across the wheel to find the complement of orange, and adds some patches of blue sky.

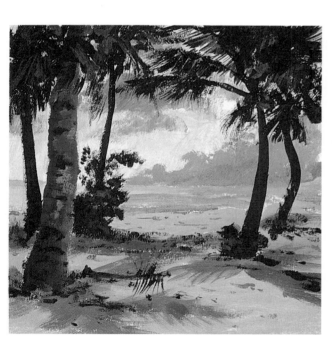

REPEATING COLORS

Another way to achieve color harmony is to interweave one particular color through all the others. This tropical landscape is unified by the repetition of a similar color in the clouds, on the distant shoreline, and in the shadows on the foreground. The cool shadows on the sand accentuate the warmth of the sunny areas of the beach.

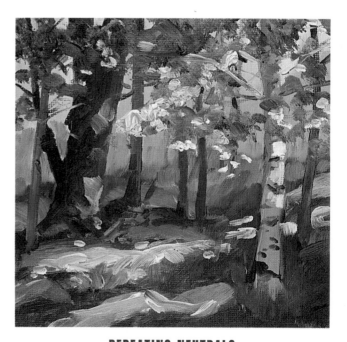

REPEATING NEUTRALS

A subtle way to tie rich colors together is to interweave the bright colors with neutrals. Between the tree trunks, the artist has introduced warm and cool grays that reappear in the gaps between the foliage, on the foreground rocks and grass, and in the trunk of the birch at the right. The neutrals provide a unified setting for the diverse colors.

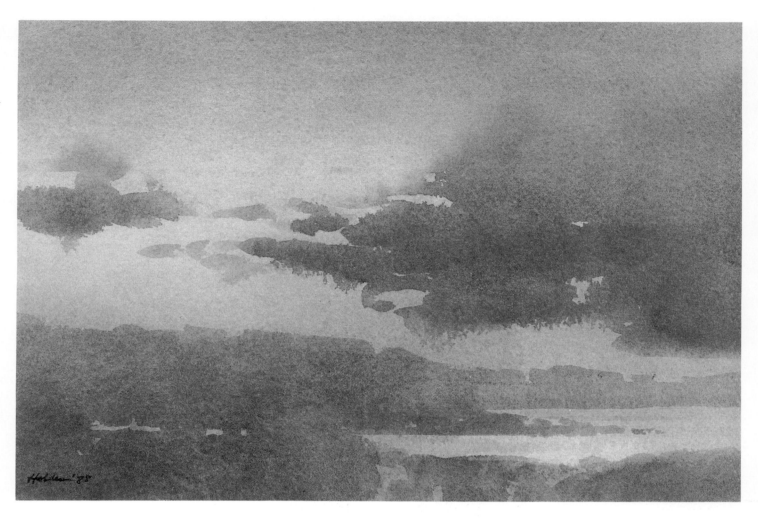

RED CLOUD II

by Donald Holden, watercolor, 7 ¼″ × 10 ¾″

This glowing coastal scene is painted with a palette of just three colors: cobalt blue, Venetian red, and yellow ochre. These three primaries—a delicate blue, a subdued yellow, and a coppery red—produce all the mixtures that you see. Over an undertone of yellow ochre, the rocky shore and the clouds are painted with varied mixtures of cobalt blue and Venetian red, some mixtures containing more red while others contain more blue. The upper sky is darkened with a wash of cobalt blue and Venetian red. The horizon is warmed with a wash of yellow ochre and Venetian red. And then the entire picture is unified by a final wash of yellow ochre that covers everything. As the old masters knew so well, all you need are three colors to paint a picture with a full color range.

Photo courtesy Susan Conway Carroll Gallery, Washington, D.C. Collection of Don Wilson

PART FOUR
PAINTING
WITH A LIMITED
PALETTE

STEP ONE

To learn more about values, try a painting in which you work with just two colors, one warm and one cool, plus white. This *tonal painting* will depend heavily upon values, but this very limited palette can produce richer colors than you might expect. Here the artist places just burnt sienna, ultramarine blue, and white on the palette. Blending the two colors with solvent, he outlines his composition on the canvas. Then with a large, flat bristle brush, he blocks in the sky with ultramarine blue and white, warmed with a touch of burnt sienna. As he works downward toward the horizon, he adds slightly more burnt sienna to the mixture to warm the sky color.

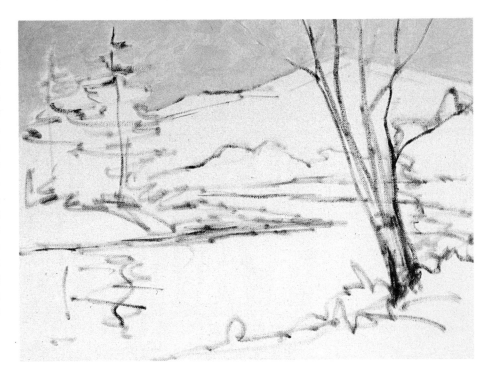

STEP TWO

The warm but subdued color of the mountain is painted with the same three colors that appear in the sky, but now burnt sienna dominates. This time, the artist cools the mixture with a touch of ultramarine blue, and lightens it with white. Just as the sky contains some warm areas in which there's a bit more burnt sienna, the mountain contains some cool tones where the artist adds a bit more ultramarine blue to the mixture. Look at the sky and mountain closely: these areas contain lots of subtle variations, sometimes cooler and sometimes warmer, where the artist varies the proportions of blue and burnt sienna in the mixtures.

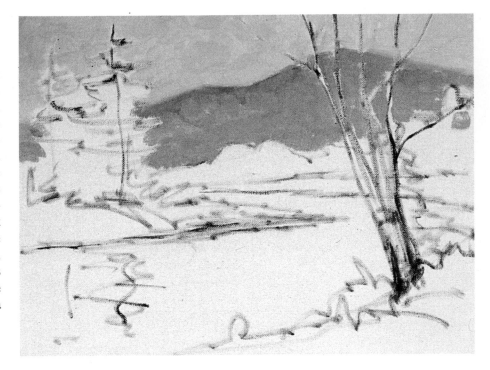

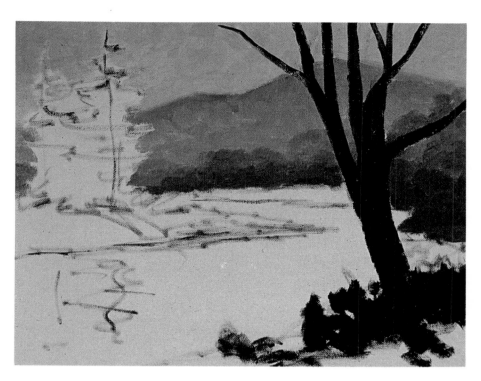

STEP THREE

Now the artist establishes the darkest note in the picture. Blending ultramarine blue and burnt sienna—without white—he picks up this mixture on a medium-sized bristle brush and paints the dark tree and the dark tone of the shore. Blending more white into this mixture and adding more blue, he suggests the dark trees at the foot of the mountain on the far shore. The artist has now established the four major values: the light value of the sky (to be repeated in the water), the dark value of the tree and nearby shore, the lighter middletone of the mountain, and the darker middletone of the distant trees.

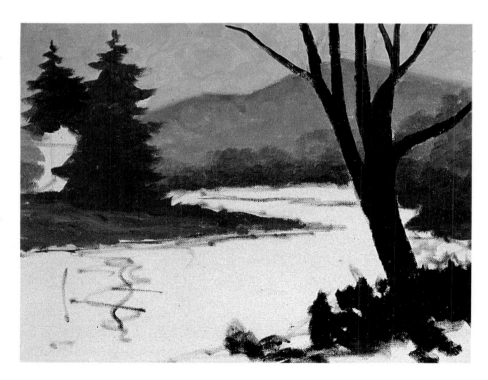

STEP FOUR

So far, the artist has concentrated on the distance and foreground. Now he turns to the middleground. He blocks in the hot color of the dead evergreen and the shore beneath it with a mixture that's mainly burnt sienna, darkened here and there with a touch of ultramarine blue, and occasionally lightened with a hint of white. To the left, he begins to paint the shape of another evergreen with a mixture that's similar to the one he's already used for the trees at the base of the mountain. Half-close your eyes so that you see these two trees and the shore beneath them as *values*. They're the same dark middletone as the low trees on the distant shore.

STEP FIVE

The artist finishes the dark tree at the extreme left, adding some of this color to indicate shadows beneath the trees and along the edges of the shore in the middleground. He carries the sky colors across the water. Because the water mirrors the sky, he places bluer mixtures in the foreground, gradually adding more white and a bit more burnt sienna as he moves into the middleground. The water in the center of the picture is mainly white—tinted with ultramarine blue and burnt sienna—to suggest the light of the sky shining on the bright water. The artist finishes blocking in the dark foreground with more of the color that he's already used on the dead evergreen.

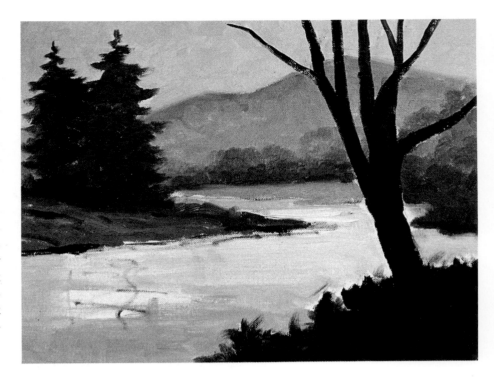

STEP SIX

The artist blocks in the foliage on the tree in the foreground. These dark, warm tones are mainly burnt sienna, darkened and cooled with ultramarine blue, and occasionally lightened with a touch of white. He uses a dark version of this same mixture to add another small tree trunk at the extreme right. Adding just a bit more white and an occasional touch of burnt sienna to the mixture, he blocks in the dark reflections of the trees in the water at the lower left. Notice how the reflection grows warmer beneath the hot color of the dead evergreen. With the same mixture that he used in the reflection, he adds a small evergreen to the middleground shore.

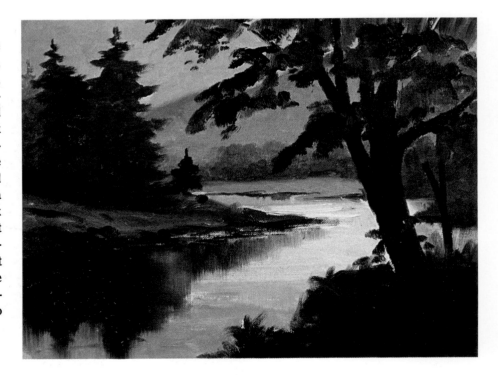

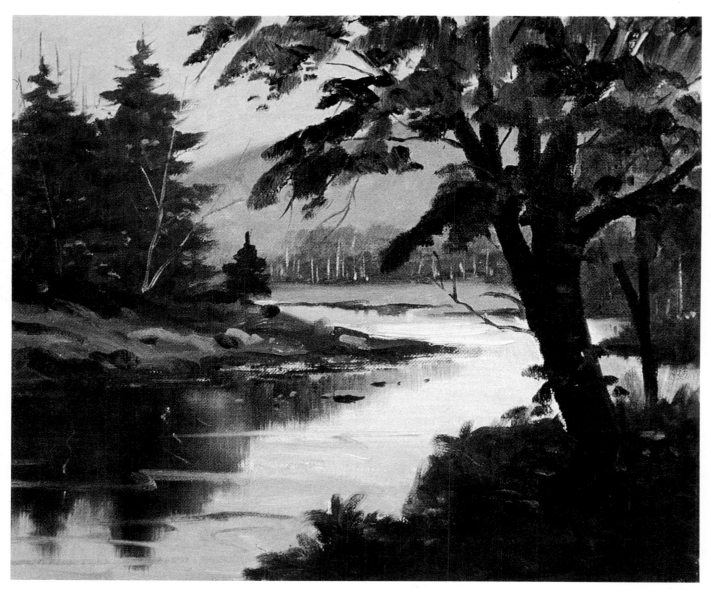

STEP SEVEN

It's always best to save texture and detail for the final step. Working with the sharp point of a round, softhair brush, the artist adds more branches to the dark tree in the foreground and suggests a few individual leaves. He uses the same brush to indicate a few small rocks in the water and on the shore in the middleground. Rinsing the brush in solvent and drying it on a scrap of newspaper, he picks up the pale mixtures used for the sky and the distant mountain and he adds lighter details, such as the ripples in the water at the lower left, the light-struck branches on the shore in the middleground, and the pale trunks of the trees on the distant shore. He also adds a few more branches to the evergreens at the ex-treme left, some touches of light on the shore beneath these trees, and even a few touches of light to the shadowy shore at the lower right. Looking at the finished painting, you may find it hard to believe that so much color was created with just ultramarine blue, burnt sienna, and white. Try such a limited palette for yourself and discover how many different mixtures you can make with the simplest possible means.

WHY VALUES ARE IMPORTANT

1 Seeing color as value—as if you're looking at a black-and-white photograph—helps you make accurate color mixtures.

2 If the values in your painting are right, the picture looks real. Light and shadow—far more than color—make us see three-dimensional form.

3 Values create a convincing sense of space.

In this demonstration painting, the values follow the "laws" of aerial perspective. The darkest values are in the foreground. Lighter values appear in the middleground. And the palest values are in the distance.

4 If your values are convincing, you can be creative with color. No matter how "realistic" or "unrealistic" your color, we see the forms if the values are right.

STEP ONE

Phthalocyanine blue and burnt sienna (plus white) will give a surprising range of warm and cool mixtures, and a full range of values. As in the preceding demonstration, this kind of limited palette forces you to create a *tonal* picture that depends on accurately observing values. The artist begins by making a pencil drawing on illustration board. He blocks in the sky with a mixture that's mainly phthalocyanine blue and white, softened with a bit of burnt sienna. Toward the horizon, the artist adds more white to his strokes. He quickly blends the strokes of the sky into one another before the color dries.

STEP TWO

When the sky is dry, he paints the palest, most distant mountain with the same mixture that appears in the sky, with less white. He paints the darker, slightly warmer mountain at the left with a mixture that contains less white and more burnt sienna—adding an extra touch of burnt sienna for the darker foliage at the top. Obeying the "laws" of aerial perspective, the nearer mountain at the right is distinctly darker, mainly blue and burnt sienna, with very little white. The artist adds less water when he paints the two darker mountains, so the color is less fluid and the strokes look rougher.

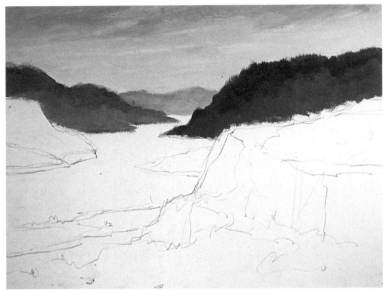

STEP THREE

Moving closer to the foreground, the artist paints the darker, warmer cliff at the left with a mixture that contains more burnt sienna and less white than any of the earlier mixtures, although it still contains plenty of blue. The low triangle of land at the center of the picture is darker and cooler, so the artist adds more blue to this last mixture. When he paints the low strip of land in the lower left, the artist indicates the dark lines of the trees with the same cool, dark mixture that he's used for the small triangle above. But then he adds more burnt sienna and white for the lighter patches.

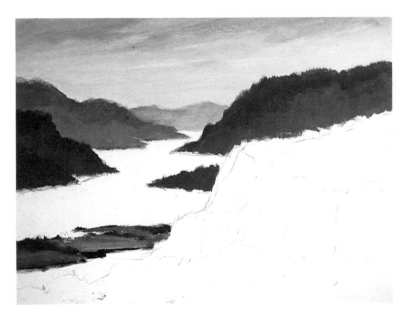

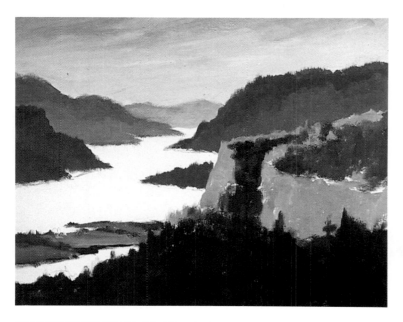

STEP FOUR

He covers the warm, sunlit sides of the cliffs in the foreground with strokes of burnt sienna and white, cooled with a very small amount of blue. The dark, warm foliage along the tops of the cliffs is burnt sienna, subdued by blue and lightened with just a touch of white. He uses this same mixture, containing almost no white, to block in the warm, shadowy mass of trees in the foreground. By the end of Step 4, the landscape clearly obeys the "laws" of aerial perspective: the warmest, darkest tones—and the strongest contrasts of light and shadow—are in the foreground, while the colors grow cooler and paler in the distance.

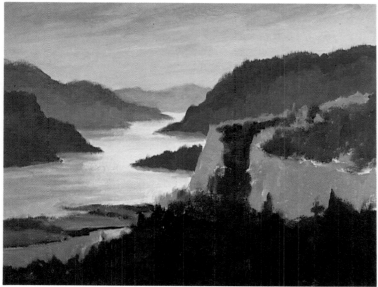

STEP FIVE

The water is painted with a series of straight horizontal strokes. To express the movement of the water and the shimmer of the light on its surface, the artist *avoids* blending the strokes smoothly into one another, but allows each stroke to retain the imprint of the brush. The darker strokes obviously contain lots of blue, just the slightest hint of burnt sienna, and a moderate amount of white. He adds more white as the stream goes into the distance, where it catches the sunlight. He adds very little water to the paler strokes, so the rough texture of the white will accentuate the sparkle of the light.

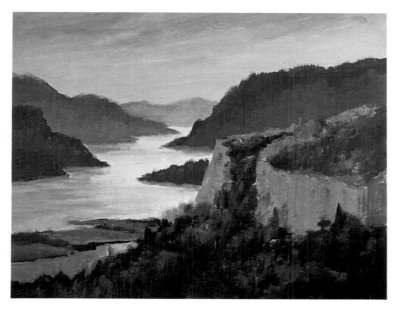

STEP SIX

Then he begins to develop the foliage along the tops of the cliffs and in the immediate foreground with small, rough strokes. These strokes are varied mixtures of all three tube colors, with more blue in the cooler strokes and more burnt sienna in the warmer strokes. He adds just a little water to these mixtures so that the paint will be thick enough to produce rough, irregular strokes. He applies the color with short, scrubby movements of a stiff bristle brush. The strokes have a ragged quality, like the foliage. He begins to suggest the craggy texture of the cliffs with similar rough strokes.

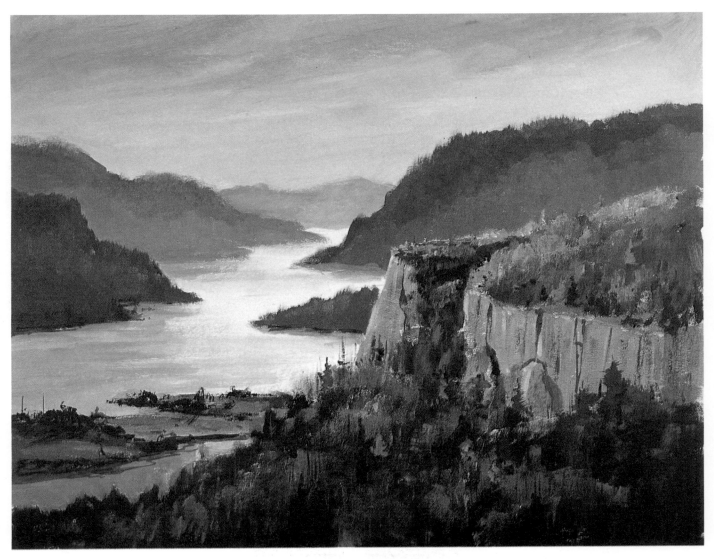

STEP SEVEN

To render the detail of the cliffs and foliage in the foreground, the artist switches to a small, round, softhair brush. Slender strokes of dark color suggest trunks and branches among the trees, and deep cracks in the sides of the cliff. These very dark strokes are phthalocyanine blue and burnt sienna, without white, but diluted with lots of water to produce a liquid paint consistency that lends itself to precise strokes. For the touches of light on the sides of the rocky cliffs, the artist rinses this small brush and dips it in white that's tinted with the slightest amount of blue and burnt sienna, again diluted with plenty of water for exact brushwork. In the lower left, the artist adds a few more dark strokes to suggest detail among the trees on the low strip of

land. He also adds some shadow lines at the near edge of the shoreline. In the finished picture, the colors are subdued, but they're full of warm and cool variations. The values have been carefully observed and accurately recorded to create realistic light, atmos-

phere, and space in the landscape. To strengthen your command of values, try other tonal palettes, such as phthalocyanine blue and burnt umber, ultramarine blue and burnt umber or burnt sienna, or phthalocyanine green with burnt umber or burnt sienna.

TRY A THREE-COLOR TONAL PALETTE

Once you've learned how much color you can produce with a two-color tonal palette (plus white), experiment with three colors.

1 Just add yellow ochre to your palette of phthalocyanine blue and burnt sienna and you can make wonderful greens, subdued oranges, golden grays, and other surprising mixtures. (Don't forget the white.)

2 Try a more subtle blue-brown combination:

ultramarine blue and burnt umber. Then add a bright color like naphthol crimson to give you stunning warm mixtures: reds, violets, pinks, red-browns.

3 Keep experimenting with these three-color tonal palettes by adding just one bright color to the blue-brown combination. Try cadmium red light or cadmium yellow light. Or phthalocyanine green.

STEP ONE

Discover how many mixtures you can produce with a palette of three primaries: ultramarine blue, cadmium red light, and cadmium yellow light, plus white. The artist sketches the main shapes with blue, blocks in the shadow with blue and red, and covers the background with all three colors, plus white.

STEP TWO

For the color of the handle, the artist blends yellow, red, and white with a speck of blue, adding more white for the lighter part of the curve. The shadow areas are a mixture of blue and red, and this mixture is used to indicate the woven texture of the basket.

STEP THREE

Leaves are blocked in with varied mixtures of blue, yellow, and white. Some strokes contain more blue, others more yellow. You can also see where the artist adds more white or less to the mixture, so that some leaves seem to catch the light, while others are in shadow.

STEP FOUR

The artist suggests more shadows in the leaves with blue and yellow, warmed here and there with red. For the tablecloth, he blends just a touch of all three primaries with a lot of white, then adds more blue to this mixture for the shadows of the fold, which sometimes contain a hint of red.

STEP FIVE

The bright notes of the flowers are painted with thick strokes of pure yellow, plus a slight touch of red in the shadows. The artist blends a few more touches of yellow into the leaves to heighten their color here and there. At this stage, the only patches of bare canvas are the shapes of the white flowers.

STEP SIX

The artist begins the white flowers with mixtures that may *look* like pure white, but actually contain just the slightest hint of all three primaries. The petals that catch the light are painted with thick white, slightly tinted with red and yellow. The petals in shadow are also painted with thick white, tinted with just a little blue and a speck of red. The brushstrokes radiate outward from the centers of the blossoms. The artist exploits the weave of the canvas to give his strokes a soft, ragged texture that matches the softness of the flowers.

46

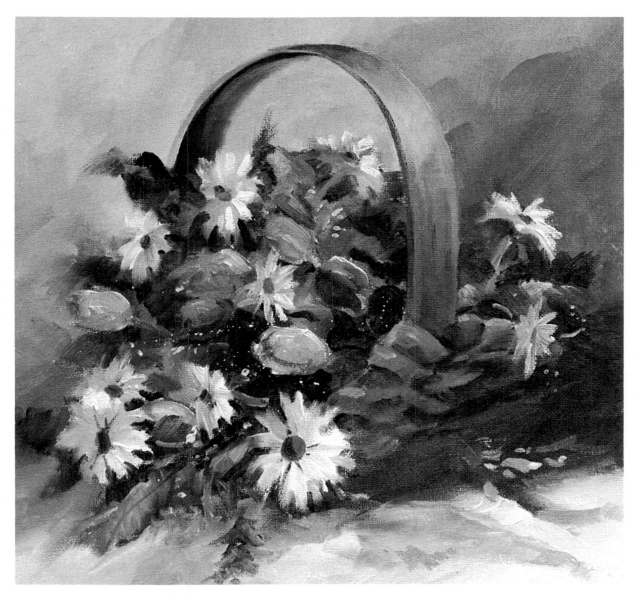

STEP SEVEN

The artist paints the hot colors of the remaining flowers with almost pure red, lightened with a touch of white and subdued by a hint of the blue in the shadows. The warm centers of the white flowers are painted with red and yellow, with a touch of blue added for the dark notes. He completes the casual, sprawling bouquet by adding a few more white flowers and scattering some petals on the cloth that covers the table. He also reinforces the leaves with dark strokes of blue and yellow to strengthen the shadows, adding pale strokes of blue, yellow, and white to suggest more leaves caught in the light. With a small round brush, he picks up the dark shadow mixture of blue and red that appears beneath the basket; he draws a few lines within the petals of the white flowers and sharpens the edges of the flowers here and there. The finished painting is ample proof that these three primaries—ultramarine blue, cadmium red light, cadmium yellow light, plus white—can create a full range of colors.

MAKE SOME PRIMARY COLOR CHARTS

To learn more about what the primaries can do, look back at the oil color chart on page 13 and make some primary color charts.

1 Mix pairs of primaries—blues and yellows, reds and yellows, reds and blues—to see the variety of secondaries.

2 Change the proportions of these mixtures to create tertiaries: more blue and less yellow to make blue-green; more yellow and less red to make yellow-orange; more red and less blue to make red-violet, etc.

3 Modify all these two-color mixtures by adding a touch of the third primary.

4 When necessary, add a bit of white to bring out the brilliance of the color.

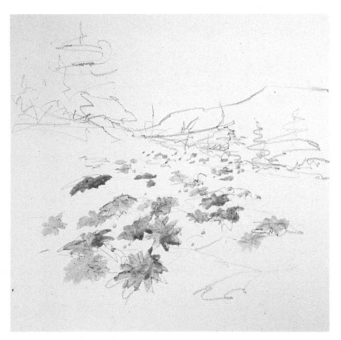

STEP ONE

Now try a watercolor with the same three primaries: ultramarine blue, cadmium red, and cadmium yellow. Here the artist starts with a simple pencil drawing of a field of wildflowers and then covers the shapes of the flowers with a masking liquid—sold at most art supply stores.

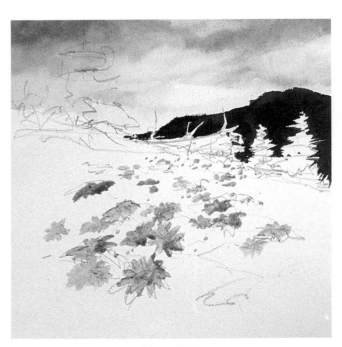

STEP TWO

He paints the sky with ultramarine blue and a touch of cadmium red, adding more water toward the horizon. When the sky is dry, he paints the dark mountain with the same mixture, barely diluted with water. He carefully brushes the dark tone around the tree trunk and evergreens at the horizon.

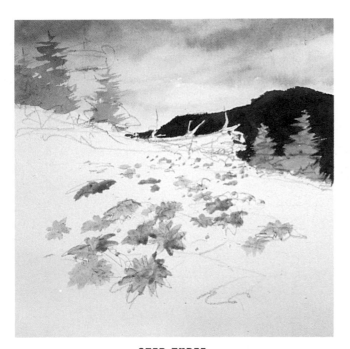

STEP THREE

When the dark hill dries, the artist paints the two evergreens at the right with *almost* pure yellow, slightly subdued by specks of red and blue. He mixes blue and yellow, then adds a whisper of red, for the muted color of the evergreens in the upper left corner.

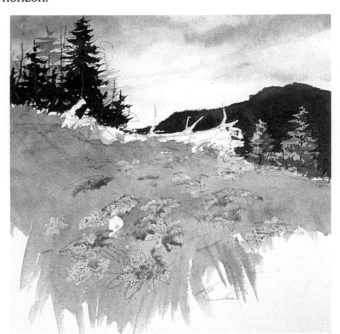

STEP FOUR

The darker evergreens in the upper left are painted with blue and yellow, a hint of red, and very little water. The warm shadows on the sunstruck trees at the right are a blend of red and yellow, subdued by a touch of blue. And the grass mixture is mainly yellow with whispers of red and blue.

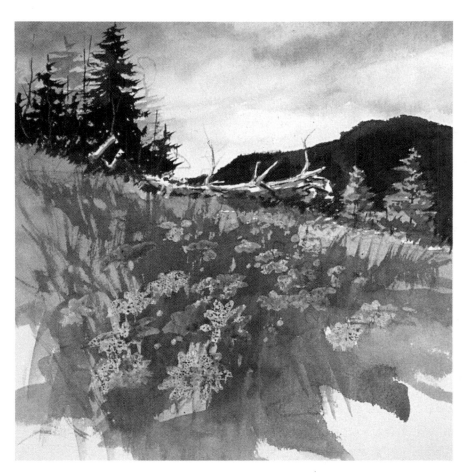

STEP FIVE

At the end of Step 4, the tree trunk on the horizon remains bare paper. Now the artist mixes a rich brown that's mainly cadmium red and cadmium yellow, darkened with a few drops of ultramarine blue. He brushes this color carefully along the underside of the tree trunk, leaving bare paper for the sunlit edges of the wood. Moving up from the bottom edge of the picture, he warms the foreground with that same mixture, lightened with more water. While the warm foreground mixture is still wet, he mixes a subdued, cool tone with ultramarine blue and cadmium yellow, brushing this across the middleground and allowing the cooler mixture to flow into the wet, warm color of the foreground.

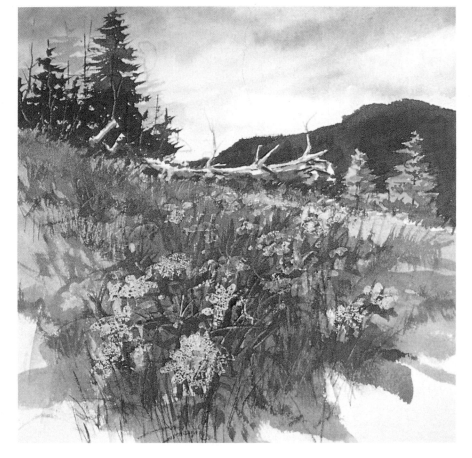

STEP SIX

After allowing the foreground colors to dry thoroughly, the artist creates two new mixtures on his palette, one warm and one cool. With ultramarine blue and cadmium yellow, plus a few drops of cadmium red, he mixes a dark, subdued green that he carries across the meadow with slender, erratic strokes to suggest blades of grass. The warm grass color is cadmium red and cadmium yellow, darkened with a touch of ultramarine blue. This mixture is loosely brushed across the foreground to warm the tone of the meadow.

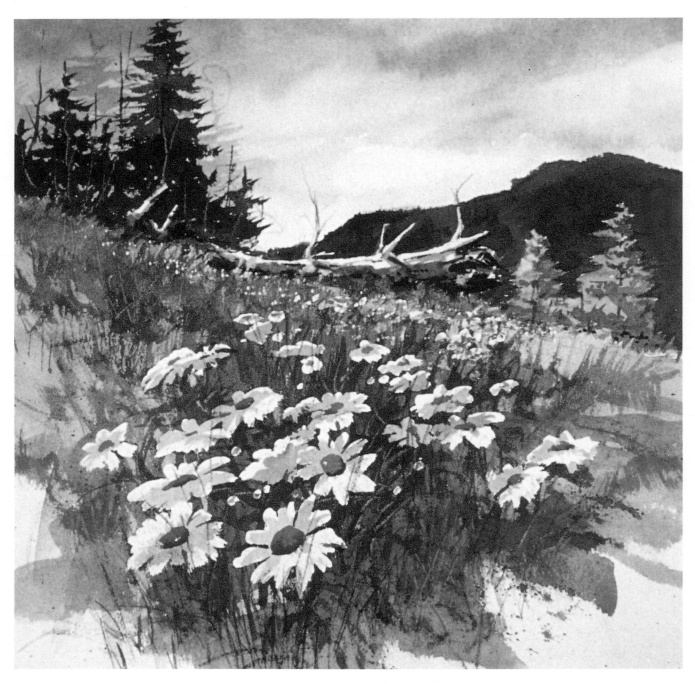

STEP SEVEN

Now you'll see the purpose of the masking liquid that covered the flowers in Step 1. The rubbery, water-resistant fluid has dried and formed a protective skin over a part of the painting that was to be kept pure white. Now the "skin" peels off easily. When the artist removes the dried masking liquid from the flowers, their shapes are brilliant white paper. To paint the pale shadows on the petals, the artist mixes all three primaries to make a neutral tone, then dilutes it with plenty of water. He applies this tone sparingly to preserve the brilliant white of the petals. Then, at the center of each blossom, he places a bright mixture of cadmium red and cadmium yellow, softened by just the slightest hint of ultramarine blue. He completes the painting by creating a dark mixture of ultramarine blue and cadmium red, plus just a little cadmium yellow, for the strokes of strong shadow that he places on the tree trunk and beneath the flowers in the foreground. (The shadows beneath the flowers intensify the whiteness of the petals.) The fascinating thing about this picture is that almost every mixture, whether rich or subtle, contains the three primary colors—yet the mixtures are varied because the artist keeps changing the proportions of the three primaries.

STEP ONE

This acrylic demonstration is painted with ultramarine blue, cadmium red light, cadmium yellow light, and titanium white on a canvas board. As usual, the artist starts with a pencil drawing. Then he paints the cool sky at the top with blue, plus a drop of red and white. He adds more white to this mixture for the lighted areas of the clouds. For their shadowy undersides, he adds a touch of yellow to the sky mixture to produce a warm neutral that he lightens with white.

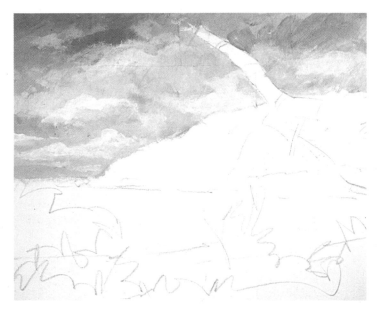

STEP TWO

The artist carries the shadowy tone of the clouds across the lagoon, since water reflects the sky colors. When this pale tone is dry, he mixes a darker tone with lots of blue, a hint of red and yellow, plus white. He picks up a small amount of this color on a big bristle brush, which he holds at an angle and passes *lightly* back-and-forth over the rough surface of the canvas. The weave of the canvas breaks up the strokes to produce an effect that's called *drybrush*. The ragged drybrush strokes produce an irregular gradation from dark to light, suggesting the shimmering light on the lagoon.

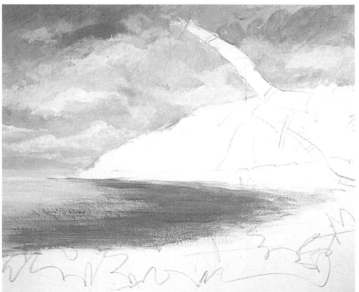

STEP THREE

The primaries tend to subdue one another when they're all in the same mixture. For the dark, soft tone of the wooded headland, the artist blends blue, yellow, and white to create a rich, subdued green—and then he adds a hint of red to make it more neutral. Along the top of the headland, he uses drybrush strokes to suggest the ragged texture of the foliage. The darker shapes of the trees along the bottom of the slope are mainly blue and red, with a hint of yellow. The warm sand is blocked in with red, yellow, and white, softened with a speck of blue.

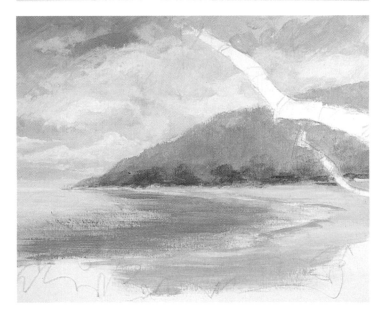

STEP FOUR

When the colors of Step 3 are completely dry, the artist paints the rich, warm, dark shapes of the leaning trunks with red and blue. In the warm areas, red dominates the mixture, while the darker markings on the trunks are dominated by blue. With a round, softhair brush, the artist paints the hanging foliage with blue and yellow, muted with a slight hint of red. The paler leaves at the right are modified with white, while the darker leaves at the top contain no white at all.

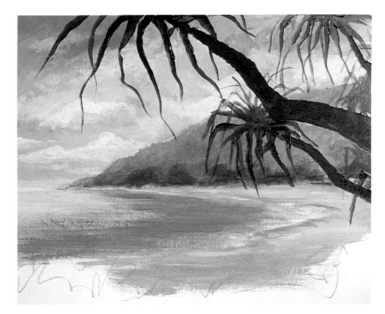

STEP FIVE

Switching to a smaller round brush, the artist paints the foreground foliage with a dense network of little strokes. He works with thick yellow and blue, diluted with some acrylic painting medium to produce a rich, buttery texture. He mixes the colors not on his palette, but directly on the canvas board, painting blue strokes over the yellow and yellow strokes over blue to create a lively, irregular tone. Mixed on the canvas board in this way, the colors suggest variations of sunlight and shadow.

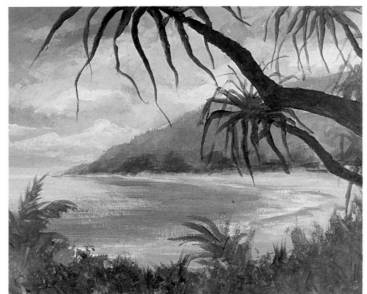

STEP SIX

The artist continues to develop the foreground foliage by overlapping strokes of yellow and blue. He works with small strokes, sometimes letting the yellow break through to suggest sunshine and sometimes letting the dark strokes suggest shadows. Then he adds more foliage to the palms with warm strokes that are mainly red and yellow, slightly subdued with a speck of blue. He uses the same warm tone to build up the detail of the trunks, lightening some of the strokes with white. Now there are lights and shadows on the trunks and in the hanging foliage.

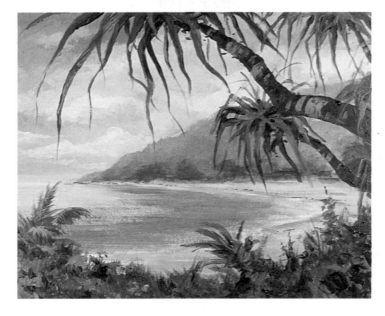

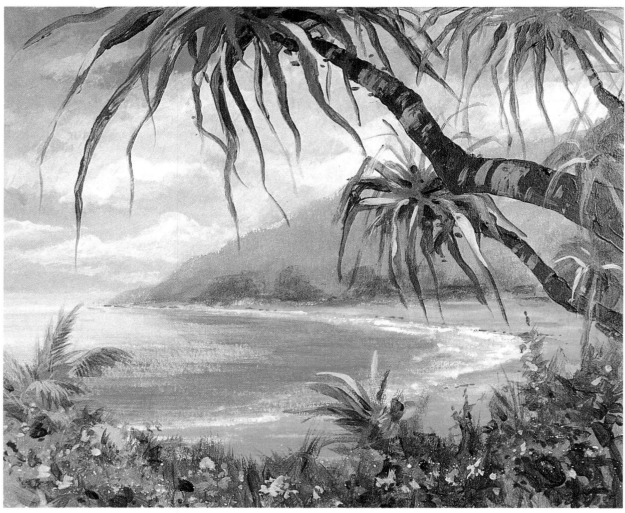

STEP SEVEN

Blending blue, yellow, and lots of white on the palette, the artist adds more pale, sunlit leaves to the clusters of foliage that dangle from the trunks of the palms. He adds a few strokes of the same pale mixture to the tangled foliage in the foreground to suggest more sunlit leaves. Then, with the very tip of a round brush, he adds tiny touches of this color throughout the foreground foliage—plus touches of red and yellow, sometimes pure, and sometimes tinted with white. Now he fills the foreground foliage with tropical wildflowers, produced by the spatter technique. To make the wildflowers, the artist picks up some very fluid color on a softhair brush, holds one hand a few inches above the painting surface, then smacks the handle of the brush against his outstretched hand. Droplets of liquid color spatter across

the picture. The artist completes the picture by sharpening the edge of the beach with slender strokes that suggest foam. These strokes are almost pure white, faintly tinted with blue and diluted with water to a fluid consistency for precise brushwork. The final

picture proves the versatility of a palette that consists of just three primaries, plus white. Not only do you see a variety of subtle color mixtures, but you also see strong darks that are produced by mixing bright colors, without the aid of black.

EXPERIMENT WITH THREE-COLOR PALETTES

The three primaries are just one example of a three-color palette. Try a variety of three-color palettes, selecting your colors to suit the subject, such as:

1 For a fiery autumn landscape, try cadmium red light, cadmium yellow light, and phthalocyanine green—plus white. The green will subdue the hot mixtures when needed, and will add some cool notes.

2 For a moody seascape, try phthalocyanine blue, phthalocyanine green, and cadmium red light—plus white. The red will warm or subdue the cool mixtures, and will give you some warm notes.

3 For a desert landscape, try burnt sienna, cadmium yellow light, and ultramarine blue for the cool mixtures that will dramatize the hot colors by contrast.

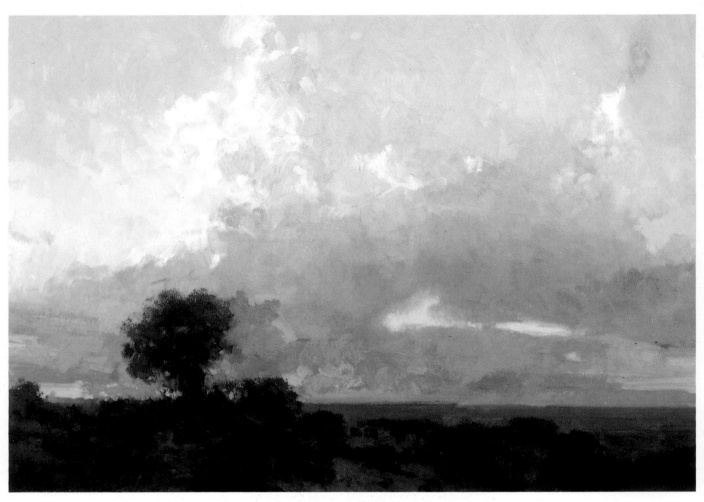

WEST OF WINSLOW

by James Reynolds, oil on canvas, 14″ × 20″

Paradoxically, the secret of painting a vivid sunset is to keep your fiery colors to a minimum. In this awesome Western sunset, the only hot color is a narrow strip at the horizon. Below that strip is a shadowy landscape on which night has already fallen. Above are dark clouds, the last glimpse of blue sky, and some touches of sunlight on the loftier clouds. Study the sunset mixtures and you'll see that they're surprisingly quiet oranges with a touch of yellow where the sun is actually setting at the left. Because these sunset mixtures are surrounded by darker, cooler colors, the hot tones look *hotter* than they really are.

Photo courtesy O'Brien's Art Emporium, Scottsdale, Arizona

PART FIVE
COLOR
STRATEGIES
GALLERY I

SUDDEN SQUALL

by Daniel Bennett Schwartz, oil on board, 9¼″ × 13½″

Pure, clear color depends on bold, decisive brushwork—as you see in this dramatic landscape in which you can feel the cool wind of the oncoming storm. The artist applies his paint with broad, flat strokes. He visualizes the shapes clearly before he touches the brush to the painting surface, and he mixes the exact colors on the palette so he won't need to overwork the wet paint on the board. He does just enough blending to soften and fuse colors where necessary, but he stops before the color loses its vitality; it keeps a wonderful freshness because the color areas are flat and simple, with minimal gradation and minimal detail.

LAST LIGHT

by Albert Handell, oil on board, 24″ × 30″

The artist surrounds the warm colors of the buildings and the bare ground with the cool colors of the snowy foreground and the dark, cool colors of the distant landscape and sky. Here and there he weaves the cool tones into the warm central area. In the same way, he weaves warm notes into the snowy foreground and into the blues and purples of the distance. A flash of golden light pulls the viewer's eye to the center of interest. Handell works with complementary colors that enrich each other: blues and purples against oranges and yellows. Notice that the greatest contrast of values appears at the focal point of the painting—where the dark foreground and the distant mountains meet the sunlit patch of soil and the bright edge of the building.

Photo courtesy Ventana Gallery, Santa Fe, New Mexico

BEACH, SCOTLAND

by Francis Cunningham, oil on canvas, 17" × 23"

Many of the greatest achievements in landscape painting are executed mainly in grays. Notice that the word is grays—not just gray. As you can see in this magical landscape, the word *gray* encompasses a wide range of subtle colors. Here you can discover blue-grays, brown-grays, green-grays, and grays for which there are no names. The side of the cliff alone is a lesson in how many grays you can create: warm and cool, light and dark, all with hints of other colors. The secret of mixing grays is *not* to rely on black and white, but to experiment with many color combinations, such as blues and browns modified by touches of other hues; complementary colors that neutralize each other to make grays; and even combinations of primaries, which will produce grays that suggest every color in the rainbow.

Collection, The Century Association, New York

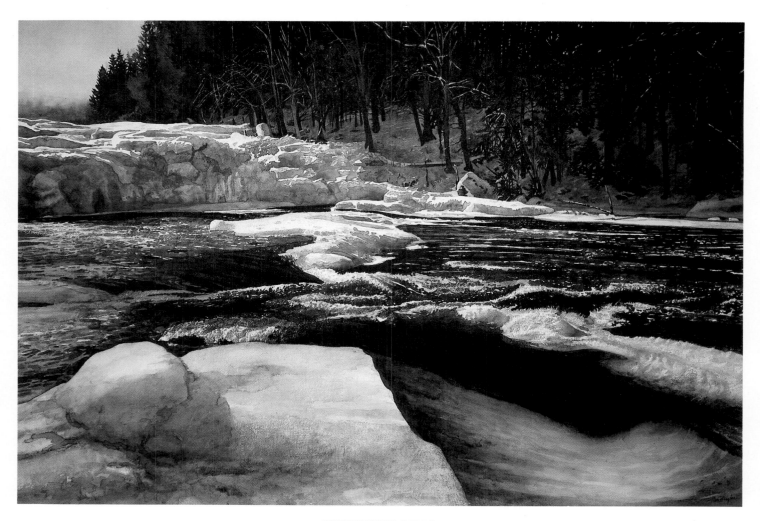

BUTTERMILK FALLS

by Allen Blagden, watercolor, 36″ × 60″

Here's another outstanding example of tonal painting: a wintry landscape that's painted in an extraordinary range of cool colors. Study the variety of blues, greens, and blue-greens. Despite the picture's limited color range, the colors are never monotonous; they keep changing as your eye moves over the picture. Blue melts into blue-green and then into green. The darks are really blue-blacks or black-greens. For a delicate change of pace, the artist introduces a hint of warm color into the distant woods. And the most brilliant light in the picture — the strongest contrast of light against dark — is the sunlit patch of snow at the center of interest. The success of this painting depends upon the precise observation of values and delicate color variations.

ST. MAARTEN

by Everett Raymond Kinstler, acrylic on canvas board, 18″ × 24″

One of the time-tested methods of planning a landscape is to visualize the subject in "planes": foreground, middleground, distance (or background), and sky. Bearing in mind the "laws" of aerial perspective, the artist places his strongest lights and darks—and therefore his strongest value contrasts—in the foreground, where the dark umbrellas cast dark shadows on the bright sand. The mountain in the middleground is still fairly dark, but contains few value contrasts, while the distant mountains are paler and distinctly cooler. The sky is the lightest value of all. The overall color scheme is cool, with touches of warm color strategically placed to lead your eye to the center of interest. Kinstler painted this fresh, spontaneous tropical landscape on the spot in less than two hours.

FALL IN ESSEX

by Charles Movalli, oil on canvas, 20″ × 24″

This artist also works on the spot, racing against time and
weather to record the fleeting effects of light and color with
decisive, spontaneous brushstrokes. The freshness of his
color depends on three factors: accurate observation of color
and value before the artist touches brush to canvas; precise
color mixing on the palette; and broad, simple brushstrokes
that retain their brightness and clarity because Movalli makes
a bold stroke and *stops*. He never overworks the color on the
canvas, never brushes and rebrushes his color until it turns
dim. He allows one wet stroke to blend into another as the
brush moves, but he keeps blending to a minimum. Broad,
flat strokes always produce the most vivid color.

FLOWERS AND INCOMING FOG

by Charles Reid, oil on board, 18" × 22"

In this high-key, relatively low-contrast still life — with a landscape background — the artist places his few darks and strong contrasts at the center of interest. The leaves in the vase provide the strongest contrast. The composition *looks* casual, but the orchestration of color is thought out with great care. The yellows and yellow-greens of the distant field are echoed in the still life. The sky color is reflected in the shadows on the vase, on the post of the window frame, beneath the dishes and fruit. Examine the painting at your leisure and you'll discover many other color notes that echo one another and do an inconspicuous job of tying together a lovely pictorial design.

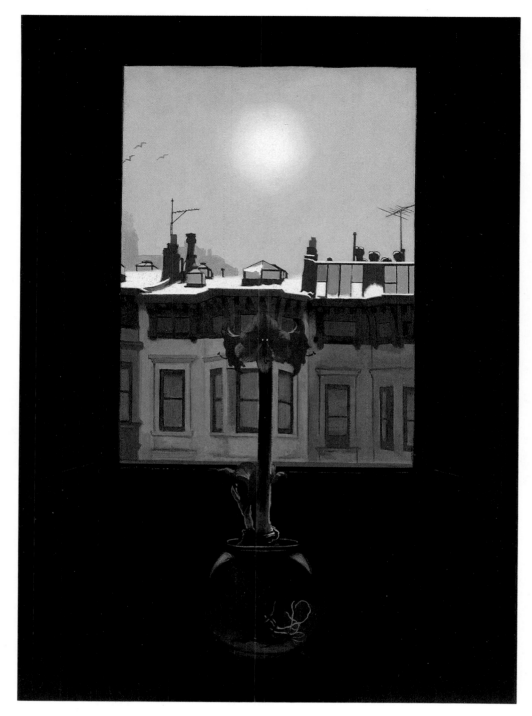

AMARYLLIS IN WINTER

by Harvey Dinnerstein, oil on board, 24¾″ × 17¼″

This formal design, with its low key and subdued colors, is also beautifully orchestrated. The dark shape of the window frames a fragment of urban landscape which, in turn, frames the bright note of the red flowers—the focal point of the picture. The two vivid red blossoms are the only strong colors, which are dramatized by the surrounding neutrals. (A similar strategy is used in the sunset in "West of Winslow" on page 54.) The sky color is echoed in the central windows behind the flower. And the colors of the sky and the buildings are reflected in the glass vase that emerges from the dark shadow.

SAWMILL

by Claude Croney, watercolor, 13½″ × 20″

Working with a limited tonal range of browns and grays, the artist develops far more variety of color than you see at first glance. There are lovely olive and golden tones, surprising places where the color shifts from warm to cool and back again, and unexpected hints of blue and red that enliven the shadowy machinery at the left. Obeying the "laws" of aerial perspective, the foreground colors are darker and warmer—containing more contrast—than the paler and cooler distant colors. Notice how Croney "reserves" the lights in the sky—which is watercolor lingo for leaving the bare paper untouched to suggest pure light.

Collection of LeRoy Marek, Jr.

MIDNIGHT HAUL
by Don Stone, oil on canvas, 20" × 24"

This haunting night scene is painted almost entirely in grays —
mostly cool gray mixtures with a hint of warmth in the dark
silhouettes of the boats. Against this very low-key back-
ground, the bright notes of the lights on the ships and the
reflections of the lights in the water provide the few warm
touches that the picture needs for color variety. The one
strong value contrast is the flash of moonlight on the water
at the center of interest. Night scenes demand careful color
observation because the subject may surprise you. As you
see here, the sky is often much lighter than you might expect.
Naturally, this will also be true of the water, which normally
reflects the sky.

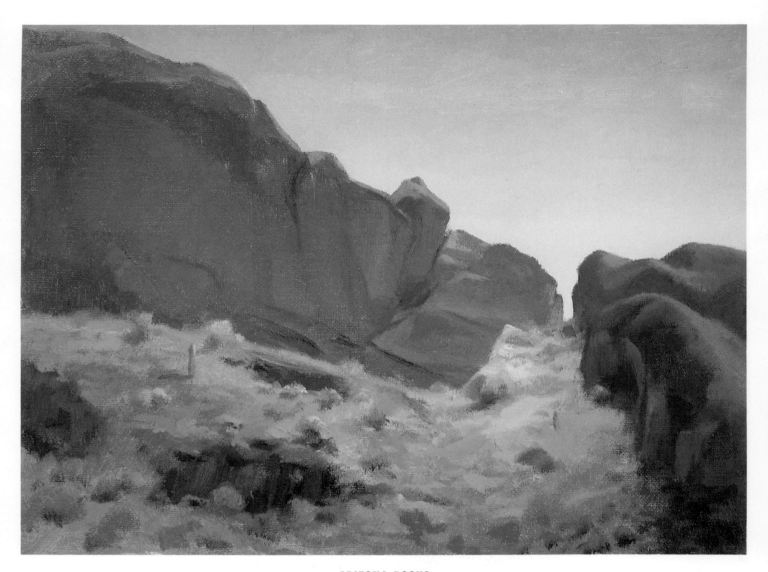

ARIZONA ROCKS

by Thomas S. Buechner, oil on canvas, 9" × 12"

Shadows are filled with color, especially reflected color. You're looking across the sunny foreground at the shadow side of a huge rock formation—and that shadow is filled with color that reflects the nearby land and the sky. At the left, the rock formation picks up the golden tone of the foreground, while at the right, the rock takes on the cooler tone of the sky above. That sky color also appears in the shadows on the darker rocks in the right foreground. You can't invent such colors. Nor can you paint them from photos. Buechner's poetic landscapes are painted from nature, with loving attention to the colors that must be experienced firsthand.

Private collection

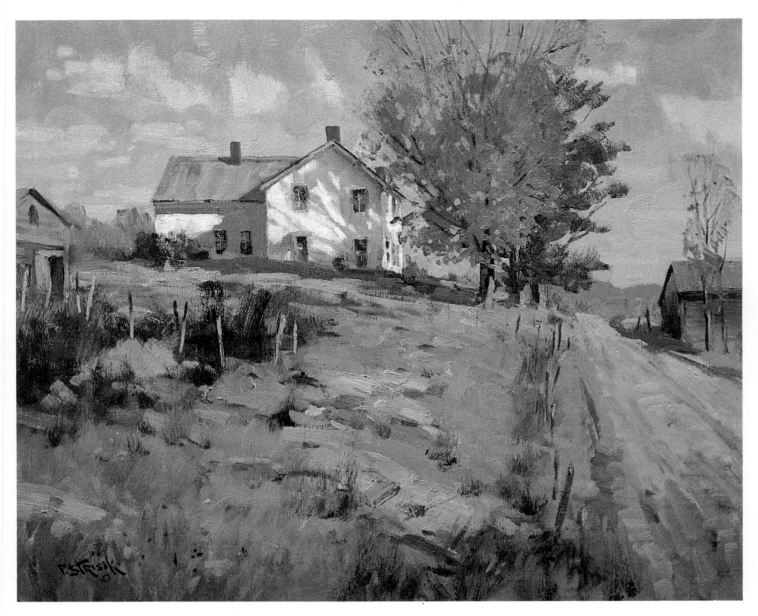

ROAD TO FLETCHER

by Paul Strisik, oil on canvas, 16″ × 20″

At first glance, the color strategy seems simple. The center of interest, which is the meeting of the white house and golden tree, brings together the lightest and brightest notes in the painting. The tree is placed against its complement: orange leaves against a blue sky. And the cool color of the field accentuates the warmth of the tree. But as your eye roams over the canvas, you discover that the artist has used this one warm color to pull the whole picture together. Small touches of orange appear at several points on the horizon, along the edge of the road, and in the scrubby bushes in the left foreground. And touches of the complementary sky color are barely visible—but important—throughout the foreground.

Collection of William Rowett, Jr.

NOVEMBER EVENING

by Carl Schmalz, watercolor, 22" × 30"

The drama of this landscape depends on a very simple, very
bold value scheme. The entire picture is dark, except for two
slender strips of brilliant light at the horizon. And at the hori-
zon, Schmalz introduces the one powerful color contrast: the
rich blue of the mountains against the warm glow of the fad-
ing light. Thus, the contrast of values is echoed by a warm-
cool contrast at the focal point of the pictorial design. The
birds aren't just a picturesque touch; they're a subtle bridge
between the sky and the land—tying together the upper and
lower halves of the picture.

Private collection

BUTTER ISLAND

by Peter Cook, oil on board, 24″ × 36″

Coastal subjects are filled with reflected light—which means reflected color. The sea reflects the sky color, as you see here. But then the light bounces off the sea—which acts as a huge mirror—and fills the shadows on the rock formation with cool reflections. The sea also mirrors the darks of the rocks. And the tops of the rocks pick up the brilliant sunlight that also illuminates the tops of the clouds. The artist captures the magic of a sunny day so beautifully because he pays particular attention to the way in which each part of the picture influences the other parts. And the only way to learn this lesson is to paint on the spot.

Private collection

GERANIUMS

by William F. Draper, oil on canvas, 20″ × 16″

*The brilliant red of the geraniums is accentuated by the nearby complement —
the green leaves. But the artist paints only a few bright green leaves and subdues
the others to a more shadowy green. Thus, the green leaves provide a
complementary setting for the red flowers, but don't compete. Examine the
shadows on the wall behind the flowers and leaves. Like all shadows, they're
transparent and luminous. This is obviously an outdoor still life because the
shadows reflect the cool light of the sky.*

Photo courtesy of Wally Findlay Galleries, New York

PART SIX
PAINTING
WITH A FULL
PALETTE

STEP ONE

Working with a full palette doesn't necessarily mean that you *must* paint a picture in brilliant colors. A full palette will work equally well for mixing the many muted colors in nature. It's a good idea to try a subdued subject, like this winter scene, to again force you to think about values. Here, in the first step, the artist brushes in the composition with ultramarine blue and a little burnt umber, diluted with solvent. Then he blocks in the sky with ultramarine blue, burnt sienna, yellow ochre and white, blending in more yellow ochre and white as he moves to the right.

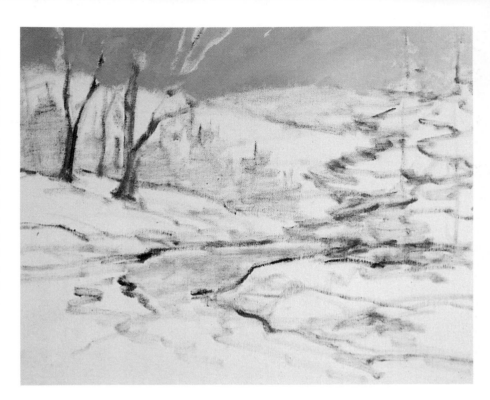

STEP TWO

The angular shape of the stream is painted with the same colors as the sky—ultramarine blue, burnt sienna, yellow ochre, and white—since the color of the water repeats the color of the sky. However, the artist changes the proportions of the mixture slightly, adding a bit more blue to the water and then adding more burnt sienna (but no white) to suggest the shadows at the edge of the shore. Blending more white into the water, he adds a few pale strokes that suggest the movement of the water. He paints the distant mountain with still another version of this mixture, now dominated by burnt sienna.

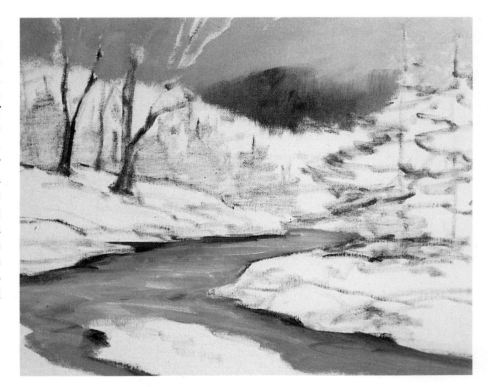

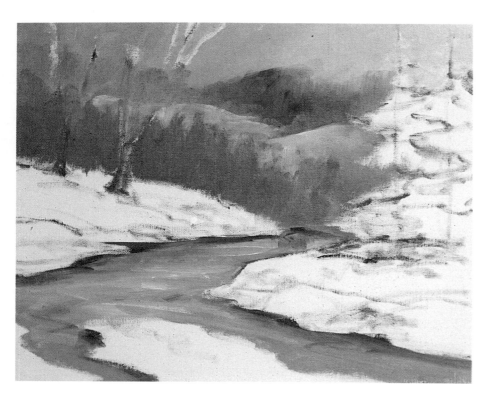

STEP THREE

The artist begins with the sky mixture — ultramarine blue, burnt sienna, yellow ochre, and white — to paint the strip of snowy slope beneath the distant mountain and above the diagonal row of trees. (Remember that snow is just another form of water, so it's also inclined to reflect the color of the sky.) Then he paints the shadowy row of trees that slant down the snowy hill on the left — a combination of brilliant cadmium orange, subdued ultramarine blue and burnt umber, plus white and an occasional touch of yellow ochre. This same mixture is used to paint the dark trees on the horizon — in the upper left-hand corner.

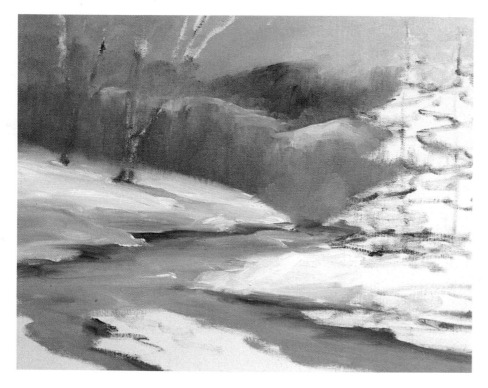

STEP FOUR

The artist begins to work on the snow, starting with the triangular patch of shore in the middleground. He paints the sunlit top plane of the snow with a little cerulean blue and yellow ochre, mixed with a lot of white. (Cerulean blue is cooler and brighter than ultramarine blue.) Then he paints the shadows on the snow with ultramarine blue, a touch of alizarin crimson, burnt umber, and white. Although snow may *look* pure white, never paint it with solid strokes of white, used straight from the tube. The "white" snow is actually full of subtle color because it picks up so much reflected color from its surroundings and from the sky.

STEP FIVE

The artist blocks in the rest of the snow with the same color combinations: cerulean blue, yellow ochre, and white for the sunlit top planes; and ultramarine blue, alizarin crimson, burnt umber, and white for the shadowy planes of the snowbanks. The dark tones of the evergreens are painted with another surprising combination of bright colors: cadmium orange and viridian, plus burnt umber for the darker tones and a touch of white for the lighter strokes. This color combination, carried downward into the stream, reflects the dark tones of the trees.

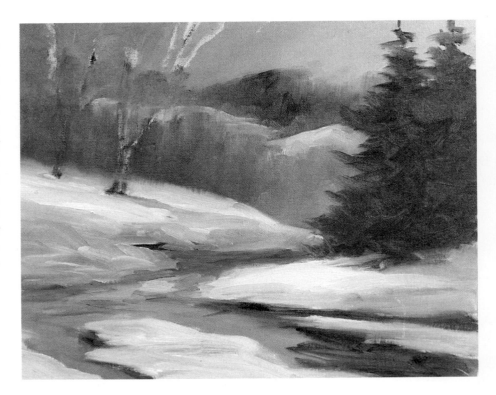

STEP SIX

At the left, the artist begins the dark trees with another interesting mixture of brilliant colors: cadmium red, viridian, burnt sienna, and a touch of yellow ochre. Adding a little white, he paints the distant tree trunks with a slender brush, varying the strokes by adding more white or yellow ochre. The dark rocks along the shore are the same mixture as the dark trees. Taking a second look, the artist decides that the water reflects its shadowy surroundings more than it reflects the sky. He repaints the stream with ultramarine blue, burnt umber, alizarin crimson, and a bit of white.

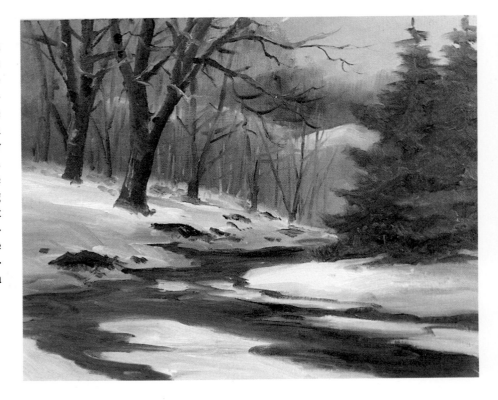

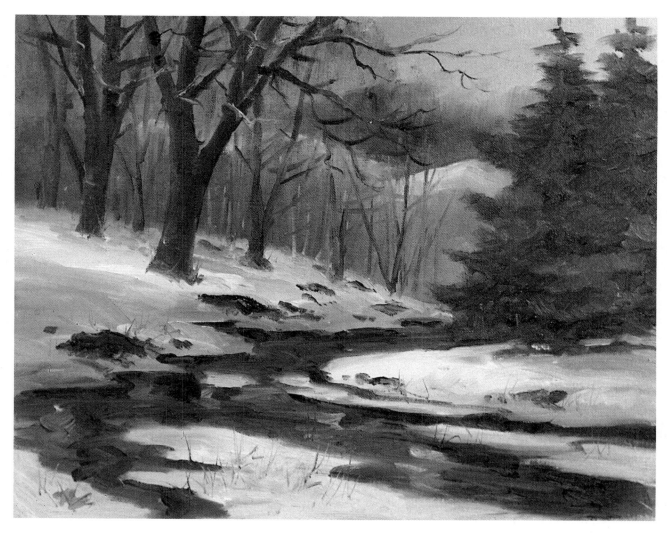

STEP SEVEN

In this final stage, the artist develops the detail of the foliage and branches, suggests some detail in the foreground, and builds up the darks and lights. Working with a slender brush, he adds more tree trunks, branches, and rocks with various combinations of brilliant colors that produce subtle darks: cadmium red, cadmium yellow, and phthalocyanine blue; cadmium orange, viridian, and burnt umber; cadmium orange, ultramarine blue, and burnt sienna. Minute changes in the proportions of these mixtures can produce interesting color variations. For example, a bit more cadmium orange adds a note of warmth to the mass of evergreens at the extreme right. An additional speck of cadmuim red adds a hint of warmth to the shadowy mass of trees that moves down the distant slope at the left. To brighten the top planes of the snowbanks, the artist piles on thick strokes of white that's slightly tinted with cerulean blue and yellow ochre. He uses the same mixture to add chunks of snow to the dark stream. And a few casual strokes of this mixture indicate the reflections of the snow in the dark water. The warm tones of the weeds, breaking through the snow in the foreground, are scattered strokes of yellow ochre modified with a touch of burnt umber, and occasionally darkened with ultramarine blue.

MAKE THOSE QUIET MIXTURES COLORFUL!

1 *Make a bright mixture with two primaries and then add a touch of the third primary to subdue the mixture without losing its richness.*

2 *Don't add black to subdue a bright mixture. Find a color to do the job—a warm color to quiet a cool mixture, a cool color to quiet a hot mixture.*

3 *Make interesting darks—colorful "blacks"* *that aren't black—by mixing powerful complements like phthalocyanine blue and cadmium red light.*

4 *Make lively, varied grays and browns by mixing complements like ultramarine blue and cadmium orange, plus white. Try all the complements. Mix even more grays and browns by combining blues with browns, then adding white and slight touches of other colors.*

STEP ONE

This demonstration shows you how to use a full palette of colors to produce a subdued painting of a coastal landscape. The artist begins with the usual pencil drawing. Then he wets the sky with clear water, stopping at the headland and the horizon. On the wet, shiny paper, he brushes various mixtures of ultramarine blue and burnt sienna, some warmer and some cooler, depending upon the proportions of the colors in the mixture. The strokes fuse softly on the wet paper.

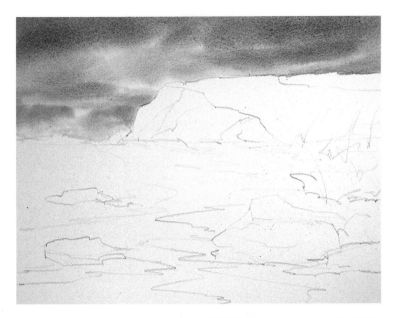

STEP TWO

The artist lets the sky dry thoroughly. (An electric hair dryer will speed the drying process.) For the warm top of the headland, the artist mixes alizarin crimson, yellow ochre, and ultramarine blue. He adds more water for the paler areas at the lower edge of the wash. The cooler side plane is painted with various blends of cerulean blue, yellow ochre, and burnt sienna. When the top of the headland is thoroughly dry, he adds darker strokes of viridian and alizarin crimson to suggest distant trees. A few strokes of clear water blur the end of the headland to indicate foam breaking against the rocks.

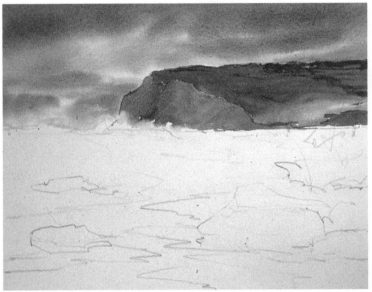

STEP THREE

For the warm, dark, jagged shapes of the beach, the artist combines three primaries on his palette: the bright, clear cerulean blue, the brilliant alizarin crimson, and the more subdued yellow ochre. The dark bushes at the right are painted with phthalocyanine blue, yellow ochre, and the slightest touch of cadmium red to produce the powerful, mysterious dark that you see here. While the color is still damp, he scratches away a few branches with the pointed end of his wooden brush handle.

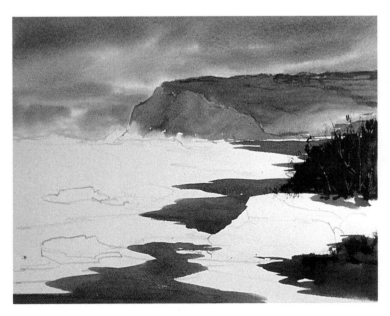

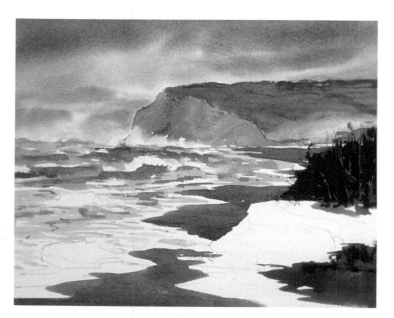

STEP FOUR

On this moody, overcast day, the color of the waves is subdued, like the surrounding landscape. First, the artist paints the paler tones of the water with cerulean blue, new gamboge, a little burnt umber, and lots of water. Then, for the shadowy edges of the waves and the dark patches under the pale foam, he adds more cerulean blue and burnt sienna. The foaming tops of the waves—as well as the foam that spills up the beach—remain bare white paper.

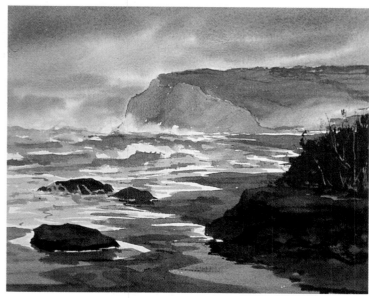

STEP FIVE

The dark rocks in the foreground are first covered with a flat wash of cerulean blue, burnt sienna, and new gamboge. When this mixture dries, the artist blends a rich dark—phthalocyanine blue and burnt umber—to paint the shadows and cracks in the rocks. Across the sand in the foreground, the artist washes a soft, cool mixture of ultramarine blue, alizarin crimson, and burnt sienna to unify the color of the beach. With a darker, warmer version of this mixture—less water and more burnt sienna—he darkens the beach's edge and adds the reflection beneath the big rock in the lower left.

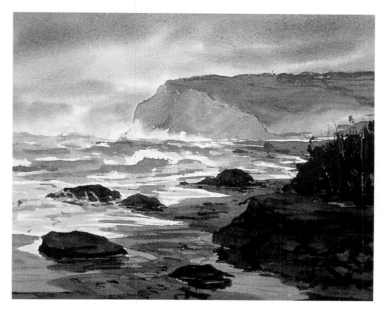

STEP SIX

The artist begins to build up the detail in the foreground with small, dark strokes. He uses the sharp point of a small brush to place crisp, dark touches of phthalocyanine blue and burnt umber on the rock formation in the lower right; to add two more dark rocks to the edge of the beach—one in the foreground and one in the middle of the picture—and to add other inconspicuous details like the reflection in the lower right corner and the tiny touches of darkness that suggest pebbles, seaweed, and other coastal debris at the water's edge.

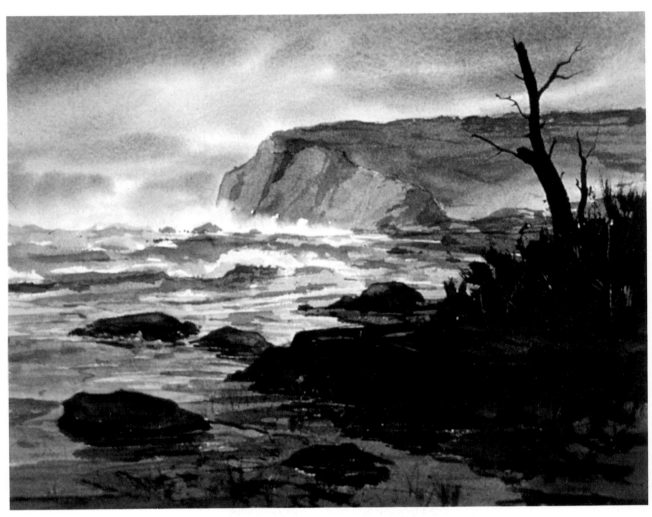

STEP SEVEN

In the final stage of the picture, the artist makes an important change. He decides to strengthen and simplify his composition by extending the rocky foreground from the right-hand corner into the center of the picture. For this dark shape, he uses the same mixtures he's already used in Steps 5 and 6. He also decides to darken and unify the tone of the beach by carrying a cool wash across the sand in the immediate foreground. This is a mixture of cerulean blue, alizarin crimson, and burnt sienna. Now the entire foreground seems cool, wet, more shadowy, and more luminous. To strengthen the contrast between the dark foreground and the paler headland in the distance, the artist places the sharp silhouette of a broken tree in the upper right with a mysterious dark

mixture of phthalocyanine blue and burnt sienna. With this same mixture, he adds strong shadows to the lower edge of the foreground rock formation, more reflections in the wet beach, and small, scattered strokes that suggest additional shoreline debris in the lower left. Moving into the middleground, he scrubs the tops of the rocks with a wet bristle brush and then blots away some of the wet color with a cleansing tissue. Now the rocks seem wet, and their wet surfaces appear to reflect the light in the sky. Mixing cerulean blue, burnt umber, and yellow ochre, the artist creates a shadowy tone that he places selectively on the side of the distant headland. Now you have a clear sense of lights and shadows on the side plane of that massive rock formation. With ultramarine blue, yellow ochre, and a little burnt umber, the artist adds more darks to the waves, strengthening their

shapes and creating stronger contrasts between the lights and darks in the water. Beneath the foam of the breaking wave at the center of the picture, he adds a few touches of shadow with cerulean blue, burnt umber, and plenty of water to make sure that the shadow isn't *too* dark. Finally, he adds a few strokes of beach grass with a pointed brush, and scratches some light lines into the shadowy foreground with the sharp corner of a razor blade. The finished picture is subdued, but full of color. Many of the brightest colors on the palette have been combined to produce all these muted tones, which turn out to be surprisingly rich when you look at them closely.

STEP ONE

Painting a sunny, outdoor subject—perhaps a seascape like this one—will give you an opportunity to use your *full* oil palette to create richer colors. Try a gesso panel; your colors will look lighter and your strokes more distinct. Choosing a color that harmonizes with the overall color scheme, the artist draws the composition with ultramarine blue, subdued with a touch of burnt umber, and diluted with solvent. He uses a big, flat bristle brush to block in the sky with ultramarine blue, cerulean blue, a hint of alizarin crimson, and white—adding more white for the cloud mass.

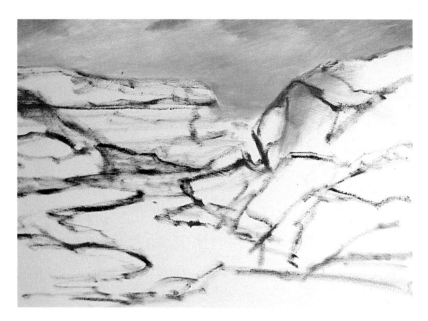

STEP TWO

The open sea normally reflects the color of the sky, and the water is often quite dark at the horizon. The artist indicates the dark, distant strip of ocean with the same mixture that he's used for the sky—but with less white. Where sunlight strikes the end of the headland at the horizon, he applies warm strokes of alizarin crimson and cadmium yellow, subdued with a touch of cerulean blue and lightened with white. The rest of the headland is cool and shadowy; the artist interweaves strokes of the warm, sunny mixture with cooler strokes of the sky mixture. Hints of warm color shine through the cooler shadow tone.

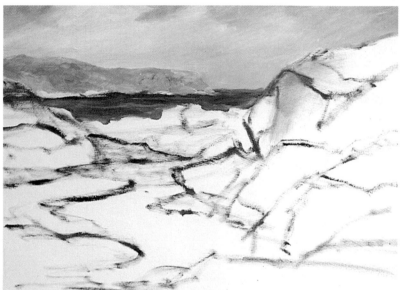

STEP THREE

Picking up his largest bristle brushes, the artist blocks in the dark tones of the foreground rocks. He concentrates on the shadowy areas, leaving bare canvas for the sunlit top of the largest rock. The strokes are various mixtures of alizarin crimson, ultramarine blue, burnt sienna, and white. The warmer strokes contain more crimson, while the cooler strokes contain more blue. On the seashore, the shadows of the rocks often pick up reflected colors from the water, which is why these shadows look so luminous. To increase their luminosity, the artist adds an occasional touch of yellow ochre.

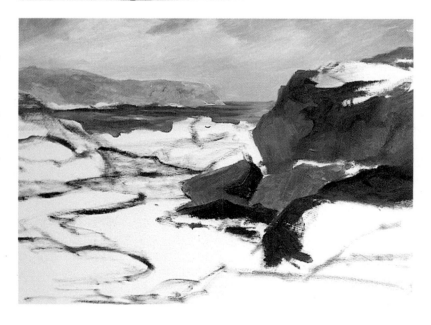

STEP FOUR

He paints the warmer colors of the rocks at the left with various mixtures of cadmium red light, cadmium yellow light, burnt sienna, and yellow ochre, subdued by an occasional touch of ultramarine blue, particularly in the darks. The sunlit tops of the foreground rocks on the right are a mixture of cadmium red light and cadmium yellow light, which produces a stunning cadmium orange. This versatile mixture is easily subdued with a drop of cool color, such as ultramarine blue or viridian, and lightened with white—with an occasional cool note of the sky mixture.

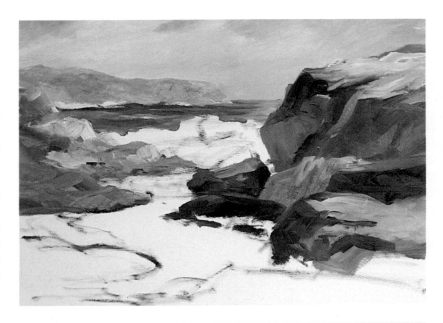

STEP FIVE

The bright, sunny tops of the rocks in the immediate foreground are again painted with cadmium red light and cadmium yellow light, subdued with a speck of ultramarine blue, and lightened with white. The darker tones on the foreground rocks contain more ultramarine blue. Now the entire panel is covered with wet color, except for the foaming water between the rocks, which remains the bare, white surface of the gesso. As you look at the rocks—particularly those at the right—you can see how sharp and distinct the brushstrokes look on the smooth surface of the panel.

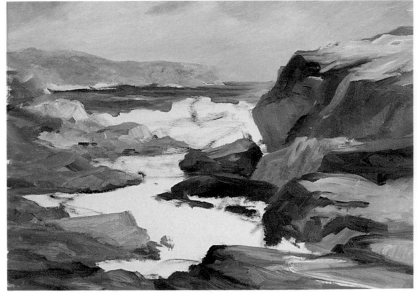

STEP SIX

Like snow, foam isn't pure white. Foam is water mixed with air, so it *behaves* like water, picking up reflected color. Therefore, under a blue sky, foam is apt to contain cool tones, as you see here. The artist paints the foam with big, rough strokes of white, tinted with ultramarine and cerulean blues. Between the rocks, the foam also reflects the warm color of its surroundings, so the artist blends in delicate touches of the rock colors. With each stroke of foam, he varies the proportions of his mixtures, adding more or less white, so the strokes suggest light, shadow, and movement.

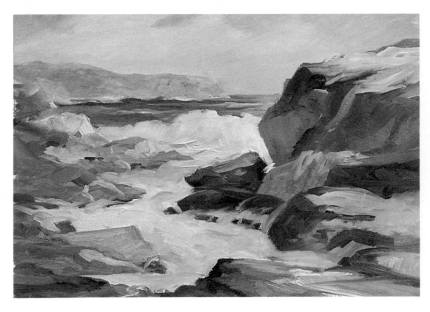

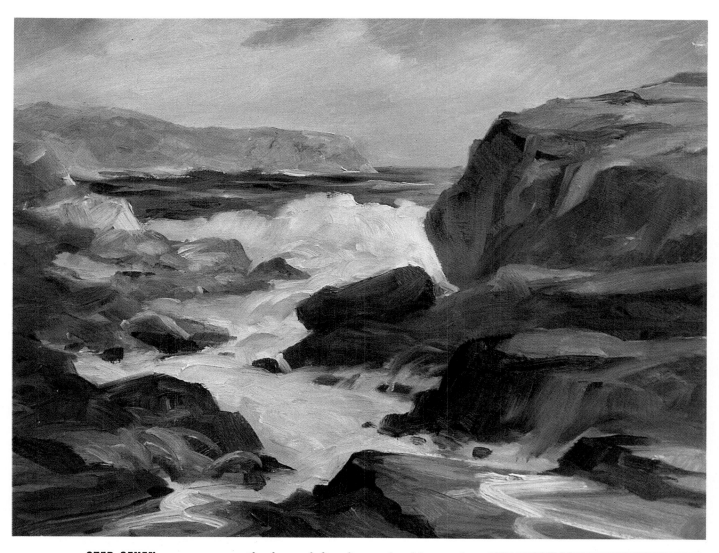

STEP SEVEN

The artist makes some interesting changes in the final stage of the painting. In the lower left-hand corner, he builds up and darkens the rocks, so now they're in shadow. He also strengthens the shadows on the rocks on both sides of the foaming water to dramatize the contrast between the dark rocks and the pale foam. These shadowy tones are various mixtures of cadmium red light, alizarin crimson, ultramarine blue, burnt sienna, and yellow ochre, plus white. Thus, there are warm strokes and cool strokes within the shadows, depending upon whether the mixture is dominated by cadmium red, alizarin crimson, or ultramarine blue. When the shadow tones become darker—as they do in the lower left—ultramarine blue and burnt sienna obviously take command. This mixture strengthens the shadow planes of the sunny rocks at the lower edge of the picture. Now the artist works with small bristle brushes to reshape the rocks and to modify the foam. Notice how he carries trickles of foam over the margins of the rocks and down into the lower left. He also uses the foam mixture to suggest the crests of the waves on the dark sea just below the horizon. Compare the finished rocks in Step 7 with the rocks in their unfinished state in Step 6. See how the rocks have become more shadowy, with the colors flowing more softly together.

KEEP YOUR COLORS BRIGHT

1 *Remember that the ideal mixture contains no more than two or three tube colors, plus white. Add more colors and your mixture may turn muddy!*

2 *Don't overmix your colors on the palette. The more you "stir" them, the less brilliant they become.*

3 *Try mixing with a knife, not a brush, to make bright, smooth mixtures.*

4 *Clean your brush (or knife) often, so traces of old mixtures won't muddy the new ones.*

5 *Keep the white on your palette away from the other colors, so the white won't pick up unwanted tints.*

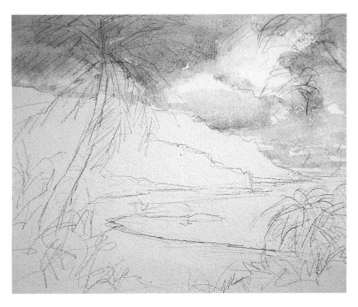

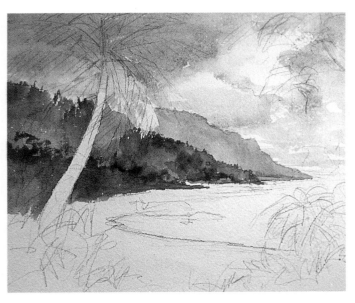

STEP ONE

Painting a colorful landscape in bright sunlight will give you an opportunity to learn more about the range of color mixtures that you can produce with a full watercolor palette. After sketching the composition, the artist begins by painting the sky a brilliant phthalocyanine blue, softened with a touch of burnt umber. For the shadows on the clouds, he adds more burnt umber and a speck of alizarin crimson to warm and subdue the dazzling blue.

STEP TWO

For the distant mountain, the artist again mixes phthalocyanine blue, alizarin crimson, and burnt umber with plenty of water. He renders the nearer, tree-covered slope with small strokes that flow together: ultramarine blue and cadmium yellow for the cooler tones; new gamboge, alizarin crimson, and a hint of ultramarine blue for the warmer tones. And he paints the low, shadowy cluster of foliage with ultramarine blue, alizarin crimson, and yellow ochre.

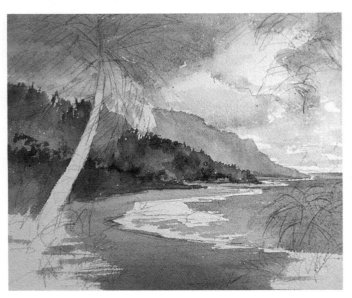

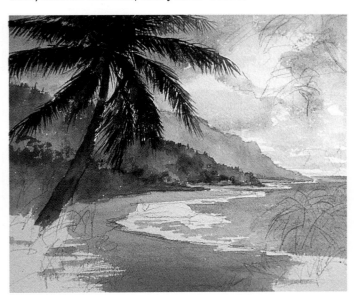

STEP THREE

He paints the water with a mixture of phthalocyanine blue—the same color that appears in the sky—softened with yellow ochre and a touch of burnt umber, plus lots of water. The color stops just short of the beach so that the bare paper will suggest foam. Then the artist carefully blocks in the curving shape of the beach with yellow ochre and burnt umber, adding less water in the foreground and more water as the beach winds around into the middle distance.

STEP FOUR

When the sky, distant mountain, and wooded slopes are dry, the artist begins work on the big palm. First he paints the warm tone of the trunk and the warmer foliage—which you can see under the darker foliage—with ultramarine blue and cadmium orange. When this warm tone dries, he mixes a darker, cooler tone with phthalocyanine blue, new gamboge, and burnt umber. He paints this dark mixture over the warm undertone of the foliage.

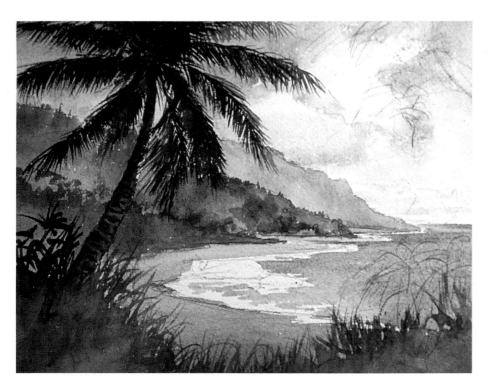

STEP FIVE

Now the artist covers the lower edge of the picture with a greenish mixture of ultramarine blue and new gamboge, warmed with alizarin crimson. He works upward, carrying this mixture over the beach and water with slender, curved strokes that suggest tropical grass, silhouetted against the sunny sand and water. At the left of the palm tree, he adds a few strokes of dark, cool foliage with the same mixture that he used for the dark foliage of the palm in Step 4. These dark strokes blur softly into the wet color of the beach grass at the foot of the tree. Strokes of phthalocyanine blue and burnt sienna suggest shadows and textures on the trunk of the big palm.

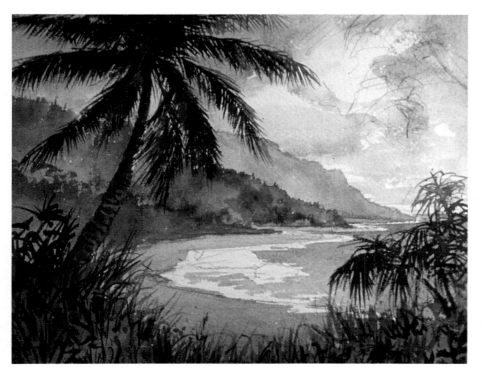

STEP SIX

When the warm foreground tone is dry, the artist blends phthalocyanine blue, yellow ochre, and burnt sienna on his palette to produce a dark, shadowy mixture. Slender, curving strokes of this mixture are built up over the dark undertone of the foreground to suggest dense tropical growth. At the right, the artist adds a cluster of tropical plants with this mixture. Notice how he adds more water for the paler foliage at the top. Just under the big palm, the artist places a few spots of cadmium red, softened with a speck of burnt umber, to indicate tropical flowers along the beach.

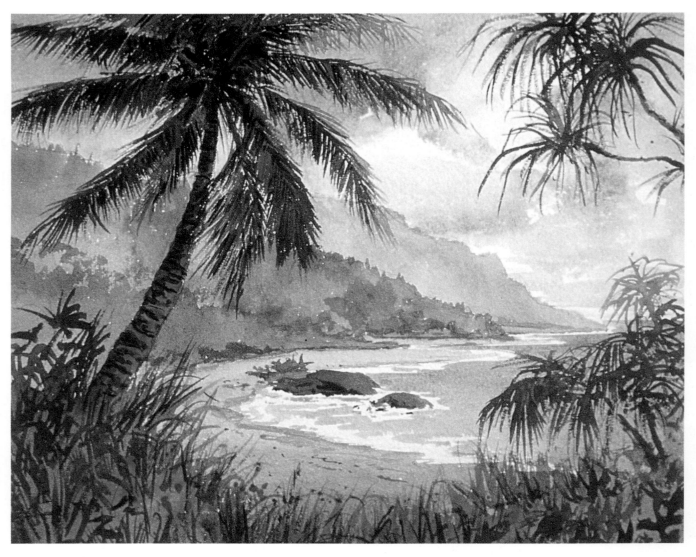

STEP SEVEN

To complete the "frame" of dark foliage around the sunny beach, the artist adds more branches in the upper right corner. These are painted in the same way as the beach grass in the foreground. The artist starts with a paler, warmer mixture of ultramarine blue, cadmium yellow, and burnt sienna, lightening this tone with water. When these first strokes are dry, he completes the branches with a darker, cooler mixture of phthalocyanine blue, new gamboge, and burnt sienna. With this same dark mixture, he thickens the shadowy foliage of the big palm and adds more dark strokes to accentuate the texture and detail of the trunk. The dark shapes of the rocks in the water are finally painted with ultramarine blue, new gamboge,

and a little cadmium red—with more ultramarine blue for the small strokes of shadow. The artist dilutes this mixture with water to strengthen the edge of the beach where it meets the ocean. Tiny strokes and dots of the rock mixture are scattered along the beach to suggest shoreline debris, such as pebbles and seaweed. A few more wildflowers are added among the foreground foliage with cadmium red and a slight touch of burnt umber.

USE BRIGHT COLORS SELECTIVELY

1 The fact that you have the full palette at your disposal doesn't mean that you must fill every inch of the painting with bright color. Too many bright colors cancel each other and confuse the viewer.

2 Before you begin to paint, decide where the bright colors should go and where the quiet colors belong.

3 Save your brightest colors for important

places, such as the center of interest.

4 Dramatize these bright colors by surrounding them with subdued color or by placing muted color nearby.

5 Make sure that these bright color areas don't leap out of the painting. Don't hesitate to subdue a color area that looks too bright.

STEP ONE

Now the artist demonstrates using the full range of acrylic colors to paint a sunny landscape. On thick illustration board coated with acrylic gesso, the artist draws the main shapes in pencil. He draws the surrounding rocks with care, since these define the edges of the stream. With a big bristle brush, he blocks in the cool upper sky with cerulean blue, yellow ochre, and white. He strokes warm shadows on the undersides of the clouds with yellow ochre and white, plus a speck of cerulean blue. For the sunlit areas of the clouds, he uses *almost* pure white, tinted with the shadowy mixture.

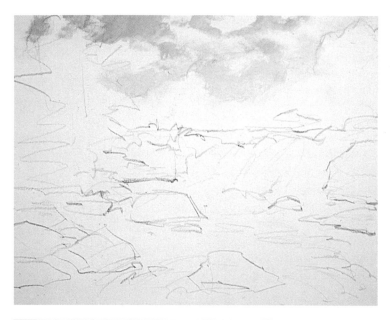

STEP TWO

The artist paints the deep tones of the trees at both sides of the painting with a thick mixture of phthalocyanine blue, burnt sienna, and yellow ochre, with just enough water for a pasty consistency. He then drags the bristle brush across the surface with ragged strokes that suggest the texture of the foliage. On the far shore, between the two masses of dark trees, the artist paints the pale trees with cadmium yellow light, cerulean blue, and lots of white—with a dark patch of cerulean blue, cadmium yellow light, burnt umber, and white to indicate the tone of the shadow beneath the trees.

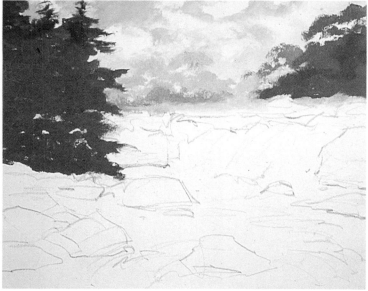

STEP THREE

With a slender bristle brush, the artist paints the cool tones of the water with varied mixtures of ultramarine blue, cerulean blue, a little naphthol crimson, and white. The darkest blue strokes contain more ultramarine blue; the paler blue contains more cerulean blue and white; and the warmer strokes contain more crimson. The colors are diluted with enough water to produce a thin, milky consistency, and the mixture is scrubbed thinly over the illustration board to suggest the lively, foaming action of the water. The direction of the strokes follows the movement of the water.

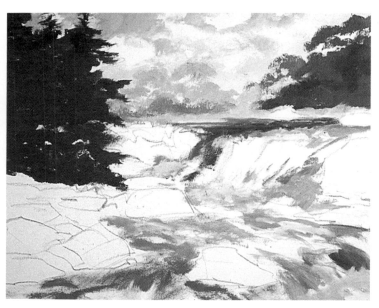

STEP FOUR

Having preserved the pencil outlines of the rocks, the artist now blocks in their color. The sunlit tops of the rocks are mixtures of cadmium red light, cadmium yellow light, burnt sienna, and white. The warm shadows on the sides of the rocks are burnt sienna, cadmium red light, ultramarine blue, and white, with an occasional touch of yellow ochre. And the strong darks along the lower edges are phthalocyanine blue, burnt sienna, and a slight hint of cadmium red light. The paint is thinned with acrylic medium and water to a creamy consistency that lends itself to broad, solid strokes.

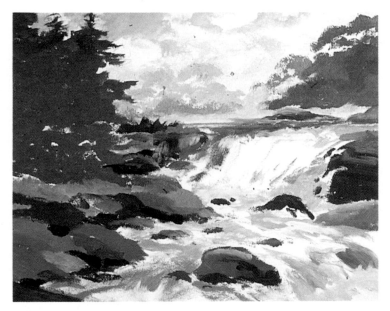

STEP FIVE

Now the artist works on the water with strokes of white, blended with acrylic gel medium to produce thick strokes that will stand up slightly and retain the imprint of the brush. He tints the thick white with small amounts of cerulean blue and an occasional touch of ultramarine blue to vary the values of his strokes. Where the foam is most dense, the white is thickest and the brushstrokes are roughest. The strokes follow the movement of the water down the waterfall and over the rocks toward the lower right. The original blues still shine through.

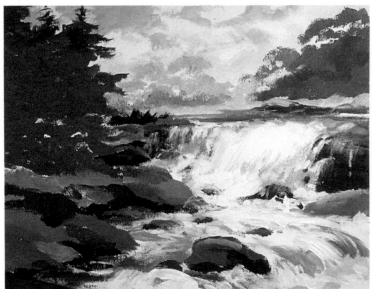

STEP SIX

Within the dark mass of foliage at the left, the artist adds deep shadows with phthalocyanine blue, burnt sienna, and a speck of cadmium red light. He dips a pointed softhair brush into this mixture—adding a bit of white—to draw pale trunks and branches against the dark foliage on either side of the stream. Beneath the dark trees at the left, the artist places a shadow on the rocks by repainting the tops with phthalocyanine blue, yellow ochre, and burnt sienna. Beneath the far shore, the artist drybrushes a thick stroke of white, faintly tinted with cerulean blue, to suggest sunlight on the water.

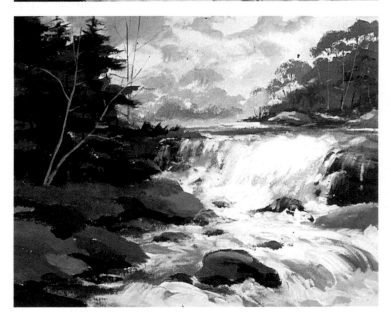

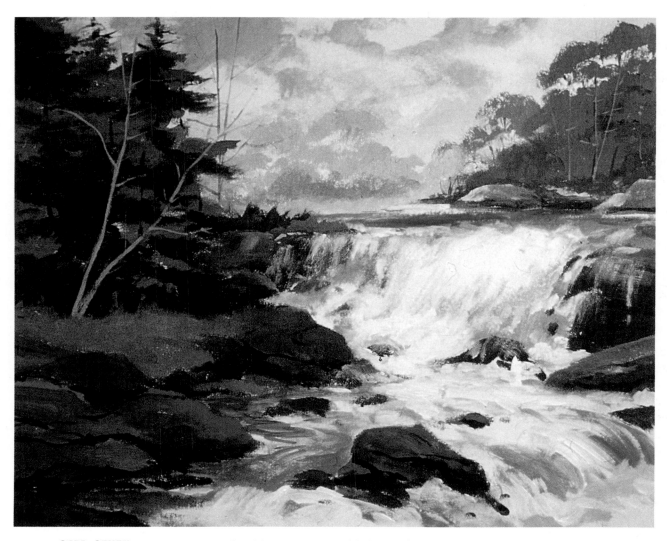

STEP SEVEN

In this final stage, the artist concentrates on the details of the rocks and the water in the foreground. With a sharply pointed softhair brush, he draws the dark divisions between the rocks themselves and the cracks in the rocks with precise strokes of phthalocyanine blue and burnt sienna, diluted with liquid painting medium and water to produce the right consistency for precise brushwork. Suddenly, the broad masses of color in Step 6 are transformed into realistic rocks. Beneath the warm shapes of the rocks, the artist places strokes of this dark mixture to reinforce the shadowy edges of the rocks in the water. In the foaming water beneath the rocky shore at the left, the artist places thin, swirling strokes of phthalocya-nine blue, warmed with burnt sienna and lightened with a touch of white, to suggest the reflections of the trees. The erratic brushwork indicates that these reflections are broken up by the movement of the stream. The artist brightens the foam in the foreground with carefully placed, thick strokes of white—faintly tinted with cerulean blue. As you review the seven steps in this demonstration, you'll see that the mixtures contain most of the bright *and* subdued colors on the palette. The completed painting is filled with color and with sunlight, but no garish mixtures leap off the painting surface. Each color stays in its place, as it does in the natural landscape.

CONTROL COLOR BY CONTRAST

Mixing bright colors on the palette isn't the only route to bright color. Remember these methods for controlling color by contrast:

1 A bright color looks brighter when you place it alongside its complement. (Blue looks more vivid if there's orange nearby.)

2 A subdued color also looks brighter if its complement is nearby. (A quiet green looks more intense if it's side-by-side with an even quieter red.)

3 Any color—bright or not-so-bright—will look more intense if the nearby colors are much more subdued. Those nearby colors don't have to be complements. A quiet yellow will become a sunny yellow if you surround it with a very quiet green.

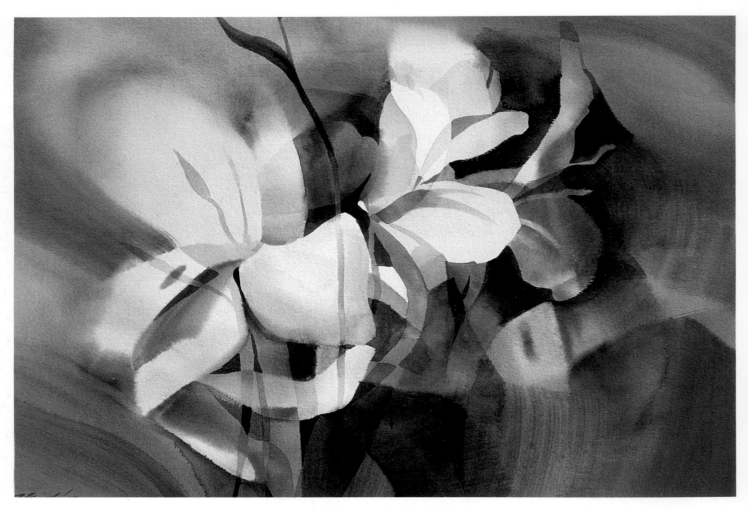

WHITE CHORUS
by Zoltan Szabo, watercolor, 22″ × 30″

White is really the brightest color of all because it's pure light. For this reason, watercolorists have a particular love for their white paper and plan their pictorial designs with great care to "reserve" and work around those areas of paper that they plan to leave untouched. In this dramatic floral closeup, the artist surrounds the blossoms with an intricate pattern of warm and cool colors—one color glazed over another—that's lively and fascinating in itself, but never upstages the white areas. The white blossoms reflect the surrounding colors, especially in the shadows on the petals, but these reflections are always delicate—and pure whites sing out against the surrounding darks.

PART SEVEN
COLOR
STRATEGIES
GALLERY II

STILL LIFE WITH LOBSTER

by Gregg Kreutz, oil on canvas, 30" × 40"

The still life objects emerge from a dark background, but this darkness is transparent, with hints of light and color. As Leonardo pointed out, darks are just areas that receive less light. The colors of the still life objects echo one another. The red of the lobster is repeated in the more subdued reds of the fruit. Yellow notes are placed near the lobster, on the brass pot, and in the basket. The reflected colors are most fascinating; every shadow picks up colors that appear elsewhere in the picture. The artist works with a lot of transparent color, which gives the painting an extraordinary inner glow.

EGGPLANT

by Thomas S. Buechner, oil on canvas, 12" × 16"

The radishes are dramatized in two ways: the red shapes are contrasted with the complementary green of the stems and leaves—a quiet green that doesn't steal attention from the red; and there's a contrast in value: the lighter shapes of the radishes are placed against the dark background of the eggplant. The eggplant contains reflections of both the red and the green. And the wall is one of those "grays" that's hardly a gray at all, but full of light and very subdued color.

Private collection

THE PIAZZETTA

by Bernard Dunstan, oil on board, 14½″ × 9½″

This quiet painting, almost monochromatic when you first
look at it, is filled with color. In fact, you keep discovering
color *within* color. The artist brushes one wet stroke over
another wet stroke, warm color over cool, and cool color
over warm. The underlying color always peeks through. This
"broken color," as it's often called, creates a magical feeling
of atmosphere and shimmering light, even when you're
painting a gray day. An overcast day is never colorless. The
color is simply more subdued and demands closer obser-
vation.

ANOTHER SPRING

by Harvey Dinnerstein, oil on canvas, 60" × 78"

The color strategy is surprising and fascinating. The artist surrounds the neutral color of the architecture with the brighter color of the landscape. But then the powerful value contrast of jagged light and shadow draws your eye down into the tunnel, where you look into the mysterious darkness. The more you look into the darkness, the more color you see: a flash of warm color and suggestions of architectural detail within the luminous shadows. Notice the spotlit floor within the tunnel. This bright light makes the tunnel look even darker.

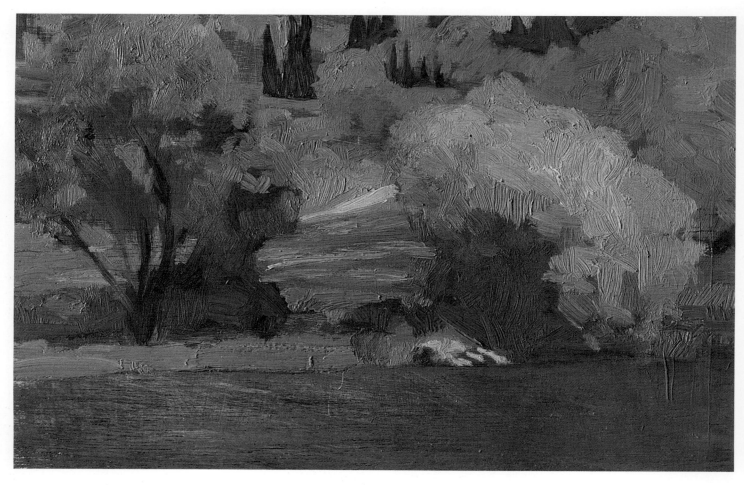

POPPY FIELD

by Daniel Bennett Schwartz, oil on board, 7½" × 12"

Through a break in the green landscape, your eye travels to
the hot color of the field of poppies, which appears at the
focal point of the painting and again at either edge. But to
call this a "green" landscape is an oversimplification. It's a
remarkable study in *greens*. As you scan the painting, you see
greens that contain more yellow or more blue; olive greens
that lean toward brown; and shadows within the trees, rang-
ing from deep olive to an unexpected purple. A summer land-
scape always runs the risk of looking like a monotonous
green salad. The secret is to discover — or invent — a variety of
greens, as the artist does here.

WILDFLOWERS, DONEGAL

by Morton Kaish, oil on canvas, 44″ × 48″

It's an ambitious job to control this much color and detail. The artist holds all this richness together by interweaving the green and brown background tones throughout all the other colors. He also interweaves the yellow — the color of the center of interest — through many other areas of the pictorial design. He continues this interweaving process with all the less obvious colors: although there are *clusters* of blue, pink, and violet flowers, tiny notes of these colors constantly reappear elsewhere. And the artist also knows that the design needs one quiet place: the dark corner in the upper right.

ABOVE GULL ROCK

by Don Stone, oil on canvas, 12" × 16"

When you paint a winter landscape—a scene with lots of snow or ice—it's essential to remember that snow and ice are just water. And like water, they have very little color of their own, but reflect the surrounding colors. This wintry coastal scene is instructive because it shows both the distant sea and the snow in the foreground. They all reflect the dim, cold tone of the overcast sky. The values vary from the brighter snow in the foreground to the dark sea in the distance. But they're *all* water. And they *all* reflect the same atmospheric color. To provide a foil for all this wintry color, the artist adds a few touches of warmth to the snowy field.

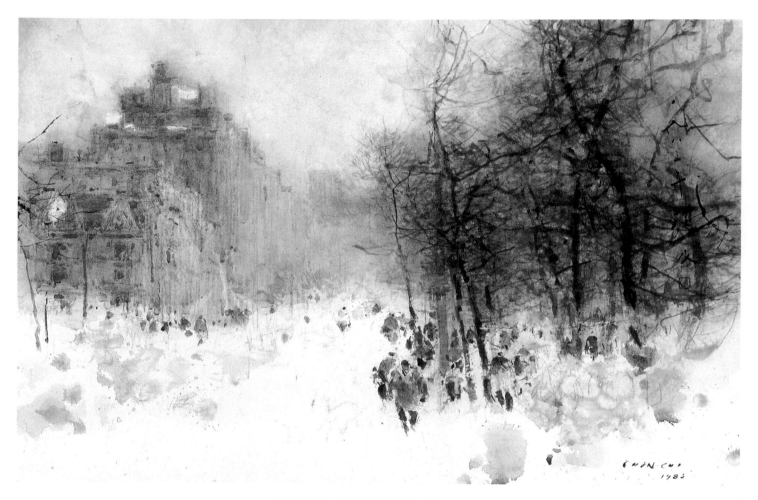

SNOW ON FIFTH AVENUE, NEW YORK

by Chen Chi, watercolor, 17" × 27"

Although a snow scene tends to be monochromatic, a warm color scheme can be just as effective — and just as accurate — as a cool one. In this delicate, mysterious winter cityscape, the golden tone of the overcast sky sets the overall tone of the landscape. Thus, the buildings and trees are painted in browns, beiges, and golds. A warm painting needs a few cool notes — just as a cool painting needs a few warm ones — so the artist introduces a few touches of blue and mauve. These cool mixtures appear in the distant buildings at the horizon and among the figures in the foreground. The whites of the snow are bare paper, with touches of shadow that echo the tones of the trees and sky.

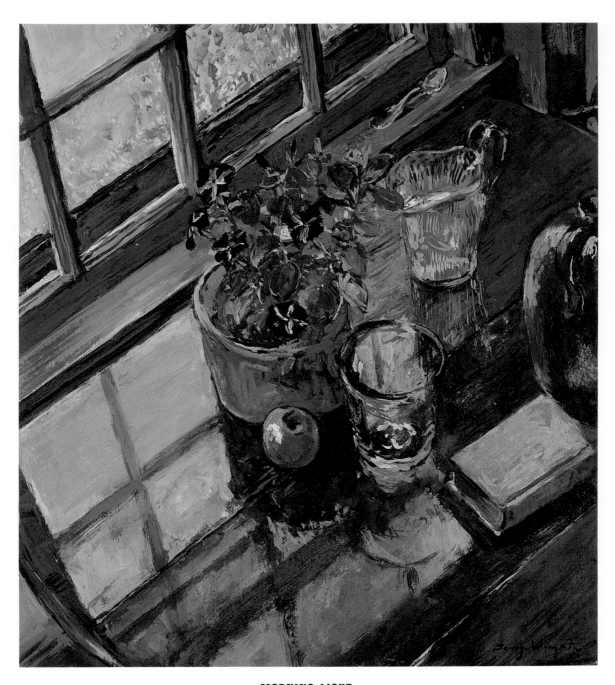

MORNING LIGHT

by George Wingate, oil on board, 6¾″ × 6″

This miniature still life — reproduced actual size — is filled with the silvery color of the early morning light on one particular day. The light moves through the painting and unifies the entire design, touching every object: the windowframe, the shiny countertop, and the still life itself. Wingate paints directly from nature and tries to finish in a few hours, so that he captures the unique character of the light. The lesson, once again, is that light and color are inseparable. Light has a specific color — which you must observe and try to record faithfully.

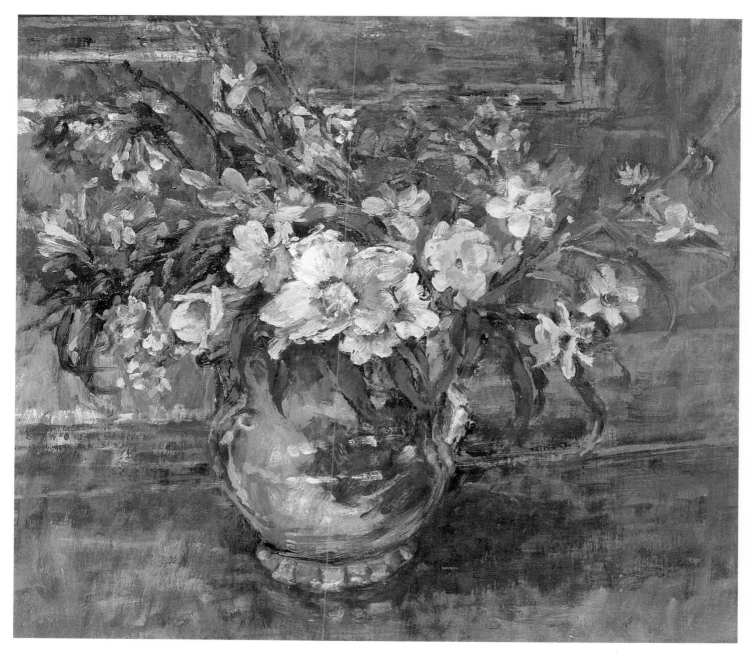

CHRISTMAS FLOWERS ON THE PIANO, LLWYNHIR
by Diana Armfield, oil on board, 10½″ × 12¼″

The artist accentuates the sunny color of the yellow flowers by surrounding the blossoms with the subdued greens of the leaves and very quiet background mixtures. The smaller blossoms—red, pink, and white—act as a foil for the yellow blossoms, but don't compete. Study the action of the reflected colors. The colors of all the flowers reappear in the vase. And every color in the painting is woven into the wall and the tabletop. These reflected colors are based on observation, of course, but the artist also decides that a specific color is *needed* at a specific place—and puts it there.

Photo courtesy Browse & Darby, London

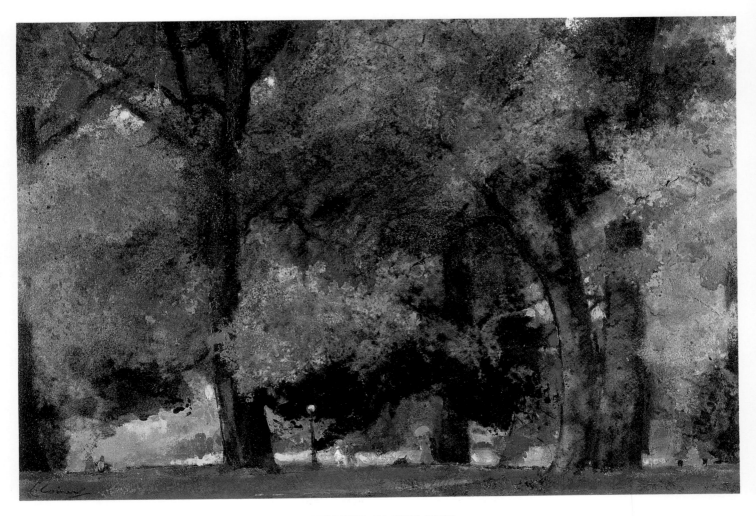

MEMORIES OF HYDE PARK

by Charles Coiner, oil on canvas, 30" × 44"

The profusion of cool color in the foliage is beautifully balanced by the bold warm notes of the trunks and the ground — but there are also some small notes of warm color that are less obvious, but equally important. The tiny touches of warm color in the figures are a classic device in landscape painting. But notice how these warm colors are echoed in the dark shadows on the trunks and in the strips of shadow on the ground. Nor is the foliage a single monotonous green, but a tapestry of blue-greens, yellow-greens, blackish greens, and other mixtures.

Private collection. Photo courtesy Midtown-Payson Galleries, New York

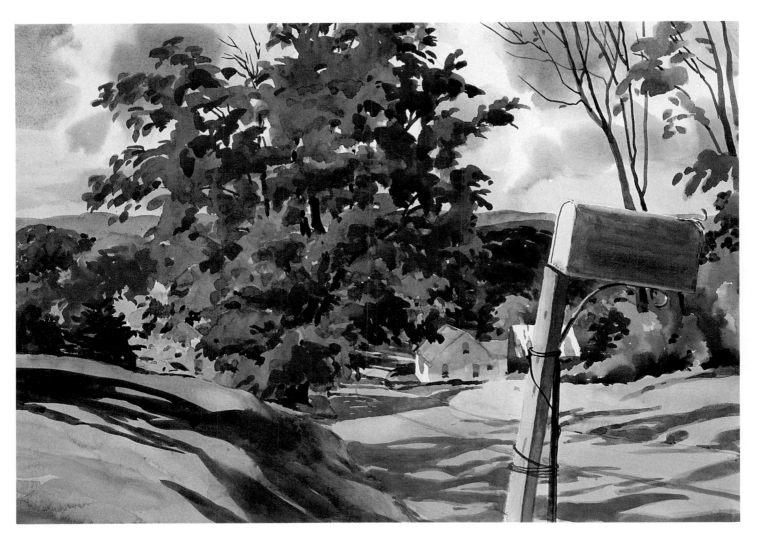

LOOKING WEST TO AMHERST

by Carl Schmalz, watercolor, 15" × 22"

Just as a summer landscape runs the risk of drowning in
greens, an autumn landscape runs the risk of overwhelming
the viewer with hot color. The artist creates a handsome bal-
ance of warm and cool, surrounding the red tree with cool
sky tones that break through gaps in the foliage and then
reappear in the road, the house, and the mailbox; placing
his other warm notes among greens and yellow-greens; and
unifying the picture with crisp strokes of colorful darks. Here,
as in so many successful paintings, the key to unified color is
repetition — the intertwining of the same colors throughout
the picture.

Private collection

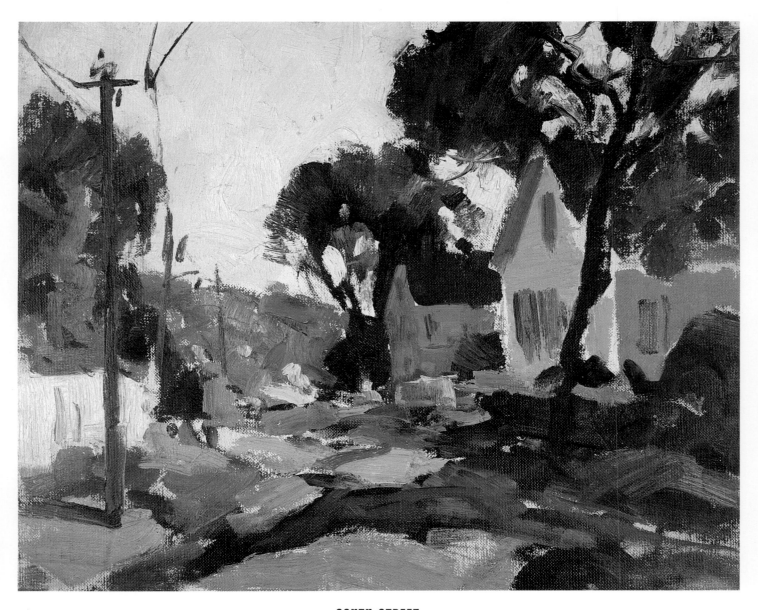

SOUTH STREET

by Charles Movalli, oil on board, 16″ × 20″

Working outdoors under pressure, the artist has very little time to linger over his color mixtures. Movalli turns this pressure to an advantage in his way of mixing color. He mixes the colors on his palette swiftly and casually, not always blending them thoroughly, but just enough to approximate the color he wants. Then, when he brushes this mixture onto the painting surface, the stroke often seems to contain two or three tube colors that blend in the viewer's eye, but not quite. Movalli also paints one wet stroke over another so that a casual mixing process takes place on the painting itself. The result is a wonderful vibrancy and richness that can't be achieved by methodical mixing and smooth blending.

MORNING MIST

by James Reynolds, oil on canvas, 12" × 16"

This small canvas is another striking example of the rich, shimmering color that can be achieved by loose color mixtures on the palette and wet-in-wet brushwork on the painting surface. Look carefully at the glowing color in the foreground and you'll see that virtually every stroke seems to contain multiple colors because the tube colors are just barely blended on the palette *and* because the artist paints wet-into-wet, allowing the underlying strokes to shine through. This picture also reveals the special intensity and freshness of *impasto* painting: strokes of thick, juicy color that are applied quickly and allowed to retain the texture of the brush.

Photo courtesy O'Brien's Art Emporium, Scottsdale, Arizona

SUMMER

by Chen Chi, watercolor, 52" × 26"

*A monochromatic color scheme — which really means a painting in a limited
color range — doesn't have to be in grays or browns. Here's a rich landscape
that seems to be painted entirely in greens until you study it carefully and see
how the artist has masterfully interwoven touches of yellow, blue-green, and
warm and cool grays. Despite the limited color range, every inch is filled with
lively constantly changing color.*

PART EIGHT
ADVANCED PAINTING METHODS

STEP ONE

The old masters often painted in separate operations, called *underpainting* and *overpainting*: painting the whole picture in gray or brownish gray, then adding color when this underpainting has dried. Here, the artist starts the underpainting with a mixture of ultramarine blue, burnt umber, and white.

STEP TWO

He completes the monochrome underpainting with this same mixture, adding varying amounts of white and diluting his oil colors with the simplest painting medium: a 50-50 mixture of linseed oil and solvent. The finished underpainting is a study in values, like a black-and-white photograph.

STEP THREE

The underpainting is dry. He switches to damar medium, adding lots of it to make his color transparent. Then he *glazes* cadmium red, alizarin crimson, and burnt umber over the wall; yellow ochre and burnt sienna over the table; and cadmium red and cadmium yellow over the covered pot.

STEP FOUR

The cucumber is glazed with ultramarine blue and cadmium yellow, while a bright glaze of cadmium red and alizarin crimson goes over the tomato. The cucumber remains dark and subdued because of the dark underpainting. But the vivid red glaze really sings out on the pale underpainting of the tomato.

STEP FIVE

In this final stage, the artist glazes the pepper with cadmium yellow light and ultramarine blue. He glazes the orange with cadmium red light and cadmium yellow light, plus a tiny hint of white that makes the glaze semitransparent rather than absolutely transparent. The small jar and the knob on the top of the big jar are both glazed with cerulean blue. The drapery is glazed with a delicate mixture of ultramarine blue and alizarin crimson, with lots of painting medium. The artist then adds a small amount of white to each of the glaze mixtures and adds more touches of light to each object. You can see these touches most clearly on the pepper, orange, and tomato. He brushes burnt sienna over the sliced mushroom in front of the tomato; uses a rag to wipe away some wet color from the lighted edge of the table; darkens the shadow side of the big pot and the round indentation on the side of the pot; and wipes away some of the glaze on the big pot to suggest cool reflections.

REMEMBER THESE STEPS

1 *Sketch the main forms with a neutral mixture of blue and brown. Paint the entire picture in various values of this mixture. Use more white for lighter values.*

2 *Keep this underpainting slightly lighter than you want the finished picture. The glazes will make the picture darker.*

3 *When this monochrome (or grisaille) underpainting is bone dry, mix your tube colors with a resinous painting medium and begin to glaze these colors over the forms. Start out with thin, pale colors.*

4 *Gradually build up the color by glazing darker, richer mixtures over the original glazes. To strengthen the lights, add a touch of white to the final glazes that go over the highlights.*

STEP ONE

So far, the watercolor demonstrations have shown the *direct* technique, where each color is mixed separately on the palette and applied directly to the paper. But the British old masters of watercolor perfected a method using a monochrome underpainting and starting with a precise pencil drawing that defines the light and shadow planes as shown. The artist mixes a warm, neutral tone with burnt umber and ultramarine blue, plus plenty of water. This is applied to everything except the lightest planes, and left to dry. Now we have the lights (the white paper) and the pale middletones.

STEP TWO

The artist locates the darker middletones. He covers these areas with a second wash of the same mixture that he used in Step 1. Because these areas now contain two separate washes, they're twice as dark as the tone that covered the paper in the first step. When the second wash is absolutely dry, he locates the darks and blocks in these areas with a third wash identical in tone to the first two washes — or perhaps just a bit darker. When the third wash is dry, the artist has a complete rendering of the pattern of light and shade on his subject in four values: light, two middletones, and dark.

STEP THREE

So far, the artist has established forms and indicated light and shade. Now he can concentrate on color. He washes pure ultramarine blue over the sky and the rocky shadow shapes to cover just the darks and the darker midtones. This cool wash also covers the distant rock formation at the left. When the blue wash is dry, he runs a warm wash of cadmium red, burnt sienna, and yellow ochre over the distant rock formation. He reinforces the shadows with ultramarine blue and alizarin crimson. He works with bright, clear color since these mixtures become subdued as they travel over the monochrome underpainting.

STEP FOUR

The artist begins to warm the foreground with a pale wash of new gamboge and cadmium red. When this golden tone dries, he enriches parts of the foreground with a stronger, brighter version of the same mixture, containing more cadmium red and a touch of burnt sienna. On the dried washes that cover the foreground, the artist begins to suggest some desert plants with dark patches of ultramarine blue and cadmium orange.

STEP FIVE

The artist carries the warm foreground tone—new gamboge, cadmium red, and burnt sienna—up over the big rock formation with rough, irregular strokes that suggest the texture of the rocks. This tone immediately warms the lights, middletones, and darks on the rock. In the foreground, the artist develops the desert growth with a series of pale strokes of ultramarine blue and cadmium orange. When these strokes are dry, he adds darker strokes of the same mixture.

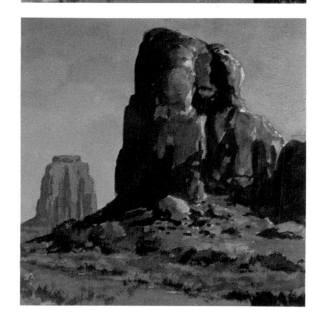

STEP SIX

Mixing a dark wash of ultramarine blue and burnt sienna on his palette, the artist deepens the shadow on the big rock formation and on the slope with bold, decisive strokes. Smaller strokes of this same dark mixture are used to suggest cracks in the rocks, and to indicate boulders on the ground. A few more touches of warm color are added to the lighted planes of the massive rock formation with new gamboge, cadmium red, and burnt sienna. The color of the slope at the foot of the rock is also intensified by a few strokes of this mixture.

STEP SEVEN

With a dark mixture of ultramarine and burnt sienna, the artist adds more cracks and other details within the big rock formation. These slender strokes appear not only in the lighted areas, but also within the shadows. He cools some of the middletones in the rocks with a pale wash of ultramarine blue. He suggests more boulders and pebbles with tiny, dark touches of ultramarine blue and burnt sienna. He spatters some of these dark flecks onto the paper with a wet brush that's shaken over the surface. With this mixture, he strengthens the shadows beneath the desert plants in the foreground. At the last minute, the artist decides that the ragged strip of desert plants needs to be cooler, so he brushes them with a pale wash of ultramarine blue and new gamboge.

The shadows of the distant rock formation are accented with darker strokes of ultramarine blue, alizarin crimson, and burnt sienna.

TIPS FOR MONOCHROME UNDERPAINTING

1 Keep the values paler than you want them to be in the finished picture. The darkest areas should be middletones. A pale underpainting is important for two reasons: The color washes make everything darker; and the color won't show over a too-dark underpainting.

2 "Reserve the lights," that is, leave bare paper for the lightest areas of the underpainting. The color washes will make these "reserved lights" sing out.

3 Build up your colored washes in gradual stages, so you can keep the painting under control. Use two or three pale washes in succession to paint a dark area. Don't try to do it in one dark wash.

STEP ONE

Now try a color underpainting in acrylic. After making a pencil drawing on watercolor board, the artist underpaints the trees at the left with cadmium orange and cadmium red, adding more red for the ground. He paints the sunny foreground with cadmium red and yellow ochre; the sky with yellow ochre and burnt sienna—leaving bare paper for clouds; the dark foliage at the right with phthalocyanine green and burnt sienna; and the mountain with naphthol crimson and utramarine blue—adding more blue for the water.

STEP TWO

Over the finished underpainting, he glazes cerulean blue, ultramarine blue, and white, diluted with water, over the sky—adding more water at the horizon. He brushes a thicker mixture of ultramarine blue, naphthol crimson, and white over the mountain. And he loosely brushes cadmium orange, cadmium yellow, and burnt sienna over the dark foliage at the right, behind the trunks. The resulting optical mixture is a fascinating interplay of warm and cool tones. Gaps of yellow sky tone are left untouched—for leaves.

STEP THREE

Phthalocyanine green and ultramarine blue are glazed over the foliage at the left to make another warm-cool optical mixture. The artist adds burnt sienna to this glaze, for the ground beneath, and for the opposite shore. With rough strokes, he carries a glaze of phthalocyanine green, ultramarine blue, a little burnt sienna, and lots of water (for transparency) over the sunny underpainting of the foreground, so that the bright color shines through.

STEP FOUR

The trunks are loosely brushed with burnt sienna, ultramarine blue, yellow ochre, and white—with more ultramarine and burnt sienna in the shadows. The sunlit water is cerulean blue and white, while the dark reflections are burnt sienna, phthalocyanine green, and a little ultramarine. At the top of the picture, the sunny underpainting of the foliage is glazed with cadmium yellow and cadmium red. At this stage, the artist is working with slightly thicker color, so he switches from water to liquid painting medium.

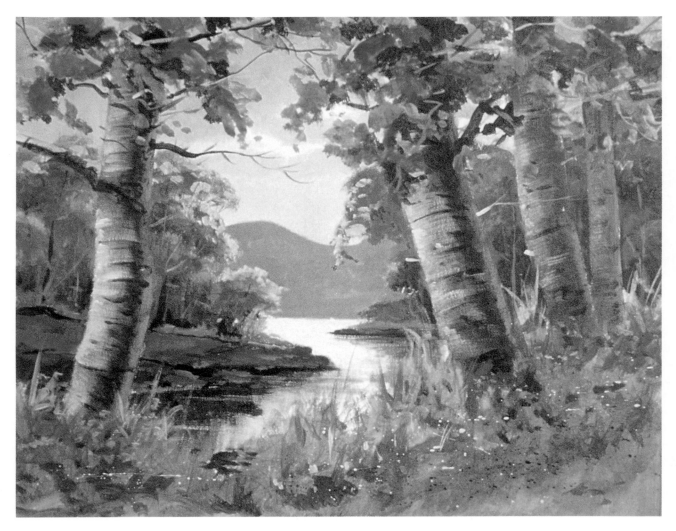

STEP FIVE

The artist adds trunks, branches, and touches of shadow to the distant foliage with a dark, transparent mixture of phthalocyanine blue and burnt sienna. He also uses this tone to sharpen the edges of the shoreline. He brushes ultramarine blue and burnt sienna over the shadow areas of the trunks, and builds up the lights with strokes of yellow ochre and white. The same mixture of yellow ochre and white reappears in the slender strokes that suggest sunstruck branches on the foreground trees and sunstruck leaves in the distant foliage. Now the artist adds dark touches of shadow and more branches to the sunny foliage at the top of the picture with strokes of phthalocyanine blue and burnt sienna. Then he concentrates on the texture and detail of the foreground. The dark strokes among the tangled grass are made with glazes of ultramarine blue and cadmium yellow light, with an occasional touch of burnt sienna, diluted with plenty of acrylic medium so that the color remains transparent and allows the sunny underpainting to shine through. The bright grass—caught in the sunlight and silhouetted against the dark background—is painted with cadmium yellow light and white, plus a drop of ultramarine blue. He adds a few touches of bright sunlight to the foreground leaves with carefully placed strokes of cadmium yellow light and cadmium orange.

WHEN THE OVERPAINTING GOES WRONG

To keep things under control, add a little color at a time. But just in case . . .

1 When a glaze is too dark or the wrong color, try scumbling a pale color over it. The optical mixture may give you the right color or value.

2 If a scumble is too light or the wrong color, try glazing another color over it. The optical mixture may give you the right color.

3 If these optical mixtures won't work, mix an opaque color that approximates the original underpainting. Cover the unsuccessful passage with this mixture. Try the overpainting again.

4 If all else fails, block out the unsuccessful passage with acrylic gesso, so you're back to the original white surface.

STEP ONE

Now that you've experienced building a watercolor over a monochrome underpainting, you'll enjoy working with an underpainting in full color. This can be a splashy, spontaneous way of working. The artist begins with a loose pencil drawing, indicating the trees, mountain, and stream quickly and simply. He brushes a rough wash of cerulean blue over the distant mountain, stopping at the trees and letting his brushstrokes show. When the cool underpainting of the mountain is dry, he paints a strip of new gamboge, softened with yellow ochre, over the distant shore.

STEP TWO

Above the warm strip of the distant shore, the artist brushes in short strokes of ultramarine blue and a little alizarin crimson to underpaint the dark trees. On either side of this cool, dark underpainting, he brushes new gamboge and a little burnt umber to underpaint the masses of foliage. He uses this same warm mixture for the shore in the foreground, carrying the warm tone into the water to show reflected color. While the water area is wet, he brushes in a strip of cerulean blue; the two wet colors fuse softly. The artist underpaints the foliage in the lower left with a warm wash of ultramarine blue and alizarin crimson.

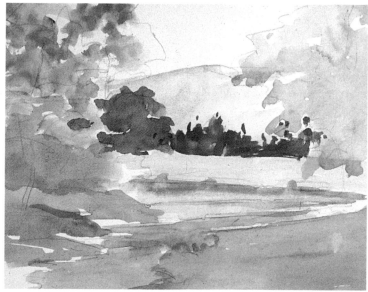

STEP THREE

The artist runs a pale wash of alizarin crimson over the cool underpainting of the distant mountains. The two washes merge to form an optical mixture that's warmer, but still remote. When the mountain is dry, the artist brushes rough strokes of new gamboge and a little burnt sienna over the dark, cool underpainting of the trees on the far shore. He adds just a touch of cadmium orange to the mixture to paint the big, dark tree in the background. Both the cool and warm overpaintings merge to form a dark, warm, optical mixture that seems to contain cooler shadows.

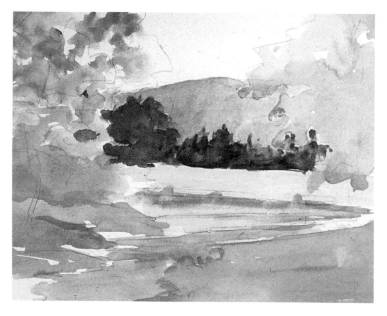

STEP FOUR

The complex form of the tree at the extreme left is overpainted with strokes of alizarin crimson, softened by ultramarine blue and burnt sienna. This dark mixture is carried into the water to suggest the tree's reflection. The mixture is deepened and subdued with a little more ultramarine blue and diluted with more water to overpaint the distant trees. Diluted with still more water, this warm mixture is carried into the stream—to form optical mixtures with the tones already there. The shadowed leaves on the right-hand tree and its dark base are defined with alizarin crimson.

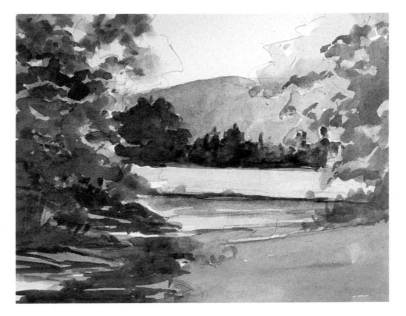

STEP FIVE

In the lower left, the artist builds up the shadows in the foliage—and the reflections in the stream—with dots and dashes of burnt sienna and ultramarine blue. Along the sunny shore beyond the stream, he adds bushes with ultramarine blue and cadmium orange—repeated in the water to indicate reflections. The artist begins to develop the grass in the lower right with short, scrubby strokes of pale cerulean blue, followed by pale, warm strokes of alizarin crimson and burnt sienna. A few strokes of this warm mixture suggest pale middletones on the tree at the right.

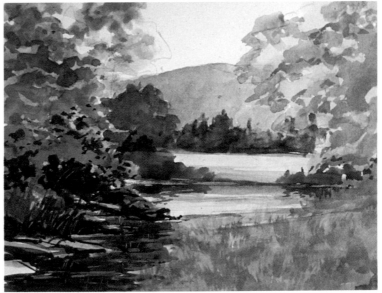

STEP SIX

He brushes cerulean blue over the sky, stopping short of the mountain to let the undertone come through. The artist darkens the bushes on the far shore and their reflections with ultramarine blue and burnt sienna. The stream is cooled with pale cerulean blue that continues to the left. The artist darkens this corner with ultramarine blue and burnt sienna, and then scrubs out the flat rocks with a wet bristle brush. He warms the big trees at either side, plus the grassy field in the foreground, with alizarin crimson softened with ultramarine blue and burnt sienna. Then he scratches weeds out of the wet color with the brush handle.

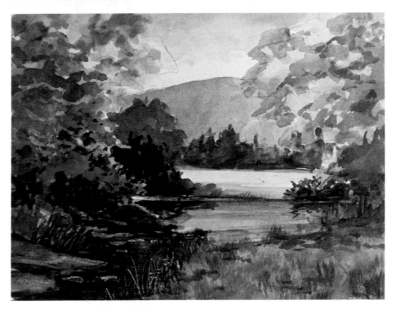

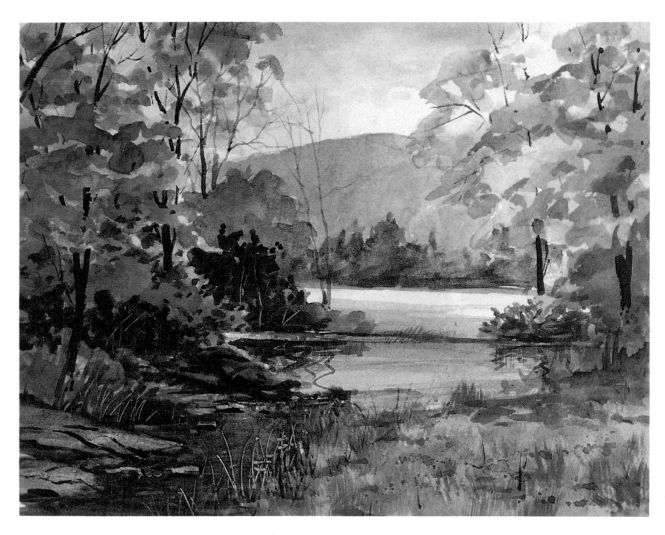

STEP SEVEN

Mixing a rich dark of viridian and burnt sienna, the artist places trunks and branches within the foliage at either side of the picture. These trunks and branches are painted with short strokes, interrupted by the clusters of leaves. He adds one more tree on the far shore with slender strokes of ultramarine blue and cadmium orange. This is diluted with lots of water to make a few broad, scrubby strokes that indicate foliage at the top. He then strengthens the foliage in the upper left with strokes of burnt sienna and alizarin crimson, subdued by a hint of viridian. He builds up the detail of the grass in the foreground with this same mixture. But he decides that the foreground is becoming too warm. So he tones down the grassy field with a pale wash of cerulean blue that mixes with the warm undertone to create a partic-

ularly fascinating, shadowy optical mixture. Where the wet bristle brush has scrubbed out the shapes of the rocks in the lower left, the artist delineates the cracks on these flat rocks with strokes of ultramarine blue and burnt sienna. To suggest the cool tone of the water running over these rocks,

he tints them with the palest possible wash of cerulean blue. The finishing touches are a few more dark strokes for the wiggly reflection of the slender tree in the water, and more pale scratches to indicate foreground weeds and branches among the bushes on the far shore.

TIPS: OPTICAL MIXING IN WATERCOLOR

1 Some tube colors are more transparent than others. Learn which colors are really transparent and which are more opaque.

2 At the underpainting stage, all your colors are equally useful, whether they're absolutely transparent or have a bit more "covering power." At the overpainting stage, stick to the really transparent tube colors.

3 If you do choose a more opaque color for your overpainting — such as one of the cadmiums, for instance — add enough water to make the color transparent.

4 Be quick and decisive when you brush on the overpainting. Don't scrub too hard, or you may dissolve the underpainting and create a physical mixture.

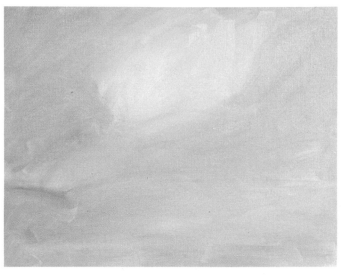

STEP ONE

When you start mixing your colors on the palette, then continue to mix them on the canvas, the colors flow into one another to create an almost instant color harmony. On his palette, the artist creates varied mixtures of ultramarine blue, phthalocyanine blue, cadmium red and yellow, all softened with a lot of white. He brushes these tones over the entire canvas. Visualizing sky and water, he places the cool tones of the water at the bottom, and a brightly lit area in the center of the sky.

STEP TWO

The artist starts to blend more color into the wet surface. He adds soft, blurred strokes of cadmium red and cadmium orange to the sky, and to the water below, where they're reflected. He darkens the water with more phthalocyanine blue—using this powerful color in very small quantities so it won't obliterate the other mixtures. There are still no definite forms in the painting, but you begin to sense the presence of sky and water.

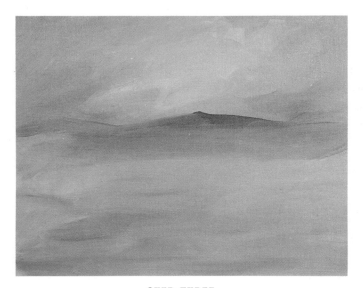

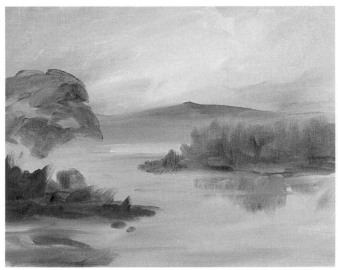

STEP THREE

The first concrete form begins to appear. The distant mountain is painted with ultramarine blue, alizarin crimson, and a little white, first mixed on the palette and then blended into the wet color on the canvas. With long, horizontal strokes, the artist melts the lower edge of the mountain into the color below. Now we see the warm color above as sky and the color below as misty water. Going over these areas again, he blends them more softly, so the harsh tones of Step 2 begin to fade and fuse.

STEP FOUR

Combining burnt sienna, viridian, and a little cadmium orange on his palette, the artist brushes this into the middleground, just beneath the mountain, to create a wooded island. He carries some strokes down into the water to suggest the reflection. Then he brushes in burnt umber, ultramarine blue, and viridian for the dark island on the left, its reflection, and the dark mass of foliage. Lines of yellow ochre and white suggest light shining on the water. Each new stroke mixes with the wet color on the canvas.

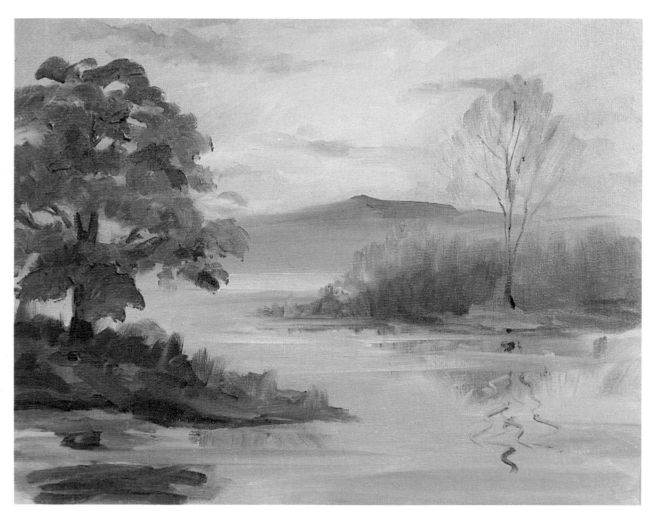

STEP FIVE

The artist builds up the form of the big tree and the island at the left with thick strokes of ultramarine blue, viridian, and a touch of cadmium orange for warmth. The island is extended farther into the water, and the tone of the land is darkened to match the tone of the tree. The reflection in the water is darkened for the same reason. A few streaks of cerulean blue, viridian, and white are carried across the reflection to suggest the light on the water. These dark tones in the left foreground are warmed by the underlying color that merges with the fresh brushstrokes. To lighten the tone of the sky, the artist blends more yellow ochre and white into the wet, underlying color. Slightly darker, wispy clouds are brushed in with cerulean blue, alizarin crimson, and white. A touch of burnt umber is added to this mixture for the soft, almost transparent foliage of the

slender tree on the right. Its twigs and the clouds merge with the underlying sky tone as the brush moves over the wet color. With a pointed softhair brush, the artist draws the slender lines of the tree trunk with burnt sienna and ultramarine blue, then carries wiggly lines into the water for its

reflection. After mixing cadmium red and cadmium yellow on the palette with a small bristle brush, he adds thick touches of this bright mixture to the edges of the tree on the left, the island below it, and the foliage in the central island to suggest warm sunlight on the dark shapes.

TIPS: WET-INTO-WET PAINTING

1 *Fix the composition firmly in your mind—or keep a sketch that you can refer to—since the paint will soon cover the sketch lines on the canvas.*

2 *When you mix colors on the palette, don't mix them too thoroughly. They'll be mixed some more on the painting surface!*

3 *Work with thin color until the final stages of the painting. Thin color is easier to mix on the palette and on the canvas.*

4 *Work with broad, loose strokes and let the strokes show. Let the viewer see how the brush moves over the painting surface and mixes the colors.*

5 *Don't scrub the colors into one another on the canvas. Don't overmix them. Simply by brushing new colors over the old ones, you can create new mixtures.*

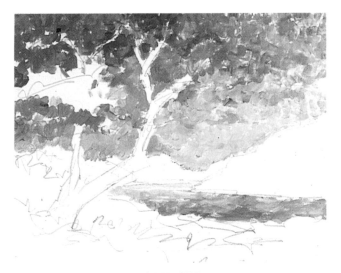

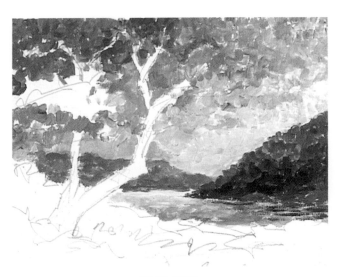

STEP ONE

The Impressionists often built up a mosaic of small strokes, painted side-by-side, *over* one another, and *into* one another. In this painting, over a pencil drawing on illustration board, the artist blocks in the sky with strokes of yellow ochre and white. Over these, he places strokes of ultramarine blue and white; cadmium red and white; burnt sienna, ultramarine, and white; ultramarine, naphthol crimson, and white—adding more white to these mixtures for the warm and cool strokes above the horizon. And these varied mixtures are reflected in the water.

STEP TWO

The bright color of the distant shore is painted with various combinations of ultramarine blue, naphthol crimson, yellow ochre, and white. Some strokes contain more crimson, others more blue, and still others more white. The darker slope at the right is rendered with deeper mixtures of these same colors, intermingled with strokes of burnt sienna and phthalocyanine green in the shadows. These dark tones are carried down into the water with horizontal strokes that suggest reflections.

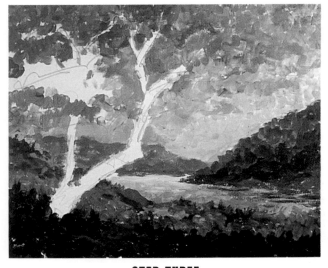

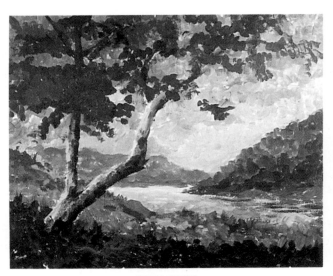

STEP THREE

The grassy foreground is first covered with strokes of phthalocyanine green, burnt sienna, yellow ochre, and a little white. While these strokes are wet, the artist adds darker strokes of varying combinations of ultramarine blue, phthalocyanine green, and cadmium red. (The warmer strokes contain more red, the cooler strokes more blue or green.) He doesn't *attempt* to blend his strokes, but each fresh stroke creates a wet-in-wet mixture with the color beneath—or an optical mixture with the dried strokes.

STEP FOUR

The artist renders the trunk with dark and light strokes of phthalocyanine blue, burnt umber, yellow ochre, and white. The lighter strokes contain more white, while the darker ones contain more blue and umber. He allows each stroke to stand unblended, capturing the texture of the bark. Then he blocks in the foliage with dark strokes of phthalocyanine green, burnt sienna, and a bit of phthalocyanine blue. The individual strokes are allowed to stand unblended, suggesting the shapes of the leafy masses.

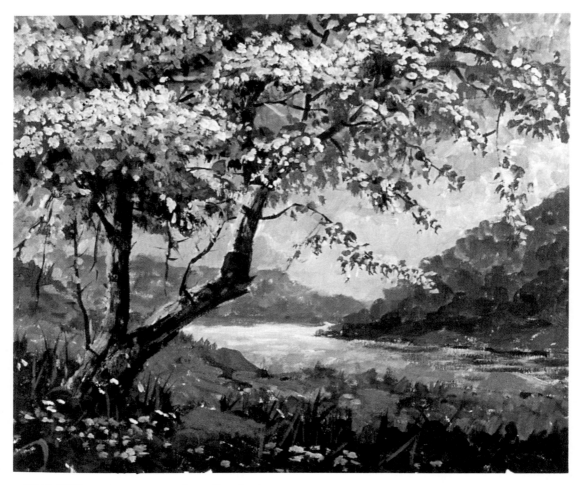

STEP FIVE

The artist suggests the blossoms on the tree with small touches of three different mixtures. The cool blossoms in shadow are a blend of cerulean blue, yellow ochre, and white. The warmer blossoms are mainly yellow ochre and white, with a hint of burnt sienna. And the bright blossoms in direct sunlight are *almost* pure white with a drop of cerulean blue. The artist adds branches and strengthens the shadows on the trunks with phthalocyanine blue and burnt sienna. Then he brightens the sunlight on the trunks with the mixtures that he's used for the blossoms. He carefully leaves gaps in the foliage to allow the sky to shine through. With small strokes of phthalo green, burnt sienna, yellow ochre, and white, the artist extends the leaves across the sky. Among the leaves, he adds more blossoms with the same three floral mixtures, so now we see rich masses of flowers in the sunlight. Among the grasses at the bottom of the picture, tiny strokes of these mixtures become wildflowers on the shadowy ground. Within the grass, the artist adds rocks with broad strokes of burnt umber, cadmium yellow light, ultramarine blue, and white. Blending more white into this mixture, he adds warm strokes to the sunlit edges of the tree trunk. He blends phthalocyanine green and burnt sienna with a touch of phthalocyanine blue for the dark grass around the tree and rocks. Then he adds white to this mixture for the paler blades of grass. Finally, a few dark strokes are added to the tree trunks with phthalocyanine blue and burnt umber to indicate the cracks in the bark.

TIPS: THE STROKE TECHNIQUE IN ACRYLIC

1 *Don't scrub your strokes together. Make a stroke and then make another stroke. As they overlap, they'll blend just a bit.*

2 *Step back frequently to view your painting from a distance. When you stand too close, all you see are a lot of individual strokes. You have to step back to see how they blend in the viewer's eye.*

3 *Work with creamy color; a thick, solid consistency like oil paint.*

4 *To make your paint even more buttery and easy to move, add liquid acrylic medium or gel medium—not water*

5 *Work with brushes that will carry plenty of thick paint: bristles like the ones you use for oil paint, or white nylon brushes shaped like bristle brushes.*

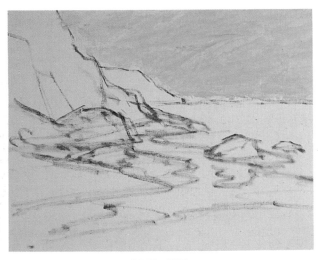

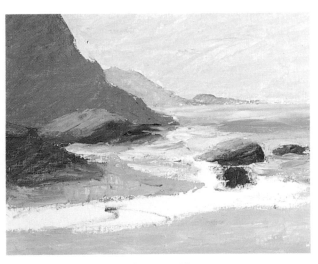

STEP ONE

For clarity and brilliance, nothing equals the dense, smooth stroke of color made by the painting knife. No brushstroke ever looks as vivid. After drawing the composition on the canvas with ultramarine blue and solvent, the artist knifes in the upper sky with alizarin crimson, white, and a speck of ultramarine. He covers the lower sky with yellow ochre and white, warmed with a hint of crimson. Then he switches from the delicate painting knife to the stiffer palette knife to scrape the paint down to a thin layer.

STEP TWO

He knifes in the dark cliff with ultramarine blue, burnt umber, yellow ochre, and white; the distant cliff with phthalocyanine blue, burnt umber, yellow ochre, and white. He paints the rocks' dark side planes with burnt sienna, ultramarine, and yellow ochre; their sunlit tops with burnt sienna, yellow ochre, and white; and the sand with yellow ochre, cadmium red, and white. The darks beneath the cliff are burnt sienna and yellow ochre, while the water is knifed on with long strokes of phthalocyanine blue, softened with some umber, yellow ochre, and white.

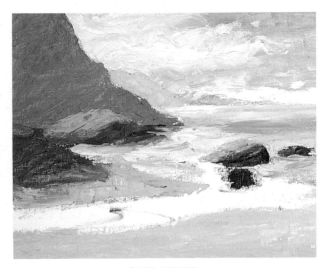

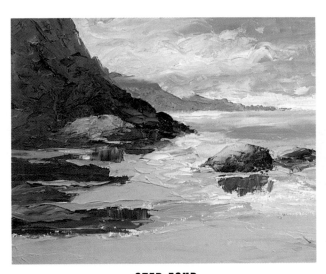

STEP THREE

Until now, the paint has been thinly applied so that the canvas texture comes through and will accept more color. Now the artist covers the sky with thicker strokes of phthalo blue, softened with umber and ochre. He adds more white to this mixture for the paler sky areas, still more white for the clouds, and more yellow ochre for the warmer patches. Adding some yellow ochre to the white on his palette, he accents the sunlit tops of the clouds, brightens the lower sky, and adds a strip of light to the water below the distant cliff.

STEP FOUR

The artist knifes a low cloud over the distant cliff and strengthens the cliff itself with sky color and some burnt sienna. He creates varied mixtures of burnt sienna, ultramarine, ochre, and alizarin crimson to darken the nearer cliff and rocks, and to add reflections. Thick strokes of white and ochre accentuate the sunlit beach and the tops of the rocks. Strokes of sky color—with varied amounts of white—complete the water, suggest sparkling foam and sunlight, indicate the wet shine on the rocks, and darken the foreground.

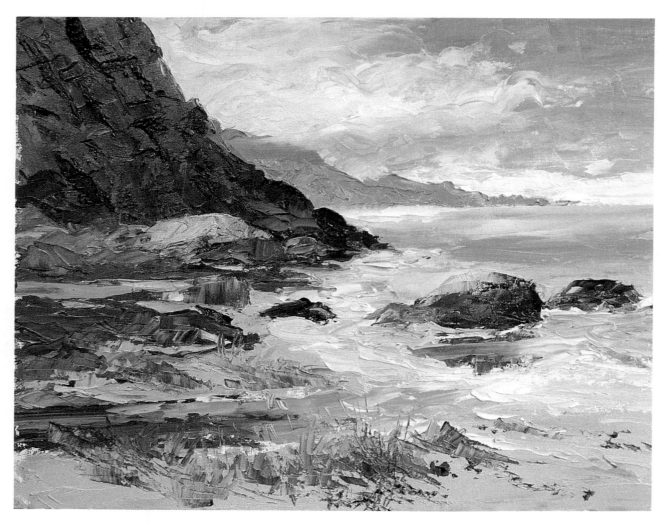

STEP FIVE

Knife painting doesn't lend itself to intricate detail, but you *can* do more precise work than you might think. To strengthen the shadowy cracks in the dark cliff, the artist mixes phthalocyanine blue and burnt sienna. He adds the dark strokes by touching the side of the blade lightly against the canvas and then pulling the knife away. With this same mixture, he adds more darks to the shore, including another rock at the edge of the beach. The artist also darkens the rock in the water at the extreme right. With the tip of the blade, he adds quick, slender, curving strokes of sunlit foam (white tinted with yellow ochre) and he carries more sky reflections into the tide pool in the foreground. To suggest more movement in the foreground water around the rocks, he adds quick, choppy strokes of sky and cloud color. Finally, to indicate the scrubby grass on the sand, he uses the tip to paint short, irregular strokes of ultramarine blue, cadmium yellow, and a little burnt umber. These slender, linear strokes are again executed by pressing the sharp edge of the blade against the canvas and then pulling away. The finished painting looks delightfully rough and spontaneous, but the color has been carefully planned. The underpainting has *almost* disappeared beneath the heavy strokes of the overpainting, but not quite. You can still see the warm underpainting in the sky and in the shore.

TIPS: KNIFE PAINTING

The painting knife produces color with a unique freshness and purity. To ensure this purity, you must observe certain "rules."

1 *Wipe the blade carefully to be sure it's absolutely clean before you pick up color.*

2 *Work with a minimum number of strokes, and move your knife decisively across the canvas. Scraping back and forth will turn fresh color to mud.*

3 *Mix your colors on the palette. Once put on the canvas, you can't correct them.*

4 *In the early stages, apply paint thinly. If your color gets too thick, scrape it down a bit with your palette knife. Save the thick strokes for the final stages.*

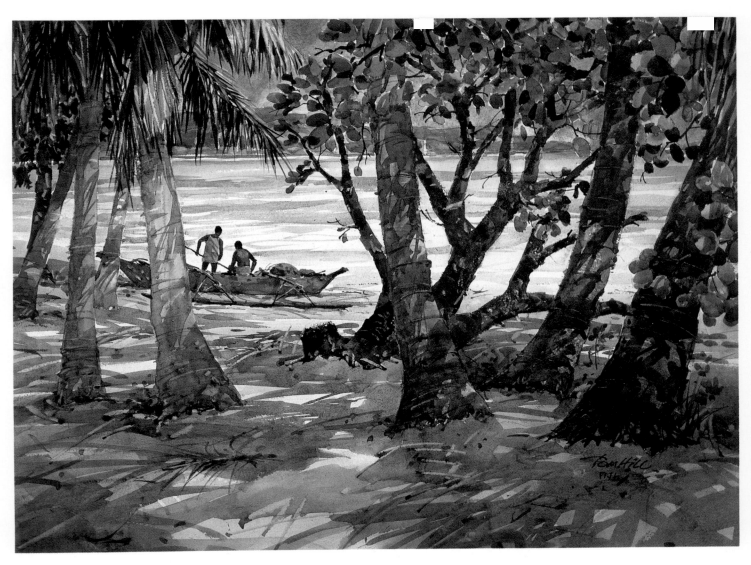

SOUTH BEACH, NAIGANI, FIJI
by Tom Hill, watercolor, 21" × 29"

The rhythmic design of this tropical landscape is reinforced by the color orchestration. The carefully designed tree trunks, some cool and some warm, are silhouetted against the lighter, brighter hues of the distant sea and sky. The central tree is the hottest color, echoing the colors of the figures and boat. The leaves are a fascinating tapestry of warm and cool mixtures: greens, golds, browns—all colors that appear elsewhere in the landscape. And the foreground is a rich pattern of cool shadow strokes and gaps of sunlit sand, with reflected colors that suggest the sky and the tree trunks. The shadows are *not* darks; they're full of light and color.

Private collection

PART NINE
COLOR
STRATEGIES
GALLERY III

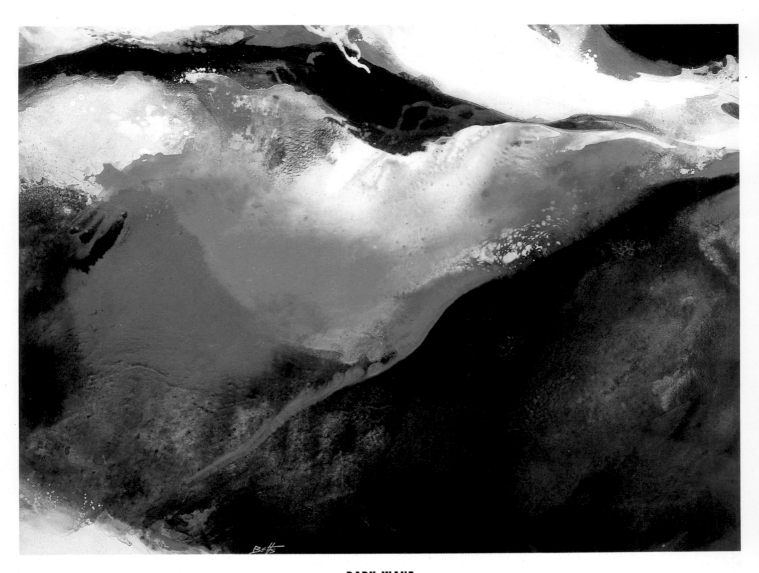

DARK WAVE

by Edward Betts, acrylic on board, 29" × 39"

This boldly designed seascape demonstrates the power of the simplest possible color scheme. The painting consists mainly of blue, green, and white shapes that create a satisfying abstract design and memorable evocation of the subject. Having chosen these few colors, the artist explores their many possibilities: magical gradations from blue to green to blue again; whites that contain hints of these colors; strokes of blue and green that penetrate the bigger shapes; and unexpected hints of yellow to provide a necessary touch of warm color. Betts also explores the full range of each color, from the palest, mistiest blues and greens to sonorous darks.

Photo courtesy of Midtown-Payson Galleries, New York

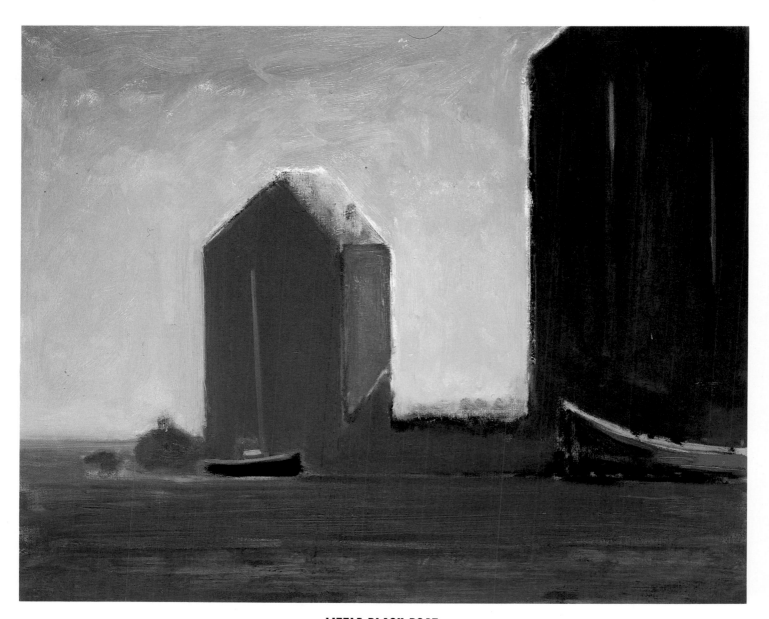

LITTLE BLACK BOAT

by Paul Resika, oil on canvas, 32" × 40"

In this spare, beautifully simplified pictorial design, the artist visualizes each element as a colored shape. The warm blue shapes of the buildings, shoreline, and sea are silhouetted against a complementary yellow-orange sky—and the complements intensify each other. The single patch of red-orange is the most brilliant note in the painting: our eye goes instantly to that spot. But this color note isn't totally isolated; the artist blends a hint of this color into the upper sky. Notice how he adds a few slender strokes of orange among the buildings to echo the bigger orange shapes. And the green boat adds a second cool color for a note of variety among all those blues.

Photo courtesy Graham Modern, New York

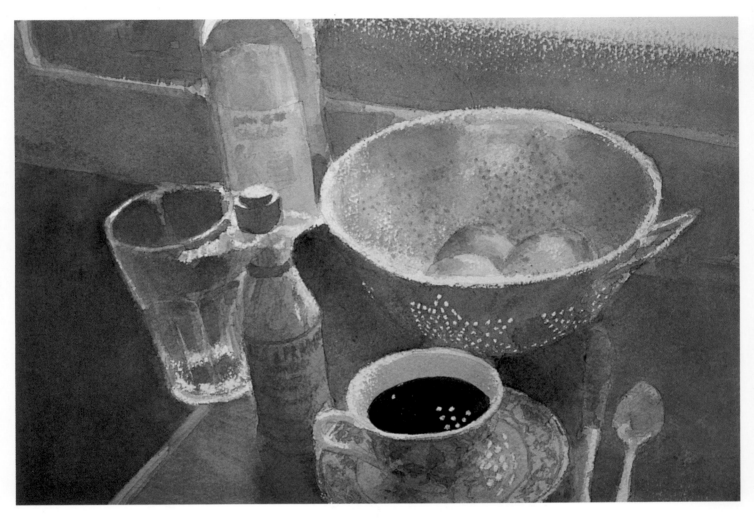

TEACUP, COLANDER, LEA & PERRINS

by W. Lee Savage, watercolor, 12 ¾″ × 16 ⅜″

This luminous still life is a study of transparent and reflective objects: glass, metal, porcelain, and a shiny countertop. The glass objects have no color in themselves, so the surrounding colors shine *through* the transparent shapes—and create reflections on the glassy surfaces. The metal and porcelain objects also act like mirrors that are filled with reflected color. Where do these reflected colors come from? The warm colors of the shiny countertop "bounce" into the shapes that rest on that counter. And a fragment of window suggests the source of the cool light that moves through the still life. Look closely and you can see that every object contains *both* warm and cool reflected color. The effect is magical and mysterious.

Collection Charles and Peggy Purcell

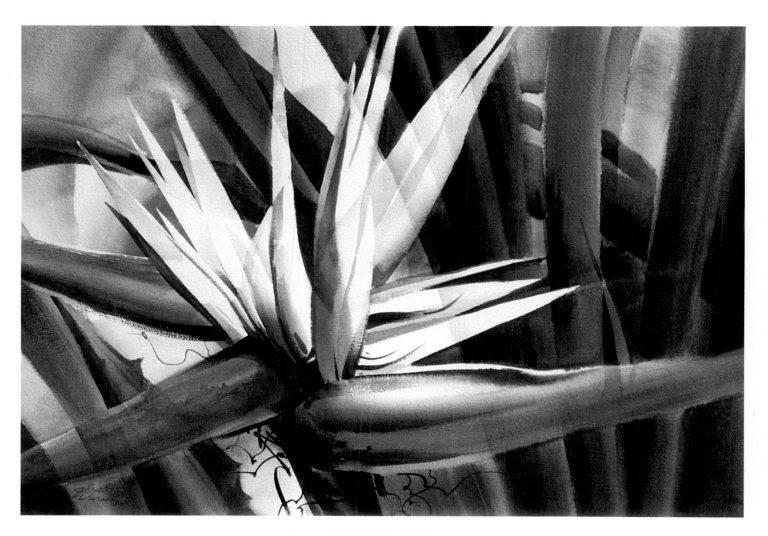

COURTSHIP DANCE
by Zoltan Szabo, watercolor, 22″ × 30″

The graceful white shapes frame the center of interest, which is the single petal that contains a flash of hot color. This hot note is reflected in the two petals below — which also contain complementary cool strokes. And both complements are reflected in the other white petals above. Behind the big blossom are blue and green shapes with patches of cool sky breaking through. Because this is essentially a cool picture, the few hot colors have great impact. The white shapes, with darker shapes behind them, also provide the strongest value contrast in this elegant design.

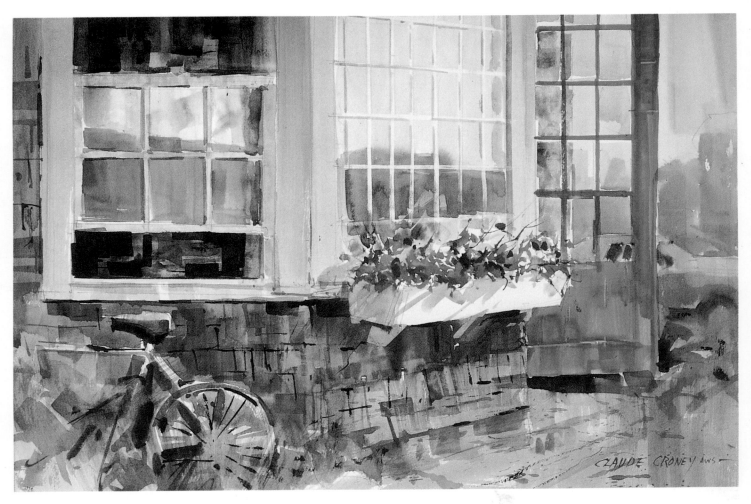

BLUE DOOR

by Claude Croney, watercolor, 13 ½″ × 20″

Surrounded by the quiet grays, browns and olives of the house and the few patches of grass, the focal point of the painting is the meeting of the flower box and the blue door for which the picture is named. The flowers and the door are the only bright colors in an otherwise subdued picture. Notice how the white flower box meets the dark shadow beneath to create a strong value contrast that helps to direct your eye to the center of interest. The other white areas are tinted with pale washes to play them down. White is, after all, a very bright color. Observe all the reflected colors in the many small panes of glass. You can't really paint glass; you must paint the reflections in the glass.

Collection of Grace L. Croney

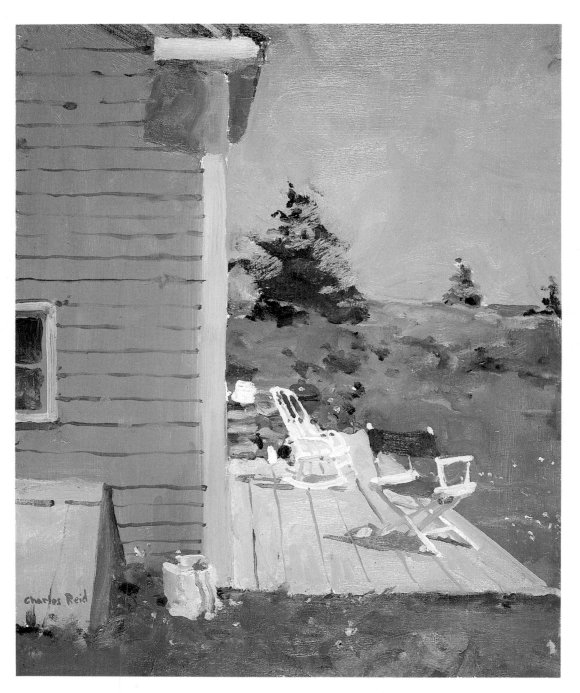

PORCH, BACCARO, NOVA SCOTIA

by Charles Reid, oil on board, 22" × 18"

If you can see them, painting subjects are literally in your backyard—like this charming outdoor study. The painting seems casual and so does its color scheme, but the design is beautifully planned. The focal point is the pure white sunlight on the chairs, which are partly silhouetted against the darker colors of the landscape and accented by a few dark notes on the chairs themselves. The blue notes on the chairs are echoed by the patches of this hue on the wall and at the horizon—and by the sky mixture. The dark grass frames the sunlit deck. Flecks of white (plus some touches of yellow and pink) animate the grass and echo the sunlit chairs. And rusty tones appear throughout the painting to tie it all together.

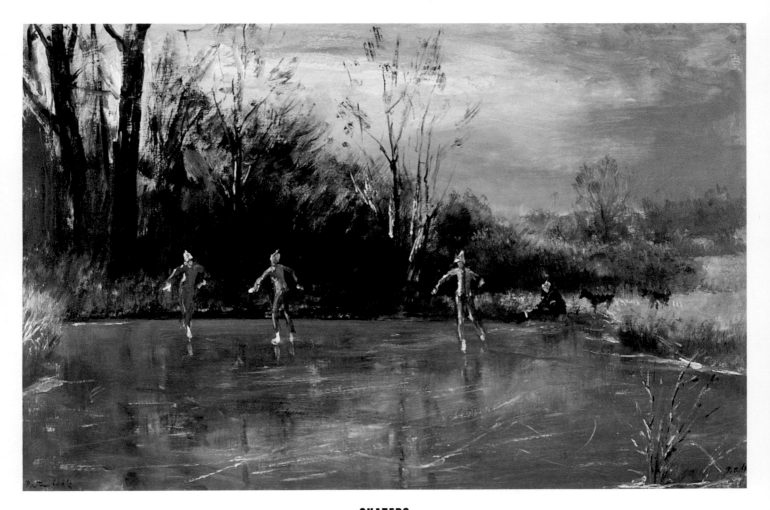

SKATERS

by Peter Cook, oil on board, 24″ × 36″

Ice, like snow, is just another form of water, which normally reflects the colors of its surroundings. In this wintry landscape, the frozen pond mirrors the cool color of the overcast sky and also picks up some of the darker tones of the foliage on the shore. The break in the clouds is reflected in the lighter area of the pond. The artist introduces some of the cool pond color into the distant landscape and into the trees at the extreme left, so that the land isn't an isolated patch of warm color, but links up with the other color areas. One skater wears a pink top to lead your eye to the center of interest. Notice how this warm note reappears in the landscape at the right.

Private collection

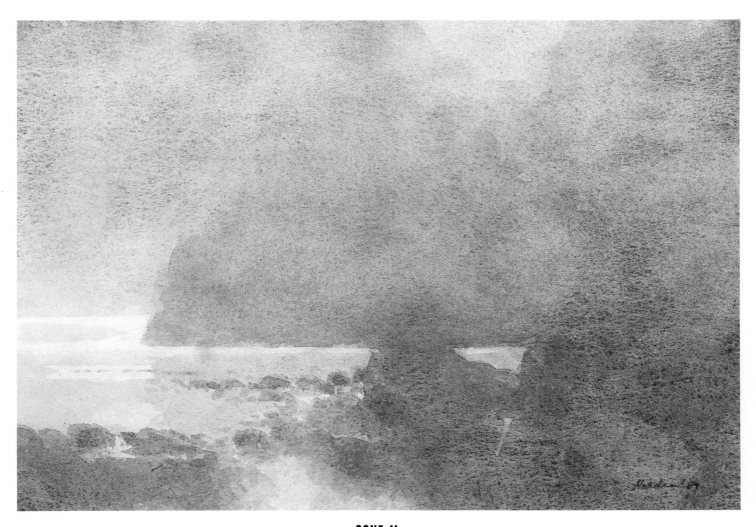

COVE II

by Donald Holden, watercolor, 7 ¼″ × 10 ¾″

The longer you look at this very subdued painting, the more color you see. The three-color palette—cobalt blue, yellow ochre, and sepia—produces a diverse range of muted mixtures: blue-grays, brown-grays, golden grays, greenish grays, as well as varied blues, browns, and golds. Painted wet-into-wet and mixed on wet paper, the color keeps changing as your eye moves over the picture. Although this looks like a monochrome at first glance, no two areas are exactly the same color. And every area contains hints of the mixtures that appear elsewhere in the painting.

Permanent collection, New Britain Museum of American Art, New Britain, Connecticut

ROAD PAST THE WATER TANK

by Barbara Luebke Hill, oil on canvas, 14" × 18"

Here's a memorable example of a picture that interweaves warm and cool color with great subtlety. Golds, mustards, and browns intertwine with grays, greens, and violets to produce a unified pictorial design. The golden wall of the central building is the brightest note in the painting, accentuated by the cool background tone and the sharply contrasting shadow that's cast by the tree on the left. The road—whose color is a subdued version of the sunstruck wall—leads the eye to the focal point. The warm tones of the ground are freshened by the violet flowers. It's worthwhile to examine the way in which the artist repeats the colors throughout the canvas.

Private collection

LILY PADS

by James Reynolds, oil on canvas, 16″ × 20″

The dark mass of foliage in the left foreground, placed against the paler foliage on the shore beyond, creates a feeling of deep space — a handsome example of aerial perspective. The artist saves his brightest colors for the surface of the pond, where the brilliant yellows and yellow-greens of the lily pads meet the blue reflection of the sky. He carries strokes of these colors into the dark foreground; lets these mixtures shine through the foliage; and adds some muted, inconspicuous strokes of the same colors to the distant landscape. He also ties the foreground to the distance by brushing some rich darks into the shoreline trees. Once again, repetition creates unity.

Photo courtesy O'Brien's Art Emporium, Scottsdale, Arizona

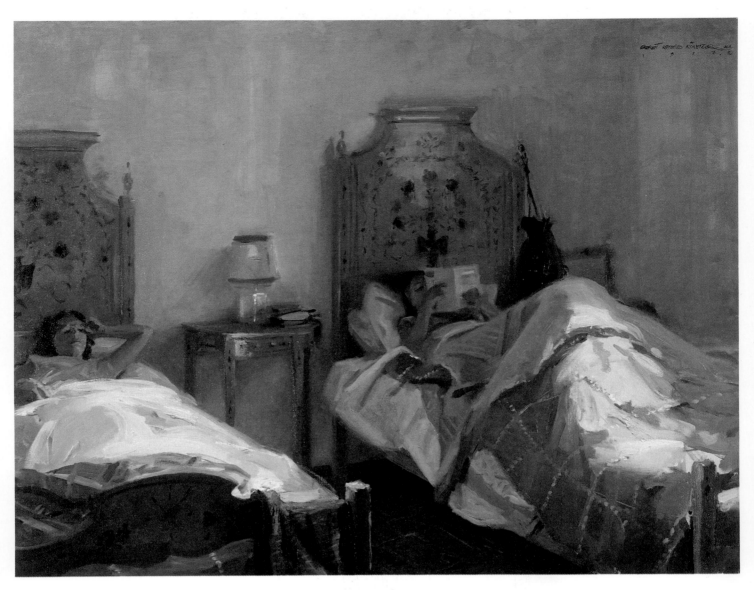

SUNDAY MORNING, PORTUGAL

by Everett Raymond Kinstler, oil on canvas, 34" × 40"

The gold and mustard walls and furniture provide a quiet setting for the rosy colors of the bed linens and the flashes of sunlight, which are the brightest notes in the picture. The painting is dominated by warm mixtures, so the artist introduces the inconspicuous blue and green shapes on the beds—for contrast and relief. The painting is a superb rendering of reflected color. Study the warm and cool reflections in the shadows on the bedclothes and in the wall, which is a shimmering tapestry of golds and grays. Despite the intricacy of the color, the brushstrokes are flat, simple, and decisive, always preserving the clarity and freshness of the mixtures.

Bibliography

Here are some sources that will help you build on the lessons you've learned in the book you've just finished reading. Some are in print and some are out of print, so you have to find them in libraries. But you should get to know the art shelf in your library anyhow! All these books are about color in oil and watercolor. Unfortunately, books on acrylic painting are scarce—and there are none on *color* in acrylic. But color is color, no matter what medium you work in. The fundamentals are the same. So just build up your personal library of color books in all media—or haunt the library.

Blake, Wendon, *Creative Color for the Oil Painter*. New York: Watson-Guptill, 1983. Although it's written for oil painters, this book is popular with painters in all media. The author explains that color is logical, not mysterious, and tells you how to put this logic to work in your paintings. Illustrated with masterpieces from the National Museum of American Art.

Blockley, John, *Getting Started in Watercolor*. Cincinnati: North Light, 1986. The author shows you all the *usual* ways to apply color and then he shows you how to go beyond these techniques to create fascinating and unexpected effects of color and texture. An exciting and surprising book.

Caddell, Foster, *Keys to Successful Color*. New York: Watson-Guptill, 1979. In a highly original book, the author identifies common color mistakes made by most students—and then he shows how to correct the problems. You're almost certain to find your color problems in these pages!

Cooke, Hereward Lester, *Painting Techniques of the Masters*. New York: Watson-Guptill, 1972. A must for painters in all media, this art instruction "classic" analyzes the techniques of great masters from the Renaissance to the present day. The information on color is outstanding. Illustrated with paintings from the National Gallery of Art, Washington.

Dunstan, Bernard, *Painting Methods of the Impressionists*. New York: Watson-Guptill, 1983. Written by one of Britain's leading contemporary painters, this inspiring book analyzes the working methods of the great Impressionist painters—who were, of course, masters of color. Illustrated with Impressionist masterpieces from major museum collections.

Gair, Angela, *Tonal Values*. Cincinnati: North Light, 1987. Understanding values is essential to any painter who hopes to master color—and this is the one book on the subject. Useful to painters in all media.

Galton, Jeremy, *Mixing Color*. Cincinnati: North Light, 1988. Filled with handsome illustrations by notable artists, this comprehensive book deals with color mixing in oil, watercolor, acrylic and pastel—and then shows how to create color mixtures for outdoor subjects, portraits, figures and still life.

Gruppé, Emile, edited by Charles Movalli, *Gruppé on Color*. New York: Watson-Guptill, 1976. The late Emile Gruppé was a master of outdoor painting and had a phenomenal knack for capturing color on the spot. Speaking through his friend and co-author, the noted painter Charles Movalli, Gruppé tells you how it's done.

Hill, Tom, *The Watercolorist's Complete Guide to Color*. Cincinnati: North Light, 1992. One of the most useful books on color, this volume is filled with practical advice, instructive pictures, and excellent demonstrations by one of our most admired watercolorists. A must for painters in watercolor.

Januszczak, Waldemar, Editor, *Techniques of the World's Great Painters*. Secaucus, New Jersey: Chartwell Books, 1980. Filled with fascinating closeup views of great paintings—with diagrams and text that explain the techniques—this lavishly illustrated book is particularly rich in facts about color.

Leland, Nita, *Exploring Color*. Cincinnati: North Light, 1985. This detailed and thorough book transforms color theory into practice via color exercises, paintings, color charts and sample color mixtures—hundreds of illustrations!

Salemme, Lucia A., *Color Exercises for the Painter*. New York: Watson-Guptill, 1970. Color is something you learn about by *painting*, so it's best to go straight from the book to the easel. Salemme's stimulating book is a series of color projects that put you to work with color—learning by doing.

Schink, Christopher, *Mastering Color and Design in Watercolor*. New York: Watson-Guptill, 1987. This intelligent book is really two books in one—an introduction to color basics *and* a practical approach to the basics of design. The information on color alone is worth the price.

Sovek, Charles, *Oil Painting: Develop Your Natural Ability*. Cincinnati: North Light, 1991. In this complete course of instruction for the oil painter, Sovek includes very useful and well-illustrated information about color, including how to produce various lighting effects in oil paint.

Stern, Arthur, *How to See Color—and Paint It*. New York: Watson-Guptill, 1984. Stern presents an innovative method—and a highly effective one—for developing your ability to observe, mix, and record color in your paintings. Although the stimulating projects in the book are for oil painters, the book will improve your work in *any* medium.

Taubes, Frederic, *Oil Painting for the Beginner*. New York: Watson-Guptill, 1965. Although this is really an introduction to oil painting, the book offers the most enlightening introduction to the old master methods of underpainting and overpainting—which is the key to the remarkable color effects that you see in so many museum masterpieces.

Willis, Lucy, *Light: How to See It, How to Paint It*. Cincinnati: North Light, 1988. (Also available in paperback.) Another interesting book on light—which means that it's also a book on color—this volume explores light effects in landscapes, seascapes, portraits, figures, still lifes, and interiors by many noted painters.